W9-AVD-205

Getting Started in

MULTI-MEDIA DESIGN

GARY OLSEN

NORTH LIGHT BOOKS
Cincinnati, Ohio

About the Author

Gary J. Olsen is a media designer at Hardie Interactive, a Dubuque, Iowa firm specializing in the development of electronic catalogs and interactive learning programs for CD-ROM and the Internet. He is also the author of *Getting Started in Computer Graphics* (North Light Books) and has worked for the past twenty years with computer applications in art, multimedia and other forms of communication. In addition, he is an exhibiting artist, photographer and communications skills teacher.

Acknowledgments

Special thanks to the following people for their inspiration as well as their expertise:

Terri Boemker and Lynn Haller, my editors from North Light books. Their experience, vision and dedication to task made the book better.

Charlie Ellis, for his organization talents and abilities. He was a key help in the chapters on managing the production process.

My colleagues at Hardie Interactive—Eric Faramus, Kevin Pedretti, Tom Darby, Jon Ellis, Dan Rohner, Ernie Nedder and Chris Lange. It's working with a talented team like this that makes multimedia so much fun.

Steve Hardie, who continually raises the bar in his quest for excellence. Without his cooperation, this book would have been practically impossible.

Linda Olsen, my wife and most valued inspiration. This book, like my first one, was a large undertaking, certainly larger than anticipated. It would have been extremely difficult without her input as well as understanding.

Getting Started in Multimedia Design. Copyright © 1997 by Gary J. Olsen. Printed and bound in Hong Kong. All rights reserved. No part of this book may be reproduced in any form or by any electronic or mechanical means in-cluding information storage and retrieval systems without permission in writing from the publisher, except by a reviewer, who may quote brief passages in a review. Published by North Light Books, an imprint of F&W Publications, Inc., 1507 Dana Avenue, Cincinnati, Ohio 45207. (800) 289-0963. First edition.

Other fine North Light Books are available from your local bookstore, art supply store or direct from the publisher.

01 00 99 98 97 5 4 3 2 1

Library of Congress Cataloging in Publication Data

Olsen, Gary.
 Getting started in multimedia design / by Gary J. Olsen.
 p. cm.
 Includes bibliographical references and index.
 ISBN 0-89134-716-X
 1. Multimedia systems. 2. System design. I. Title.
QA76.575.O48 1997
070.5'79—DC20
 96-35944
 CIP

Edited by Lynn Haller and Terri Boemker
Designed by Angela Lennert Wilcox
Cover illustrated by Angela Lennert Wilcox
Cover images from Vivid Details and PhotoDisc
Cover multimedia screen captures by Marcolina Design

The permissions on page 141 constitute an extension of this copyright page.

North Light Books are available for sales promotions, premiums and fund-raising use. Special editions or book excerpts can also be created to specification. For details, contact: Special Sales Manager, F&W Publications, 1507 Dana Avenue, Cincinnati, Ohio 45207.

How to Keep Up With the Technology: A Special Note From the Author

Writing this book was like hitting multiple moving targets. While the principles of graphic design and multimedia project management are essentially unchanging, the technology is ever-changing—evolving so rapidly, it's difficult to freeze a moment in time and hope that it will be relevant in the months to come. So I came up with a practical solution. This book has a corresponding website in the Hardie Interactive website at http://www.hardieint.com.

There you'll find important data on hardware and software innovations. I designed it expressly for keeping current information in the pipeline for fellow multimedia enthusiasts. It's also a way you can contact me via e-mail (golsen@hardieint.com) and let me know what you think and what you are doing.

As you will see, this book features a lot of talented people and their work. Since we are all now joined by the proverbial wire, it's interesting to note that this book was compiled almost entirely in cyberspace. I corresponded with all of the participants on the Internet, and graphics samples were exchanged and interviews conducted on-line. In some cases, of course, fully functional multimedia programs had to be shipped because they were just too big to download.

Meanwhile, I do feel that the most important and timeless information in this book, such as what constitutes good multimedia design, strategic thinking and planning a multimedia project—including managing the talent, costs and creative assets—will never change. Furthermore (as much as I hate to admit it), at this point in time, this kind of material is still more comfortably conveyed in book form.

G.J.O.

Dedication

I dedicate this book to the memory of my nephew, George Inserra. He died of leukemia at thirteen years old. He held such promise. He fought hard to live. He was a wonderful young man who truly loved computers.

Table of Contents

Introduction: Multimedia Strategic Thinking

An invention is often not so much an original thought, product or technology as it is a unique combination of those things already known.

Multimedia, then, is perhaps the epitome of invention. It combines a large number of known technologies and art forms—including text, audio, music, photography and video—and packages them into something new and wonderful.

This evolution of a new communication form is truly exciting to witness. What many of us are experiencing now when we first realize the possibilities of multimedia is similar to what some enterprising people experienced when they first saw television. It is also reminiscent of the phenomenal technological revolution I personally capitalized on not too long ago.

THE COMPUTER REVOLUTION, PART TWO

I was involved in an early form of desktop publishing in the late 1970s when I was running a one-person communication department for John Deere, the venerable Midwestern tractor manufacturer. At the time, I didn't consider myself ahead of any technological curve; my motivation was purely to survive amidst a continual budget crunch. I couldn't hire help but I could *buy a computer*. It was a Macintosh (one of the first) and I soon discovered it was more than just a word processor or page layout device. This machine was also a truly powerful artistic medium. This little computer quite literally took the power of publishing and graphic production from the hands of a few elite craftspeople and gave it to everyone.

The Macintosh revolution changed my life forever. In my first book, *Getting Started in Computer Graphics*, I chronicled my experiences as a computer graphic design-

er and artist, and outlined for other artists and designers how to make personal computers work for them. Appropriately, it was the first book my publisher produced using desktop technology.

I'm no longer a Macsnob. Among my current fleet of computers there's a Pentium Notebook, a Macintosh PowerPC and my original 1984 Macintosh (which I keep for nostalgic reasons). And now I'm writing these words on my Toshiba Pentium Satellite Pro—a truly awesome machine capable of playing video, full-stereo audio—and it literally screams with speed. I'm witnessing—indeed, getting to participate in—the invention of another exciting new way to deliver information and entertainment to people. It's multimedia.

YOUR MAP OF THE WORLD OF MULTIMEDIA

In this book, I hope to provide a guidebook to multimedia describing several interesting and attractive destinations, along with possible routes and modes of transportation. You can take a few short cuts, or travel the long and scenic route. You can travel economy or first class. As I tried to do in *Getting Started in Computer Graphics*, I want to build a bridge between the artist and the technology.

When I say "the artist," I'm using the term in a broad sense, since I imagine the audience for this book to be a wide-ranging group of people: among you are writers, teachers, musicians, artists, photographers, film and video producers—virtually anyone who feels this is a pretty cool way to communicate or tell a story.

But this is still high technology we're dealing with, and the learning curve can be steep. Until recently, being a writer, artist, musician or photographer was a rather low-

tech/high-touch pursuit—a pen, paintbrush, musical instrument or simple camera got you into the action. Now, we're dealing with at least $10,000 worth of computer gear to set up our creative shops. Suddenly, a career in the arts has become dependent upon high finance, science and math—the things that drove many of us toward an artistic career in the first place.

Computers are still intimidating to many of us. For example, we all fear investing in obsolescence. And there is just so much to know about ever-changing software and hardware, how does one assimilate it all? I could pack this book with facts and information and a glossary of terms a foot thick, but would it really help you become a great multimedia producer? While I've tried to cover some of this nuts-and-bolts, "here's the equipment you'll need" information, there are plenty of other resources out there that tell you what to buy and the ins and outs of various software programs. But, as I discovered, there are not too many that teach you how to think strategically to reach your artistic goals.

INSTRUCTION PLUS A BIRD'S-EYE VIEW

One of the qualities that made my last book a success was that a newcomer to the technology could sit at the computer with my book, regardless of the brand of computer they had, follow the lessons, and actually produce something neat. I try to keep that momentum going in this book. However, this book does not intend to rehash what's already in your software instruction manuals.

As you grow in capabilities and understanding, you will learn that truly great multimedia is seldom the product of solo performers. Sure, there are a lot of great one-man bands, but truly powerful music is

played by an orchestra. Multimedia requires a variety of skills, some of which you may not possess, and that's OK. The process is very similar to making a quality film or video. If you can direct the shoot, run the camera and sound, play the music for the soundtrack, art direct *and* program the computer, call me because I want to see you in action. In some cases, of course, for very simple interactive multimedia, you can do most of the chores yourself. But as your programs get more sophisticated and original, you may have to rely on other talented people. And once you have a team, you then must learn how to manage resources, costs and assets.

ART AND SCIENCE, AND COLLABORATION, TOO

Multimedia is essentially the combination of art and science. While most individuals approach projects either artistically or scientifically, most multimedia projects require some of both. You need to recognize and celebrate your strengths but acknowledge and compensate for your weaknesses. In creating multimedia, you don't have to go it alone.

Steve Hardie, the owner/president of Hardie Interactive, once told me, "It's not the treasure but the hunt for it that enriches our lives." I didn't fully appreciate this wisdom until I became involved in multimedia production. In the world of professional multimedia, I have the opportunity to work with people from all walks of life, talents and interests.

In the final analysis, what makes multimedia production such a rewarding career is that it often provides the opportunity to collaborate with other talents and produce something much more powerful than anything I could have done by myself.

The truth is, I decided not to become a full-time painter after I discovered painters often lead a very lonely workday in the studio. Becoming part of a multimedia production team gives me someplace interesting to go every morning, interesting people to work with and fascinating work to do. It's a wonderful life.

HOW THIS BOOK IS ORGANIZED

Besides the traditional chapter text in which material is organized in digestible sections, there are profiles of multimedia artists and their work, as well as miscellaneous sidebar features. These items have been strategically placed throughout the book to help illustrate the chapters' main points.

Reality Check: A reality check sidebar may go into technical issues in more depth, or provide some fresh insight into multimedia production.

Profile: Profiles focus on the artists, their backgrounds and their motivation—plus, of course, their art! These will serve as human touchstones in this seemingly vast landscape of technology.

CD-ROM: This identifies multimedia for CD-ROM projects.

The Web: Identifies projects for the Internet.

Toolbox: Identifies the software and hardware tools used for a featured work of multimedia art.

In addition, at the end of the text, there's a glossary to help you brush up on some of the terminology and a bibliography to point you toward other resources that might be helpful.

Ready to get started in multimedia? Let's boot up. ■

1

The Principles of Good Multimedia Design

Why is multimedia so different from other media forms such as video, newspapers and books? Because it's interactive. It's also nonlinear—you can navigate anywhere you want in a good multimedia program and absorb information at your own pace. Therefore, it is an excellent learning tool as well as an entertainment medium, information resource and marketing tool; it can teach and it can sell.

MULTIMEDIA IS A DIFFERENT KIND OF COMMUNICATION

Multimedia requires that creative thinking and development take place concurrently on several different levels. Since it's a combination of art and science, it is also a convergence of several different technologies—computer programming, video and audio. There are many factors that go into making a quality interactive multimedia product—good graphics, innovative programming, smooth operation. Weaknesses in any one critical production element tend to bring down the quality of the entire production.

But the technology is only half the story; the other half—the artistic side—is equally important. Ide-ally, your users should be so absorbed in the program, they forget they're interacting with a machine. Whether that happens depends not only on the technical quality of your product, but also on the quality of the storytelling and story-doing.

Multimedia Is Storytelling and Story-Doing

We as a culture love telling stories—that's why drama, television and films are so popular. But multimedia is not just about story-telling, it's also about story-doing. The user can be cast in the role of a participant; decisions and actions of the user can influence the process of the story and, indeed, the outcome. Consequently, one user can have a different learning experience than the next user.

INSTRUCTIONAL DESIGN

When developing computer-based training (CBT), you absolutely must build your application on sound instructional design principles. Instructional design for computer-based training is different than that designed for traditional stand-up or lecture-based training. Why?

With traditional classroom train-

ing, the pace of learning is set by the slowest learner in the class. But with computer-based training, the user can advance through the material at his or her own pace. Therefore, most good CBT is designed to allow the user to advance to higher levels of material only after successfully completing lower levels.

Well-designed CBT also allows the learner to skip over material already known or mastered, while slower learners can repeat levels until mastery is achieved. The net result is that all users learn what they need to know more efficiently than with traditional classroom training.

In this way, technology is changing the traditional classroom into a multipurpose multimedia workshop/lab. Students learn the factual data on their own through CBT, then discuss and apply those facts in the social settings of the classroom.

Multimedia is a great way to communicate with others and a superior learning tool. So, how do you get started?

IMPORTANT STEPS IN MULTIMEDIA DESIGN

Creating a multimedia program is no simple task; it requires a number of planning and development stages. It might be compared to producing a book or (a closer analogy) a movie.

The Screenplay Strategy

One of the best things you can do for your multimedia program is provide yourself with a screenplay, or script, before you begin. In fact, scripting is as necessary for multimedia as it is for video or motion pictures. As with a movie, a script for multimedia is typically set up to provide not only the dialogue or narration, but also the action, sound and music taking place at the same time. One of the best interactive

multimedia producers I've ever met, Dr. Joe Henderson, of Dartmouth University, has this to say about the importance of scripting: "All of my interactive projects start out as a screenplay. I'm still telling a story even though the story can unfold a number of different ways depending upon the actions of the user."

In other words, story-doing is still storytelling at heart, but with multiple outcomes rather than one. Every possible outcome the user can arrive at must still be accounted for with a well-thought out script. When this script is translated into multimedia, you've translated a story (or other meaningful information) rather than a jumble of confusing images and sounds. As Doctor Henderson puts it, "The story has to work on paper first."

Visualizing and Storyboarding

Multimedia is first and foremost a visual medium, so to be successful, it's crucial to hone your visual skills. Like any visual medium, good composition of elements and an inviting and intuitive look and feel are what work best, just as they do on a printed page.

When actually working with clients, I discovered that written descriptions of multimedia products are never enough, regardless of how well-written and descriptive they may be. Scripts describing what the user sees when this button is pushed, or what the user hears when that action takes place solicit what appear to be understanding nods from clients and co-workers; then, when they finally see something on the screen, they say things like, "I had no idea that was what it was going to look like!"

"But wait," you reply, "you read the script and approved the concept a month ago. . . ." Yet people, if they read anything in detail, will always get different and unique visual

Reality Check

Interactive Learning Is More Effective

Multimedia stimulates the visual and auditory senses, and can be entertaining. But more importantly, the user seems to learn more and absorb more information and detail in the process of using it. Studies have shown that interactive multimedia learning tools are among the most effective ways of transferring learning (75%-plus retention rate), especially when compared to lecture or text-based materials (no better than 30% retention rate). This is a compelling reason to provide more opportunities in your product for the user to interact with the information. A computer is too expensive to use simply to deliver a slide show. ∎

impressions in their heads from the same passage of text. Think of the brouhaha that erupts over casting when a movie is made from a popular book because each reader has a different vision of what the major characters should look like.

This is why storyboards featuring screens or key frames of an animation or video clip are essential in conveying the concept of a multimedia project.

Scripting and Storyboarding Save Time and Money

Scripting and storyboarding are excellent design strategies not only to help you define and visualize your own concept, but also to help *others* visualize it, important if you are doing multimedia for hire or involving a team of designers and craftspeople. With scripting, you cover all the story avenues you want

to make available in a program; with storyboarding, the look of these different pathways becomes clear. The relationship between images, screens and buttons is no longer an abstract concept.

Designing on the fly and making up the visual as you program is perilous and ultimately costly in time and money. Perhaps the most important reason for scripting and storyboarding is that it helps speed your production time. And production time can be quite expensive.

In a business scenario, clients often don't have the money or time to finance an "artistic experiment" or a project that is designed on the fly. Discipline is essential if a project is going to remain on budget, and storyboarding ensures a degree of discipline. Another important step before presenting a client with a more-or-less finished program is the alpha prototype.

THE ALPHA PROTOTYPE

A great way to advance your visual concept is to produce an alpha prototype. An alpha prototype is the very first work-up of your actual program, and may even have some initial functionality in place. This is the stage where your scriptwriting, storyboarding and other planning stages come together into an actual product—but not a final, fleshed-out version in which changes would be costly and time-consuming.

The alpha prototype should contain most compositional elements, such as button locations, windows and graphics, more or less as they will appear on screen, and they should begin to show development of an overall look or style for the program. It should even mimic functionality and approximate the information design. You don't need to use highly rendered graphics in alpha prototyping; simple shapes, like boxes with labels in them, will

do. Show where the user goes when each button on the home screen is pressed, and where subsequent choices lead.

This initial prototype shouldn't go too far—if your ideas or design are too finished-looking, it may shut out further input and development from others on the team. And there will almost certainly be other people involved in this project!

THE PRINCIPLES OF GOOD MULTIMEDIA DESIGN

Broadly speaking, multimedia design has to work on two different levels: a design level and a technical level. Since the design level is the more "fun" of the two—more artistic, more creative—we'll discuss that first.

Design Targets

The best multimedia designs are transparent to the user, creating an environmental space where the user forgets he is relating to a machine and feels motivated to explore.

How many times have you paid good money for an interactive program, fired it up on your computer and immediately thought, "Boy, is this cheesy!" In the rush to put multimedia titles on the market, many publishers merely convert existing material to CD-ROM without properly taking advantage of the technology. Books in print become books on CD; film strips and slide shows become film strips and slide shows on computers. And nobody wants to read volumes of text on a computer screen.

Don't misunderstand—it's OK to repurpose existing material to CD-ROM, and some of the best applications, like interactive encyclopedias, do just that. But you have to leverage the technology—the fact that you have a computer as your delivery mechanism allows you to show videos, play audio clips and, most

significantly, provide truly powerful interactivity.

What principles of good design continue to work well in multimedia, and how does one best apply these principles and techniques to multimedia?

• **Organic graphic design.** A good design calls attention to the content of the piece, rather than calling attention to itself. I call this organic design.

What are some attributes of organic design? It will vary, depending on the program, but typically, screens and graphics will appear to have a texture that can be revealed by dramatic lighting effects. Colors will be harmonious. Movement through the program will feel comfortable and users will easily, even intuitively, learn how to work their way through the program.

• **Storytelling and story-doing.** The key principle here is the story comes first. Before you can decide how to tell the story, you have to know what you're trying to get across—what information, what mood, what feeling. Multimedia is a very visual form of communication, so in our multimedia production company (Hardie Interactive), we put our young programmers through video and film apprenticeships. Think of your favorite film in which a story unfolds in something as simple as a close-up of a character's face. Experienced film directors and cinematographers know how to combine art and technology to tell a story, and so should multimedia designers.

Technical Targets

Designers often overlook the importance of programming in their multimedia projects, because, quite frankly, programming can be a plodding, non-spontaneous, non-artistic task.

But even the most engaging

graphic designs can lose their effect if your programming performance is poor. Beautifully produced video clips that run haltingly on the target platform spoil the whole experience for the user. Audio that sounds like it's coming out of a box of cotton balls or a bowl of cereal is annoying. On the other hand, programs featuring unsophisticated, almost naive graphics might work well simply because the programming and audio are so good.

Given the fact that programming is an important, but not necessarily attractive part of the project for many creative types, some of the best creative partnerships in multimedia are divided between programming and graphic design. Whether you're concerned with the technical end yourself or paying someone else to do it, your project must hit the quality marks in the following three technical areas:

• **Program performance:** Good performance means smooth operation and quick response—the result of an economically designed authoring code. Simplicity is still the best strategy.

• **Quality audio:** Audio should be clear, with consistent volumes and no distortion. To achieve this, audio clips should be optimized to the maximum kilohertz rate allowed by your target platform and media development software. Most multimedia authoring tools and target computer platforms do support audio tracks of 22 kilohertz or better, which you should consider to be a minimum. (For comparison, 22 kilohertz is the equivalent of an AM radio signal; CD quality audio is 44 kilohertz.)

It should come as no surprise that audio quality in multimedia production often degrades at the source. It's crucial for you to collect quality audio when you are recording it. This means using the best sound

 The Six Most Common Mistakes in Multimedia Design

• **"What is this thing . . . and where am I supposed to go?"** A lack of understanding of basic user interface design can create multimedia that mystifies users before they even get started. Either screens are filled with too many buttons, or graphics look like buttons but they aren't, or there is only one button that the user clicks on—and the program takes off like an automated slide show with no way of stopping it!

As a designer, you should make navigation visible and give visible feedback to the user's actions. If he rolls over a button, the button should respond in some way, identifying itself as a place to click. New users become frustrated if things aren't obvious. If your user interface is too cumbersome or complex, the user will not be able to properly focus on the information you want to transfer.

• **"I'm lost, and I don't know the way home."** This indicates a program that's too deep. Too many levels of interactivity with no quick way to return to a home base (or just escape) are sure ways to frustrate your user. Ask yourself, "Am I pushing the user through several levels of interactivity, nested menus and an endless series of screens to find what he's looking for? Or am I allowing the user to pull information in?"

This is especially applicable to the World Wide Web which, at its best, should be information on demand. If the user is forced into an endless click-o-rama, your design is defeating the purpose of the Internet. It's

OK to create a multi-level program, but you must give the user a navigational beacon, progress indicator, or map.

• **"I'm underwhelmed!"** Having a program that is too shallow is as bad as one that is too deep. A main menu that is a massive grocery list of unrelated topics just serves to confuse the user. A good strategy is to organize the information into a logical heirarchy of menus and screens that is natural and well-structured.

• **"Pass the Murine, I've got eye-strain!"** It's OK to have volumes of text to read, but avoid putting it into never-ending scrolling fields. This practice is particularly annoying on webpages. Instead, make your pages look like book pages, with turning buttons and arrows at the top or bottom of the screen (previous page, next page, home, etc.).

• **"It's from the Ransom Note School of Design."** What makes a good printed page design makes a good screen. Too many disparate fonts, too many lines and boxes, too many colors and tiny type against complex wallpaper backgrounds contribute to a lack of clarity and continuity. Just because your computer is capable of producing 16.8 million colors does not mean you have to use them all at once.

• **"How do I shut this thing off?"** Don't ever deny control to the user. Having video and audio files in your program are cool, but not providing controls to shut them off or skip ahead is just frustrating. Sure, you worked hard on that 3-D animation, but once a user has seen it, they probably won't want to see it again all the way through every time they boot up the program. ■

recording equipment that you can afford.

• *Quality video:* Video should be sharp and smooth-running. On today's computers, video is most often designed to run in a window smaller than the full screen area. The larger the window, the more computer power, speed and disk space will be required to run smooth video that is properly synchronized with the audio track.

Smooth-running video in a small window is better than halting video in a larger window that overtaxes the CPU. Plus, "low tax" video and animation will likely play on the widest variety of computer platforms. Full-screen (640 x 480 pixels), full-motion (30 frames per second) video will become commonplace as more people own more powerful computers. Currently, the most popular video window sizes are 320 x 120 and 320 x 240 pixels.

John DiRe
R/Greenberg Associates, New York, NY

John DiRe's formal art training includes an undergraduate degree in fine arts (his major was painting), and an M.F.A. in graphic design from Yale School of Art. His instructors included Paul Rand, Bradbury Thompson, Armin Hoffman and Matthew Carter.

John's professional experience prior to joining R/Greenberg Associates was exclusively print—book design, catalogues, brochures and posters. His clients included the Whitney Museum, New York Public Library and many major book publishers. "My design method," he explains, "can best be described as very traditional—commercial typesetting, pasteup, etc."

John is currently the senior art director at R/Greenberg, a major television post-production facility located in Hell's Kitchen, New York City, that employs about a hundred people. Production staff includes computer animators and software engineers who run Soft Image and RGA's proprietary software on Silicon Graphics workstations; they also do digital video editing and compositing. The growing interactive department consists of game designers, as well as programmers for kiosks, websites and CD-ROM projects.

The firm's design department staff of seven works with all of these production facilities to design everything from film titles to broadcast openings, special effects and

R/Greenberg Associates

graphic animation for commercials, websites and kiosks.

"All of the junior designers have come to us from art schools," explains John, "including the Art Center College of Design, Carnegie Mellon and the University of the Arts, Philadelphia.... All have a primarily print background. They learn to apply their abilities with type, composition and color to interactive media and motion graphics."

R/Greenberg's list of clients includes, Levis, AT&T, Campbells, NYNEX, Paramount Pictures, Columbia Pictures, Estee Lauder, MacDonalds and many other major corporations and film studios.

"One exciting aspect of working where I do," says John, "is the extreme diversity of design problems I am daily confronted with, as well as the range of production methods at my disposal. It is a fact at RGA that whatever can be imagined can be realized.... It is always possible to push the envelope of what has been done and seen."

The design work is content driven, explains John. "We are not tied to any particular look or style but rather let the project guide our aesthetic choices.... Since each project presents a different problem, each project yields a different visual solution."

"I am thirty-five," says John, "but the median age at RGA is probably well below thirty. The atmosphere here often feels similar to that of academia. The prevalent mindset is one of learning and discovery.... I find I learn as much from these young designers as I am able to teach them." ★

CD-ROM

Levis Kiosk: Information and Image

R/Greenberg Associates

The project: A stand-alone interactive touchscreen kiosk for Original Levi's Stores.

The client: Levi Strauss, through their agency, FCB Leber Katz.

The goal of this project was to bring an interactive, multimedia element to the interior design of the flagship Levi's store on 57th Street in Manhattan. The product needed to provide information about the range and specifics of Levi's products and history; it also needed to be hip, upbeat and engaging, as well as accessible and easy to use.

The kiosks are not much more complex than an ATM machine. The emphasis is on outstanding visuals, rather than innovative interactive logic.

R/Greenberg's final project solution actually involved seven different kiosk programs, one for each brand in the Levi's line (RedTab, SilverTab, Personal Pair, etc.) as well as one for accessories. Each brand has a different demographic that was taken into consideration in the design for that kiosk.

According to Creative Director, John DiRe, "The insane production schedule for this project was approximately ten weeks. Each kiosk has an attract loop specific to the content of that kiosk. . . . These [default animations] play in continuous loops on any kiosk that is not being used. They were created in Macromedia Director using graphic elements produced in Photoshop." ★

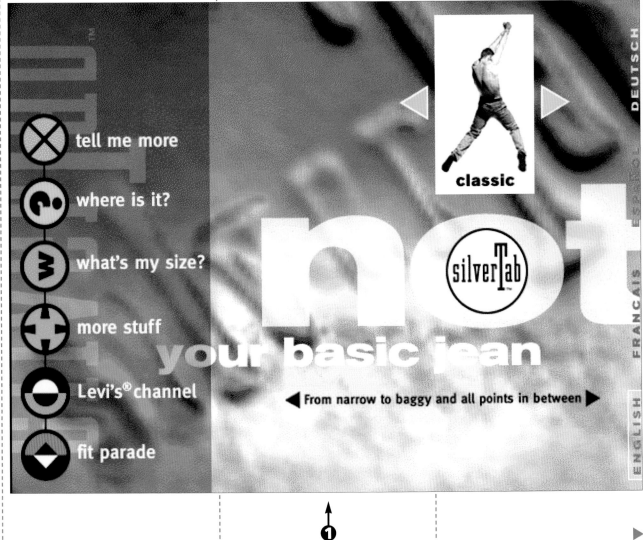

➊

R/Greenberg Associates

1 (previous page) The home screen for the SilverTab version of the program. Note the access to multilingual versions, which is available at all times. The buttons along the left-hand side of the screen take you to different information resources in the program. For example, "where is it?" actually points you to specific sections of the store; "Levi's channel" shows some of Levis' award-winning commercials.

2 A screen for Levi's RedTab jeans, in which the viewer can simply "touch pants to learn more."

3 In touchscreen applications, buttons can't be too small and close together, or they are difficult to press. These buttons are nicely spaced from the top of the screen to the bottom.

4 For every brand detail screen, a model wearing the jeans was photographed and highlighted in eight different positions. The kiosk user, by pressing an on-screen button, can rotate the model into different positions and examine the critical fit points of the blue jeans from any angle.

5 Here are two of the accessory screens you can reach by pressing "More stuff." Many of the navigation buttons don't have labels; instead, arrows rely on user intuition.

6 There are also several intriguing animations in the program, such as this watch, that pop up at opportune moments or just run when the kiosk hasn't been interacted with.

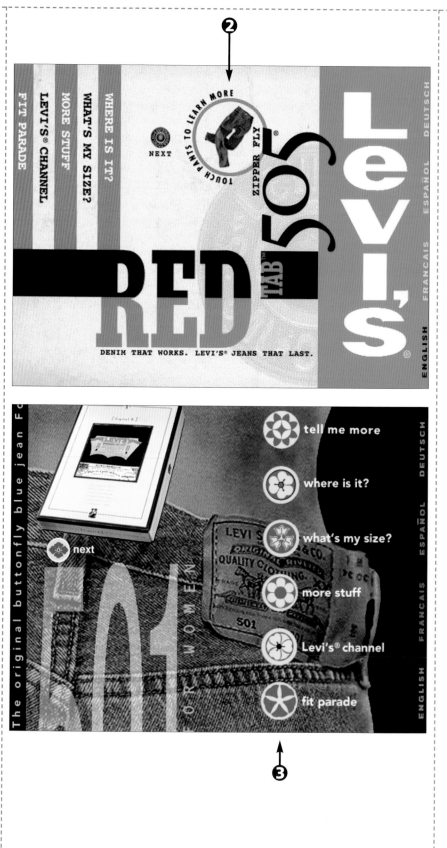

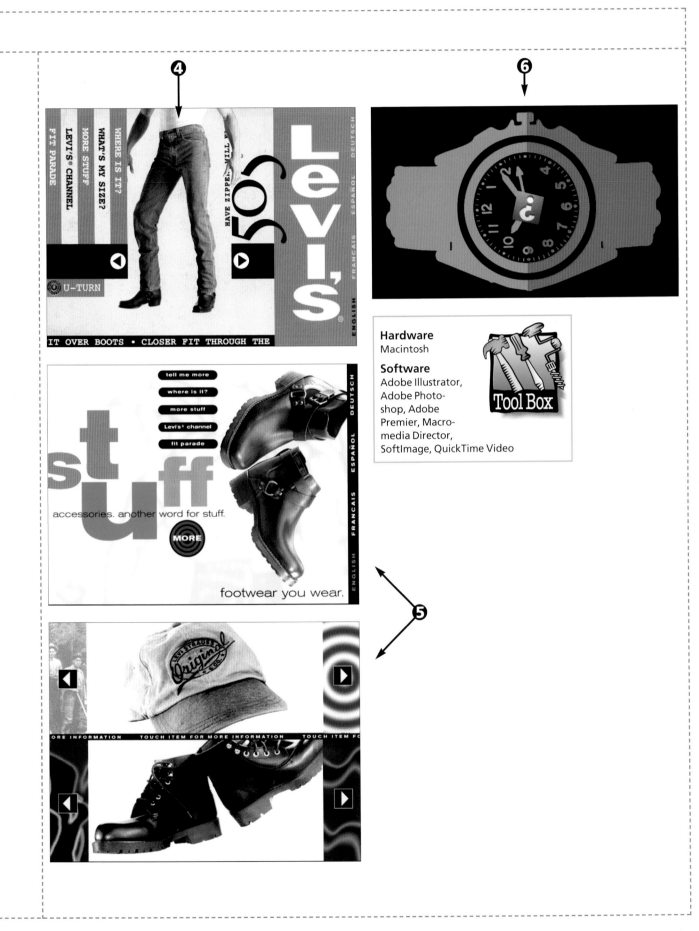

Hardware
Macintosh

Software
Adobe Illustrator, Adobe Photoshop, Adobe Premier, Macromedia Director, SoftImage, QuickTime Video

Tool Box

CHAPTER 2

The Multimedia University

There are five major career categories in multimedia. The skills do overlap, but it's a good idea to seek specialization, especially if you plan to work in an area with lots of high-tech enterprise, like on either coast. If, however, you're living in Smallville, you may have to be more of a Jack-of-all-trades. For example, I live in Iowa, and need to be able to fly from multimedia marketing presentations to CBT within a week.

THE FIVE MAJOR CAREER CATEGORIES IN MULTIMEDIA

Listed here are the primary multimedia markets and the software skills you'll need for each of them. It should go without saying that you need excellent communication skills to succeed in any of these arenas.

1. Custom Multimedia Software Development: The market is businesses. The jobs are building marketing presentations and electronic catalogs on CD-ROM and the Internet. You need experience with all of the important graphic software applications—Adobe Photoshop, Aldus Painter, etc., and production tools—Macromedia Director, Adobe Premier and so on.

2. Computer-Based Training: The market is corporations with large-scale training needs, publishing companies and educational institutions. Opportunities are here for courseware designers and qualified training specialists. Important software skills include Macromedia Authorware, Macromedia Director, Adobe Photoshop and Adobe Premier.

3. Entertainment and Computer Games: Computer games will continue to grow in complexity and sophistication, and will need acres of programmers. But if you set your sights on gaming, you should learn how to run a Unix workstation—Silicon Graphics or Sun. This is a very competitive field.

4. Website Design: The market is wide open. Virtually every organization could use a website, from large businesses that use the Web for commerce, communication and product support, to individuals. There are administrative careers as well as graphic design jobs spawned by the growth of the Web. You will have to know your graphics software, as well as HTML (Hypertext Markup Language) programming, Java, Macromedia Director, and Web-compliant database programming.

You would also do well to learn object-oriented database programming and SQL (System Query Language), Sybase, SQL For Everyone, PowerBuilder relational database developer tools, and everything you can about client/server application design.

5. Animation: Computer animators serve many markets—including the four already listed, plus film and television production. The skills required are considerable, including solid graphic arts talent, such as the abilities to conceptualize in 3-D and tell a story using a sequence of images, like a comic book artist. Of course you need superb computer skills; as far as hardware, most commercial animation takes place on high-end Silicon Graphics workstations.

Software skills include 3-D modeling (wire-frame) as well as advanced surface rendering and animation tools. Soft Image, Alias Sketch, Electric Image, 3-D Studio, Pixar's RenderMan and Pixel Putty are among the programs that serve this trade. As you work your way up, however, you'll likely be working with proprietary software few have heard of outside of the field.

THE BEST CAREER OPPORTUNITIES IN MULTIMEDIA

Where are the best career opportunities for multimedia producers? The area of greatest opportunity right now is with publishing companies and other providers of training materials for business.

Businesses are faced with a real dilemma. Most new hires lack some of the technical skills required in today's workplace. Employers can build their own classrooms, hire their own instructors, and take their employees out of production to train them, or they can contract with local learning institutions. The latter strategy has measurably helped many companies while bringing in considerable revenue to the schools.

Using Technology to Teach Technology

In Iowa, for example, community colleges have been aggressive in seizing the opportunity new technology can provide. The Des Moines Area Community College (DMACC) has collaborated with some of the state's largest employers to provide technical skills training to employers who request it for their employees. In Newton, Iowa, the venerable appliance manufacturer, Maytag, has collaborated with DMACC to train employees using computer-based training, CD-ROM and video disks.

This strategy is so successful that the colleges can't keep up with the training demands, creating the opportunity to use technology in yet another way—to deliver the technology training! Interactive courseware, for example, can have broader application to a variety of industry groups—in other words, companies can share programs. The marketing of such courseware would bring additional and continuing revenue to the schools.

What does all this have to do with multimedia? Plenty. Curriculum designers, interactive multimedia designers, programmers, graphic artists, photographers, videographers and animators will all be in great demand to help create these training materials and courseware.

SEEKING SKILLS TRAINING

Where did the people who are making their livings today in multimedia get their training? Chances are they're self-taught; technology is evolving so quickly, few schools have been able to keep pace with their curriculum. Nonetheless, there are two training paths you can pursue: the college/technical school route, or the private training/workshop route.

The first path is longer and more costly, but you do end up with impressive credentials. The other path is shorter and designed to provide you with a specific set of skills you'll need to do a job.

The College/Technical School Route

Do your research: scan the Internet (a growing number of schools are using this medium to attract students), and talk to college admissions counselors. Everybody in the business has heard about the California Institute of the Arts, for example, where students with an eye on show-business technology go. But fewer have heard of the University of Northern Iowa, which recently installed an Electronic Media Degree program. Northwestern University in Evanston, Illinois, has a well-funded computer-based training development center (as of this writing, tuition at Northwestern is $25,000 a year).

Actually, any school with a strong computer science career track plus a comprehensive liberal arts curriculum may already have the courses you need, even if they don't offer a full-fledged, multimedia degree program. There is also a helpful trend among universities and colleges who already have computer science, media, film and journalism programs to supplement their curriculum with new media courses.

If a Four-Year Degree Isn't for You

If the time and expense of a four-year degree aren't for you, there are a growing number of community colleges around the country that are getting involved in the same technology.

About ten years ago, I did research on how many schools in

The Multimedia University Curriculum

Any school could embark on a "Multimedia University" curriculum. From the aspiring multimedia student's point of view, my list of courses could also serve as a path with which to establish learning goals. Some of the courses I've listed below don't really exist, but I believe they should. So all curriculum directors reading this should feel free to take these suggestions and run with them. Career people in need of extra training should ask their schools if they couldn't put together courses on these subjects—not in twelve-week semesters, but one- to two-day workshops.

COURSE REQUIREMENTS FOR A DEGREE IN MULTIMEDIA

Technical/Computer Skills
- Programming (C, C+, C++, Visual Basic, Lingo, SQL, HTML, Java, PowerBuilder)
- System Integration, Networks, Intranets (Unix, Linux, Windows NT, MAC/OS)
- Client/Server Computing
- Internet Server Building and Maintenance
- Computer Security (System Firewalls, Encryption, Secure Internet Commerce)
- E-Mail System Development and Management

Software Engineering Skills
- Program Authoring (Macromedia Director, Macromedia Authorware, IconAuthor, Apple Hyper-Card, SuperCard, Multimedia PowerBook, Oracle Media Objects, etc.)
- Relational Databases: Applying relational databases to interactive multimedia and the World Wide Web
- Programming on the Internet (Java, HTML, SQL, Macromedia Shockwave)

Graphic Design Skills
- Composition
- Lighting Technique
- Color (Theory, Digital Applications and Color Physics)
- Digital Platform Graphic Design and Applied Art
- Photo Image Manipulation Programs (Adobe Photoshop)
- Vector-Based Drawing Programs (Macromedia FreeHand, Adobe Illustrator)
- Three-Dimensional Modeling and Rendering Programs (3-D Studio, Electric Image)
- Animation: 3-D and 2-D
- Preparing and Optimizing Graphics for the World Wide Web

Communication Skills
- Creative Writing
- Technical Writing
- Journalism
- Interactive Instructional Design
- Writing Author-Ready Narratives for Multimedia Production
- Website Management
- Designing Visual Presentations

Video/Film/Sound
- Video and Film Production
- Nonlinear Video Editing
- Videography (Cinematography, Lighting Theory and Technique)
- Script Writing (writing dialogue/adapting a story to a screenplay)
- Sound Design, Sound and Audio Effects and Music (digital non-linear sound editing and synchronization)
- Audio Engineering in the Studio Environment

New Media Business Administration
- Multimedia Project Cost Analysis and Estimating
- Project Design and Proposal Writing
- Project Management
- Creative Skills Integration, Team Building
- Intellectual Property Law (Copyright Law)
- Internet Commerce Issues: Entrepreneurship on the Web

Sociology and Psychology of the New Media
- The Sociology of the Internet
- Social Responsibility and the New Media
- The New Campfire: Seeking Tribal Community on the Internet
- Adapting to the Digital Workplace
- Education and the Internet: Adapting all we know about education and making it relevant to the Information Generation. ∎

the country offered courses in digital graphics. I found just a handful. But now, virtually every school with an applied arts program is teaching computer graphics, and if you're on a commercial art/graphic design track, the curriculum is all computer-based, except for some of the design theory courses. Such will be the case with the new media over the next ten years.

I recently had the opportunity to work with the curriculum director of a small private college, who was looking for a strategy to better prepare students for high technology employers. I was asked, "What can we do to better prepare our students for careers in this new media?" I answered with a few questions of my own, like "Is there some way you could offer a semester's worth of training in say two or three days for businesses like ours to enroll their employees?" and "Have you considered developing courseware for distribution on CD-ROM and the Internet?"

The Skills Are More Important Than the Degree

In other words, you don't need to wait until you can offer the perfect, pre-packaged program. What can you do to offer training *now?* From another point of view, you don't have to wait until you can get into the perfect program—determine what you can do *now* to get the skills you need.

The Private Training/ Workshop Route

The workshops you take will depend on the multimedia software you buy. Companies such as Adobe (who makes Photoshop, PageMaker, Illustrator, PageMill, etc.), have a long list of nationwide training centers and training consultants who, for a reasonable fee, will teach you everything from the basics to the advanced techniques in two- to four-day hands-on workshops. Prices for this training can range anywhere from $250 for a day-long or a two-day workshop, to several hundred dollars for an accredited course.

One of the best software company training networks is run by Macromedia, publishers of Director, Authorware and a whole family of the industry's most popular multimedia production software. One call to Macromedia at (415) 252-2000, and you'll have all of the training opportunities you need.

Another excellent education opportunity is the training school operated by Dynamic Graphics Educational Foundation (DGEF). Headquartered in Peoria, Illinois, DGEF has subsidiary offices around the world. Call (800) 255-8800, and request a catalog. They have short courses of three to four days on everything from computer graphic design and production to multimedia development—which is the fastest-growing course group. Their instructors are first-rate, and all classes are hands-on using the latest technology.

OM Records

Guthrie Dolin
Creative Director, OM Records

Top to bottom: Guthrie Dolin, Eric Kalabacos, Brandon J. Martinez

"Small company with an extremely large idea." That describes San Francisco's OM Records, a multimedia/music publishing firm that has taken CD-ROM technology down a very creative path.

Most enhanced compact disk offerings from major labels have been satisfied with snapshots and a compendium of liner notes for users to scroll through. So Guthrie Dolin, creative director for OM Records, admits he sees himself as a pioneer in his field. His emphasis for ECDs is still on the music, but the graphics, interactivity and animation are also extremely well-crafted, and an integral part of each project.

Guthrie is joined in his creative enterprise by Eric Kalabacos, technical director and chief programmer. Eric's background includes multimedia design and production company founder, marketing director of a Macintosh software company, and multimedia and DTP software instructor.

Brandon J. Martinez is a producer/video production and project manager for OM Records. His background includes extensive pre- and post-production coordination for motion pictures and television, including music videos and event production.

OM's graphic design is representative of the cutting-edge music tracks on their ECDs. For example, in "Spiritual High," there's a truly spiritual message in the arresting images of Buddhist shrines, pastoral scenes and psychedelic motion pictures. There's even a holistic health wheel on which the user clicks to find a divine glossary of holistic terms.

According to Dolin, "Our aim is to create an enhanced CD that successfully integrates music, artist profiles and the relevant cultural content that surrounds the music into one product." ★

1 The opening images for "Spiritual High": a golden sun amidst the clouds and a butterfly.

❶

Spiritual High: The Enhanced CD Experience
OM Records

As the lilting music begins to play on this very special enhanced CD-ROM, a beautiful butterfly flutters its way past the golden face of the sun. As the butterfly traverses the screen, the letters "Spiritual High" appear. You know then that you're in for a visual as well as an audio treat.

QuickTime videos play in a variety of window sizes. One plays inside of a daisy; when you press on the daisy, you see the movie almost full-frame. There are three full-length user-selectable background songs, and approximately thirty assorted audio samples that can be activated by the user. Total media in volume on disk is approximately 250 megabytes. ★

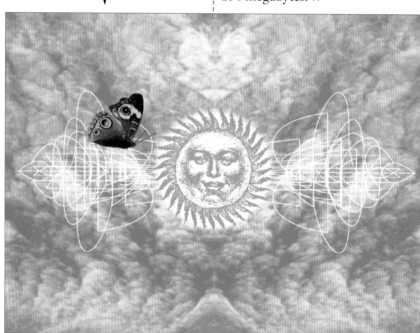

Hardware

Seven Macintosh computers, including Power PCs, Quadras of various configurations and one Pentium PC, all used for the bulk of program authoring, image processing and program testing. Drives: SyQuests, an optical drive and a 4x CD recorder. Access to an Avid Media Composer for video post production. Portable DAT drive. MIDI interface, sequencers, digital effects producers, samplers, 24 channel sound mixing board.

Software

Adobe Photoshop and Illustrator for image processing, Macromedia Director for authoring. Adobe Premier for QuickTime video, DigiDesign Sound Design II for sound editing, DeBabelizer for batch processing images.

2 The most interesting button is a blue Buddha head that giggles before it returns you to the program's main navigation page.

3 Some of the buttons are "rollovers," which change color as your mouse pointer passes over them.

4 There's also a volume control, a nice feature as it represents an added measure of control you are giving to the user.

5 A beautiful selection of still images can be viewed in sequence by moving a sun icon in either direction along the bottom of the frame.

6 This holistic health wheel is really a glossary of terms related to alternative health beliefs and practices.

7 A definition of "Ayurveda," as accessed by the holistic health glossary.

OM Records Website

OM Records

OM Records is in the record business first and foremost, where the name of the game is promotion of your hot artists and your label. OM's website messages remind one of chalk on a blackboard or graffiti—they are very hand-done and anti-establishment. They just ooze youthfulness and radical steet-chic; there's a visual surprise with every click. ★

Hardware
Macintosh and Power PCs for all graphics work.

Software
Adobe Photoshop and Illustrator for image processing.

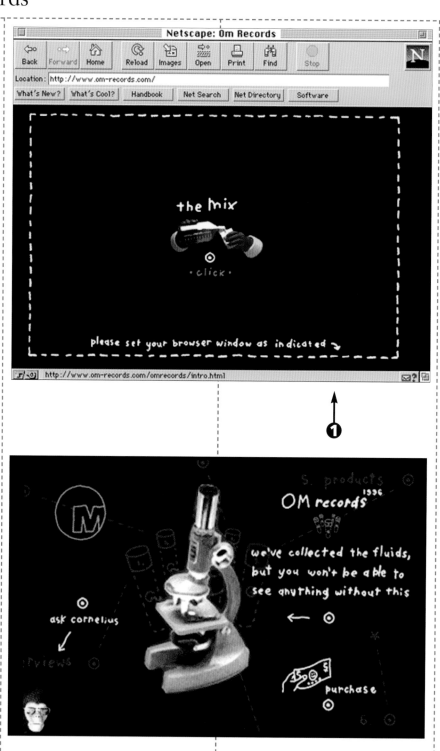

1 The first thing you see on this screen is instructions on how to resize your browser window, an excellent strategy to maximize visual impact and performance of the site.

2 Next, you move into a microscope metaphor. This site simulates the visual rhythm of some of OM's enhanced CD titles.

❸

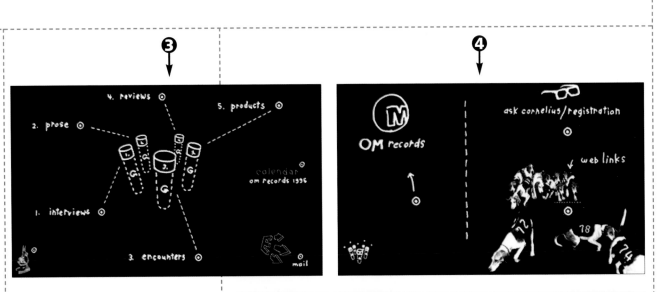

❹

3 OM's creative style and some-times not-so-subtle humor are apparent everywhere in this site. For example, the "Ask Cornelius" cues the site's user feedback opportunity while it pays homage to *Planet of the Apes*, a cult film favorite of the OM Records creatives.

4 When you compare OM's website with other corporate pages on the Internet, the designs contrast sharply. Some Web designers apply thousands of dollars worth of technology and technique to create highly rendered 3-D graphics to represent buttons or a navigation bar. OM just drew a circle with a dot in the middle. Hey, it's a button, it's cool and it works!

5 This screen features a record promotion for "Go Big," an enhanced CD that features snow-boarding, skateboarding and rollerblading clips and interviews.

6 An in-depth interview with one of OM Records' talents, Telefunken.

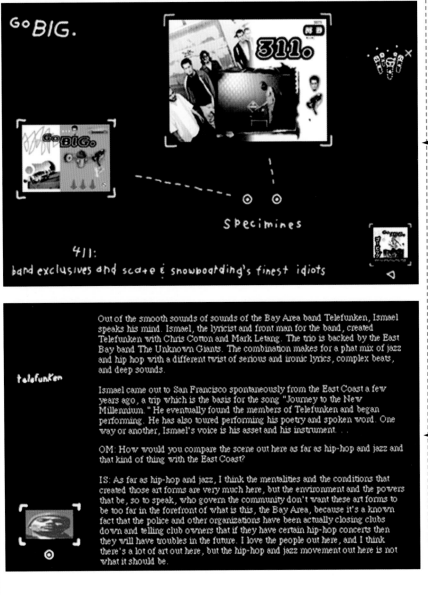

❺

❻

ProFile

Jonathon Ellis

Media Designer, Hardie Interactive

Jonathon Ellis is perhaps the best example of the newest generation of completely computer-literate multimedia artists. Fresh out of the University of Northern Iowa with the school's first B.A. in Electronic Media, Jon landed a job with Hardie Interactive using a very unique résumé. Jon, in fact, titled his multimedia program a "Cyber Résumé." He even brought his own computer to his interview—no small feat. This strategy ensured a perfect run-through of his résumé, which was nearly 700 megabytes in size and contained original animation, 3-D graphics, interactive screens and QuickTime clips of original films he produced in his media classes.

Jon's goal, for as long as anyone has known him, was to work in filmmaking. But as he became involved in the growth of multimedia production, he realized the impact new media technology was having on the entertainment arts. So, he thoroughly immersed himself in virtually all aspects of multimedia design and production, including 3-D animation, program authoring and even some programming. He enthusiastically dove into the Web work Hardie Interactive was bringing into the studio.

Though Jon didn't have time to take art or drawing classes in college, his eye for color, composition and the effects of lighting show a strong visual talent. The computer has empowered him with the ability

Hardie Interactive

to manipulate images acquired from other sources. And using 3-D programs, Jon has become a digital sculptor, creating digital puppet characters, wild and wacky space vehicles and entire magical environments.

The enthusiasm, creativity and talent for problem solving that Jon has shown are the stuff in demand in today's multimedia studios. ★

Portfolio: The Work of Jonathon Ellis

Jonathon Ellis

Among the multimedia authoring programs he has become proficient in are Macromedia Director and Authorware. Since Hardie Interac-

tive is a small company of professionals, he must be flexible and versatile in his skill set. Overlapping projects may include working a computer-based training project, a multimedia catalog, a digital video clip and a 3-D animation, all in one day.

Jon is also the principal video post-production editor and sound designer for the firm. His studio is equipped with a Media 100 running on a PowerPC 9500. His tools of choice for sound editing include Macromedia SoundEdit 16 and Macromedia Deck II. His PowerPC 9500 is so versatile, he uses it to produce everything from 3-D animation using Strata 3-D Studio, to designing graphics for webpages using Photoshop. He prefers to do his HTML work on his Toshiba Pentium Notebook using a simple text editor. ★

1 This is a graphic from the Hardie Interactive website.

Hardware
Jon's main hardware platform is a Macintosh PowerPC 9500 with 80 megabytes of RAM, Media 100 digital video editing system, a Toshiba Satellite Pro Pentium powered notebook PC and a Yamaha CD-recorder.

Software
Includes Adobe Photoshop, Premiere and After Effects, StrataStudio Pro, Macromedia Director, Authorware, FreeHand and SoundEdit 16, Deck II, Kai's Power Tools and KPT Bryce.

2 Jon combined digital clip photos with his own rendered 3-D shapes to create this Web graphic for the Hardie Interactive website.

3 Jon has become an expert at combining 2-D and 3-D art to form entirely new visual concepts. This image is an original illustration, previously unpublished.

CHAPTER 3

Basic Hardware Considerations

Investing in computer equipment is one of the most difficult and lengthy decision-making processes in one's life, even more difficult than buying a car. When investing in a computer system, you always know that you're investing in obsolescence. Eventually you commit to a platform, learn to love it and wonder how you ever got along without it. If you already have a computer system, you may be able to upgrade, which is a little more palatable than starting from scratch.

CAN I UPGRADE WHAT I HAVE?

You're looking at your four-year-old desktop publishing box—the one with the stick-on notes all over it . . . software support 800 numbers scribbled on them—and you're wondering if you can upgrade.

Let's save some time. A Mac ci class computer or 386 PC may not be worth the effort nor the money it would take to update. But this doesn't mean you should count your old computer as a total loss, either. You could turn it into a home-grown LAN (local area network) server, answering the phone and receiving faxes. Or you might keep it around just for word processing, or even use it as a full-time Web access machine.

I've had several friends ask me what to do with their old 386. I tell them to keep it. If it has a nice color VGA display and enough memory to run Windows 3.1.1, attach a 14.4 or 28.8 data/fax modem to it. It will make an adequate Internet "communications terminal."

Then consider building your multimedia production investment on a Power Mac or Pentium-based system.

MAC OR PC?

I'm asked continually, "Should I invest in a Mac or IBM?" And I ask two questions in return, "What software do you want to use?" and "On what computer platform do you want your productions to run?" I usually get responses like the following:

1. "I want to use Macromedia Director." Or Adobe PageMaker, QuarkXPress, Adobe Illustrator, etc.
2. "The target platform is Macintosh (and Mac Power PC)."
3. "My projects will run on PCs using Windows operating systems."

4. "Both Mac and PC. I'm doing cross-platform multimedia—Mac OS and Windows."

Of course, if you don't know what platform you're designing for, then it shouldn't matter what you buy, right? Wrong. It has been my experience that you shouldn't buy a computer before you select your software and know what platform you want your projects to run on.

What's Your Target Platform?

At this point in the history of multimedia, about 75 percent of all commercially developed interactive multimedia is produced on Macintosh computers. This is because so much of the graphics work, including animation and photo image manipulation, is prepared by professional designers—most of whom have been working on Macs.

Ironically, most of the commercial products they create are converted to run on PCs, because PCs represent the largest installed customer base—approximately 80 percent of computers in the home and a slightly higher percentage among businesses. Apple still dominates in primary and secondary education, but this ratio is changing as PCs make incremental gains in market share.

So your target platform depends primarily on your market—for home and business-based computer customers, you're probably designing a product that will run on a PC; if your market is schools, there's a greater chance your product will run on a Mac. Neither of these is a hard-and-fast rule, however, and you won't want to make a wrong assumption. As much as possible, determine who will be running your products before you decide how to make them.

Once you have some idea what your target platform will be, and what kind of software you want to run, you have a basis for strategic planning of your multimedia computer investment. You may discover you already have the base machine (a 486, Pentium or Mac Power PC) on which you can build.

1. If your target platform is the Mac, you should produce on a Mac. It's that simple. If you are already Macintosh proficient, and you have an investment in software, like Adobe Photoshop, you're in great shape.

At some point in the future you may want to port over one of your Mac projects to run on a Windows machine. You will be able to port from Mac to Windows if you use cross-platform development tools like Macromedia Director or Authorware.

2. If your target platform is the PC running a Windows operating system, then by all means produce on a PC platform. If yours is a total PC world, you should develop everything—graphics, interface design and code—on the PC.

But this is one of those cases where the thing you should do may differ from what you actually end up doing. In established studios with substantial investments in Macintosh hardware and software, most initial production takes place on Macs, especially the graphic production. Then the project's assets and preliminary programming are ported over to the PC platform for final assembly or programming.

Several studios I contacted discovered that a majority of their customers and target platforms were exclusively PC. They were forced to deal with the often unpredictable and tedious process of porting over programming from the Macs to the PC platform. Many production managers, especially, were in favor of switching to doing all the graphics and programming completely on the PC platform in the first place. But when you have a room full of designers who are most comfortable and productive on their Macs, there's often a trade-off: their comfort in exchange for the additional time it takes to port over graphics and programming.

There's one other possibility, and I'm sometimes asked about it: "What about a Mac Power PC with Soft Windows software or an accessory PC processor card?" From a cross-platform developer's point of view, this sounds like a convenient way to create everything on one machine—the Swiss Army knife method of computing.

But be practical. Do you actually want to maintain and run two different operating systems—Mac and Windows—in a single box? For production, you'll likely end up with two mediocre-performing computers in a single box. If you are working in a studio environment with co-developers, you'll more likely want to operate on a homogenous network (like a Unix system), where you will transfer files from Macs to PCs, share printers and file servers, net modems, etc.

Which option is right for you is a workstyle issue that is best determined by your individual expertise.

PRICE AND PERFORMANCE: THE NEED FOR SPEED

Higher-end Macintosh Power PCs and Intel Pentiums with 100-plus megahertz processing speed are expensive. Are they worth the investment? Depending on what you need and want from a multimedia production workstation, I believe they are.

For example, the Mac Power PC RISC chip was developed by a strategic partnership that included Apple, IBM and Motorola. Programs that run on this Power PC processor have been optimized to

Shopping for Price and Performance: Mac vs. PC

I recently purchased two complete multimedia workstations for developers in our organization. I did not include video capture boards, just the multimedia workstations themselves. Here's a point-by-point comparison of what I purchased for the two workstations:

For the Mac workstation:
- Macintosh Power PC 9500/132
- 32 megabytes of RAM
- Quad-speed CD-ROM drive
- 2 gigabyte hard drive
- Accelerated PCI graphics card with 2 megabytes V-RAM on board for 24-bit color resolution
- 17-inch multisync monitor
- Self-powered multimedia stereo speakers
- Extended keyboard and mouse
- 28.8 internal data/fax modem
- One year warranty from Apple (included)

Even with discount pricing I just passed the $7,000 mark. But keep in mind that these figures are constantly changing. With a number of Mac clone companies establishing themselves, the price pressure is on! Increased competition will be favorable to anyone interested in one of the new Mac clones.

For the PC workstation:
- Pentium 135 megahertz (Gateway 2000, Dell, Zeos, take your pick . . . they are all competitively priced)
- 32 megabytes of RAM
- Quad-speed CD-ROM drive
- 2 gigabyte hard drive
- Accelerated video card with 2 megabytes of V-RAM on board for 24-bit color resolution
- 17-inch VGA monitor
- Self-powered multimedia stereo speakers with sub woofer
- Keyboard and mouse
- 28.8 internal data/fax modem
- 16 bit sound card
- Ethernet card to plug into the network (Ethernet is built into the Mac Power PC platform)
- SCSI card (necessary to plug in the CD-ROM and hard drives)
- Over $1,000 worth of assorted software, including Microsoft Office, Encarta, Bookshelf and a ton of utility programs. (PC dealers were so competitive, virtually all the dealers were willing to throw in this much software just to get my business.)
- All the components were well-reviewed, high-performance brands with three-year warranties. Nearly all dealers contacted provided "upgrades" to their package lists.

Even with my upgrades, the tape total was just short of $5,000.

It definitely pays to shop around, and one of the best places to do that is through the *Computer Shopper,* a mostly-advertising doorstop of a publication that often contains good product round-up articles, largely concerning PC equipment. For Macs, any current issues of *Mac-world* or *MacUser* magazines will do. I have traditionally checked Mac prices in such discount catalogs as *Mac Connection* or *MacMall.* An increasingly good place to shop is on the Internet, where I've found prices to be even lower on computers, software and accessories. ∎

take advantage of the RISC feature that makes software run more efficiently and noticeably faster. When you are working with applications such as Adobe Photoshop, Premiere, Electric Image and Strata 3-D Studio, you will experience productivity gains that will greatly speed your production process.

But suppose you're working exclusively (or want to work exclusively) in a PC environment. You may wonder whether Adobe Photoshop really performs faster on a Mac Power PC than a Pentium. Once you've reached the Pentium level, it's more a matter of technological hairsplitting. However, some processor-intense special effects may run faster on the Power PC than the Pentium.

This is best illustrated in working with animation applications. You can wait an interminable amount of time for a 3-D animation application to render its frames to a Quick-Time movie, AVI file or to a film recorder. This is because each frame of an animation sequence must be scanned line by line: A 30-second animation, with a frame-rate of 30 frames per second, can take several hours to render frame by frame. On a Macintosh Quadra model or PC with a 486 processor running at 66 megahertz, the rendering sequence could take several hours. Run the exact same task on a 100-plus megahertz Power PC or a Pentium system, and the rendering is accomplished in minutes.

But which machine is the fastest? It depends on the software you choose to run in concert with your hardware. If you're doing a lot of 3-D animation, for example, you need to start with the animation software you feel will perform the most efficiently for your projects. You'll find that some 3-D software has been optimized to run on only one type of platform, so this will

form the basis of your decision.

In the final analysis, you must shop for the appropriate hardware/software combinations to discover the features most compatible with your work style and expectations. To research this, check out computer shows like Comdex, MacWorld, and NAB Multimedia World, a convention put together by the National Association of Broadcasters, held annually in Las Vegas. The latter is a personal favorite. It is perhaps the largest single multimedia convention and trade show in the world.

UPGRADING FROM DESKTOP PUBLISHING TO MULTIMEDIA DESIGN

If you have some experience with the hardware and software typically used for desktop publishing, you're in great shape. You probably have everything you need (hardware, software and experience) to create graphics for multimedia, since these graphics seldom exceed the dimensions of 640 x 480 pixels and 72 dpi. In fact, if all you are going to do is graphic design for multimedia or webpage creation (with color palettes that typically don't exceed 256 colors) you likely have all of the power and speed you need.

However, if you are going to venture into multimedia authoring or programming, involving desktop video and 3-D animation, you are most assuredly looking at an upgrade.

High-powered computer workstations with lots of RAM and disk capacity are essential for truly productive multimedia development. When you add the peripheral devices that enable you to capture, manipulate and store such files as sound, images and video, the need for processing power increases.

To put it in dollar perspective, a multimedia computer that includes video and sound digitizing boards, and the software you'll need to work with them, will be approximately double the average cost of a desktop publishing system. Today, you can buy a computer and laser printer for about $3,500 and be doing desktop publishing; add a scanner for imaging (as low as $400) and software like QuarkXPress, and you are still in the $5,000-$6,000 range. Multimedia setups typically *start* at $5,000 with the required memory, hardware cards, software and peripherals, and can easily go twice that high.

WEB WORK NEEDS LESS POWER

If you intend to produce material for the Internet, you don't necessarily need workstation power for production of graphics and word processing. In fact, thanks to the popularity of the Web, lower-powered machines are experiencing extended life. What appears to be a paradox (when did an advance in technology ever mean you needed *less* power?) is actually easy to explain: Most of the graphic preparation for the Web is low resolution compared to that which is required for publishing. Hence, your performance is not hampered by large graphics files.

On the other hand, if you are going to set up a workstation that is going to perform the function of a Web *server*, managing a vast array of digital assets plus Web traffic twenty-four hours a day, then you need a class of computer approaching a Unix operating system, of the Silicon Graphics or Sun variety.

CHOOSING PERIPHERAL EQUIPMENT

The rest of this chapter is devoted to choosing peripheral equipment to complete your hardware set-up.

Selecting Monitors

Multimedia software requires a lot of windows and palettes on the screen at any one time, so you need as much display real estate as you can afford. A multisync monitor with a dot pitch of .28 (or smaller) and a diagonal measurement no smaller than 17 inches is where you want to be. You can jump to a 19- or 20-inch monitor, but your display budget will double. The 17-inch diagonal is the most popular and practical size, and an excellent one can be purchased for under a thousand dollars. Personally, I prefer a Trinitron (Sony technology), for quality and reliability.

Not all monitors (especially older ones) are multisynchronous, which means they can change screen resolutions from 640 x 480 pixels (standard) to over 1,152 x 870 pixels while you work. (Your video card software usually supports this ability with a designated keystroke or two.) Multisync monitors are handy in multimedia production because an increase in the number of pixels you can display means relatively more space for multiple production windows and palettes. The downside, of course, is that your text and window details will be smaller. Multisync monitors can also adapt themselves to different computer or video hardware.

I've had the same Sony 19-inch monitor for the last three computers I've owned. It isn't multisync, but it was the best $2,000 I ever spent. Today, given the strong general preference for multisync monitors, I could buy this same (non-multisync) monitor for $150 used. Talk about depreciation!

Scanners

You'll need a scanner for detailed scans of flatwork, photos, graphics, etc., but if you pay more than $1,000, you must have money to

Hardware Choices: Development Platform vs. Target Platform

Hardie Interactive has mostly Macs in our stable, but the number of PCs is growing. Our designers prefer Macs and Apple Power PCs for the majority of their projects, especially graphics. However, our program engineer, who does a lot of code crunching, loves his Pentium. Since nearly 100 percent of our customers are PC users, we have to add a step in our production process converting our Mac-developed projects to the PC. It can be difficult, and if you can avoid this step, all the better for your bottom line.

One reason we don't convert everything over to a PC-only environment is that certain software we've become accustomed to (animation and non-linear video editing, for example) only runs on a Mac—or else just performs better on the Mac platform. Furthermore, our shop started with Macs, so we have a large investment and a huge graphics archive that would be difficult to convert to the PC. However, if I were starting a multimedia studio from scratch, and was building applications for a strictly PC market, I would go all PC, SGI or Sun and avoid the hassle of the Mac-to-PC conversion.

So what's involved if you work on a Mac, then want to run your programs on the PC?

Repurposing graphics to run on a PC multimedia application almost always means reducing their color content. This is because authoring tools for the PC don't typically tolerate high-end color, 24-bit images (though this is changing). So developers of these PC applications are constantly "dumbing down" their graphics. Consequently, to make a multiplatform application, many multimedia developers spend a lot of time dumbing down graphics as well. The only alternative would be to create only 256-color graphics on the PC and then export them to the Mac application. Why not? The answer (for us): We hate to penalize our Mac users! Our belief is that the graphics should look as good as they can on their respective platforms.

Videos have a similar set of cross-platform quality issues. We've found it is incredibly time-consuming to optimize video clips for both the Mac and the PC. Formats such as AVI and Indeo (for the PC) are good for the PC. However, QuickTime, which is the only video format that plays on *both* Mac and PC, looks good on the Mac but less than great on the PC. Such problems make us yearn for a new standard, which, we all believe, is MPEG. (See the Reality Check sidebar on pages 39-40 for an explanation of MPEG.) As MPEG becomes more widely applied, we resort to other, lesser quality results.

The bottom line? Creating your multimedia projects on the platform on which they'll be used will save you a lot of time and trouble. Porting from the Mac to the PC (and vice versa) may be easier one day, but for now it's best to work on the platform your program will play on. ■

burn; high resolution is not something you need for material that will never see a printed page. If you're a desktop publisher, you probably already have a serviceable scanner that will work fine. But wait . . . how fast does it scan something in color? Does it takes three passes even at low resolution? Do you scan over lunch and coffee breaks because it's so slow? If the performance of your scanner is cutting into your productivity, it's time to get a new scanner.

If you're doing both desktop publishing and multimedia, a midrange scanner that has the ability to do high-speed, single-pass full-color scans at 72 dpi is what you need. (That 72 dpi refers to the final resolution of the graphic after you size it to your specifications.) Some scanners will allow you to do low-speed, high-res scans for desktop publishing applications and high-speed, low-res scans for multimedia applications.

Digital Cameras

For three-dimensional objects, you'll need to take a photograph. To do this, you should get one of the best pieces of hardware for multimedia development I've ever seen—the digital camera. I take one on the road with my notebook computer: shooting, downloading and editing images as I go. These cameras can range in price from $700 (limited features, one lens focal length, limited storage) to models priced at about $10,000 (a high-end 35mm camera body with a digital back, multiple lens capabilities and close to traditional film quality).

Companies like Nikon, Kodak, Minolta and Canon have high-end entries, and the Leaf digital camera from Scitex takes magazine-quality images (plus it has the ability to scan slides from an ordinary carousel slide projector). But if you are just taking images for multimedia—with no designs on doing pre-press, where higher resolution images are necessary—look at some of the less expensive options.

The camera I use is one of the least expensive (Apple's QuickTake: less than $600), and it has served me well. Logitech, Kodak and Casio also produce some of the least costly

models. There are other digital cameras that are priced just under a thousand dollars. One manufacturer, Chinon, has a camera that can produce a higher-quality image than the Apple QuickTake, plus has a PCMCIA flash memory card. You can store your images on this memory card, then transfer the card straight from the camera to your notebook computer, no cables. Download the images, and return the card back to the camera. Depending on the capacity of your hard drive, you could collect a lot of images with a minimum amount of trouble.

Audio: Selecting the Sound Card

Macs have long been equipped with built-in sound capabilities, but the PC owner has had to be concerned with this critical component. Without a sound card, your computer cannot reproduce the rich tapestry of sounds and music that have become an important part of a quality multimedia experience. I recommend getting the very best sound card you can afford, since any sound card is relatively inexpensive (about $125 to $200).

There are a lot of different types and brands to choose from, but let's just cut to the features you need in a sound card—which, coincidentally, are standard on a quality multimedia-capable computer bundle.

• *Sound Blaster compatibility:* Sound Blaster is a trademark belonging to a card made by Creative Labs. Because of their popularity, software developers have written driver software to address these cards, hence they've become a standard.

• *16-bit stereophonic sound:* On a 486 or Pentium computer, a 16-bit sound card plays 44.1 kilohertz CD quality stereophonic sound. As a multimedia developer you should

not consider anything less than 16-bit audio cards even though you may be playing and creating some sounds (depending on your target platform) in 8 bits. Remember, 8-bit audio is OK for voice, but not for music.

• *Wavetable technology:* Wavetable cards have stored within their ROM chipsets actual wave form data on real sound waves produced by a variety of musical instruments. Instead of synthesizing the sound of a piano, it actually plays the piano sound wave from its wavetable. The net result is stunningly realistic sound—the goal of any good multimedia producer. Boards such as Sound Blaster Pro and Wave Blaster cards fall into this category.

Audio File Formats

Audio files, like graphic files, have to be saved in file formats compatible with your computer platform, operating system and multimedia software. So what are the audio equivalents to the TIFF, PICT, EPS and GIF files of the graphics world? There are a lot of file options in the PC environment, including AIFF, CMF, MFF, MID, MOD, ROL, VOC and WAV files. Right now, the most common audio formats in the PC world are VOC, WAV and AIFF files.

VOC files are Sound Blaster compatible files used mostly by DOS applications. WAV files are used by Windows.

AIFF files (Audio Interchange File Format) are a common compact disk-standard file format. They represent the highest quality digital audio. AIFF files are quite large and cannot be easily handled by multimedia applications without being reprocessed or "compressed" first. Reducing the bit depth of the sound from 32 bits down to 16- or 8-bit audio files and taking the kilohertz

Sound Resolution Summary

Sound is measured in cycles-per-second, or Hertz (named after the scientist who discovered that sound waves cause an electric circuit to oscillate). Just as digital photo quality is poor when the number of pixels in a given area is small and better as the number of pixels increases, digital audio is poor when the cycles-per-second (or Hertz) is a small number, and better when the number of cycles-per-second is greater. This quality or accuracy level of digital audio is sometimes referred to as resolution.

What you want in an audio digitizing board is the ability to record and reproduce the highest resolution possible—44 kilohertz, or CD quality sound. Even though you may not be able to play 44 kHz audio files all the time in your multimedia application, a quality board gives you the flexibility to do this when you can, while a cheap board gives you poor quality and no flexibility. If you're working in multimedia, a quality sound board is a must.

The relevant numbers are:
- 11 kHz = the sound of an unsophisticated AM radio (low quality)
- 22 kHz = the sound of an FM radio (good quality)
- 44 kHz = the sound of an audio compact disc (highest quality) ∎

rate down from 44 to 22 or 11 kilohertz reduces the audio file's resolution, which means less clarity and more "white noise." But in multimedia applications you are typically

going to have to synchronize audio with motion pictures, animation or video, and so you have to reduce the audio file sizes.

On the Macintosh, sound file management is much easier, since the Mac has long included quality sound reproduction as part of its hardware. In addition, Macs handle AIFF files and also audio clips formatted in QuickTime, which is "native" to the Mac, and the same format it uses for video. New media designers often think QuickTime is just a video compression scheme, but it's also extremely handy for audio and it's compatible with a wide variety of multimedia applications, like Macromedia Director and Authorware. In fact, I edit audio clips in Adobe Premier, a Quick-Time editor. It's just more convenient, especially when I'm capturing audio clips from a video camera which plugs right into my computer's video/audio capture card.

Understanding Video

Users love video in their multimedia, but creating good video for this purpose is neither cheap nor easy. The first attempt at this, Apple's QuickTime, was poor in quality compared to what is possible today, and the popularity of video continues to drive the technology upward to accommodate full-screen, full-motion video. But until these technical specifications are standard, multimedia producers will continue to put up with video in small windows (at fewer frames-per-second than they might like), and complicated, time-consuming video formatting schemes that only degrade the video image further to allow it to run smoothly on as many configurations as possible.

To understand how your computer manages video technology, you need to know a little about video resolution and how video

Executive Arts, Inc.

Executive Arts, Inc.
Communication Specialists

Executive Arts, Inc. is a graphic communications/design consulting company engaged in the planning, development and production of corporate communications, with a focus on investor relations, for Fortune 500 companies. Elemental is billed as the interactive technology division of EAI. Executive Arts, like many design firms, was already involved with computers for publication design, and found multimedia to be a logical and manageable leap.

EAI's client list includes Coca-Cola Company, United Parcel Service and IBM. EAI can handle all parts of a client's communication package. If they are already doing the print pieces for a particular client, and the opportunity arises to produce a CD-ROM or a website, they are in an ideal position to do that job. When contacted, EAI was just completing the IBM Annual Report website, and was extremely excited about it. ★

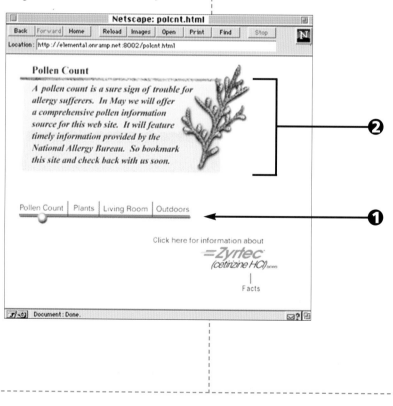

Zyrtec—Designing a Site of Help and Information for Consumers

Executive Arts, Inc.

Perhaps one of the greatest single subjects of interest on the Web is health. The Web not only has the potential to become a totally accessible medical library, but it also offers the opportunity for people to connect directly with others who have similar health concerns.

Executive Arts, Inc., Elemental division, designed this website for the manufacturers of the allergy medication Zyrtec. It's content-rich, full of information that could be of genuine help to any allergy sufferer. No question—more and more health product and pharmaceutical companies will capitalize on the Web in this manner. And sites will eventually become more sophisticated, perhaps even linked to physicians who can provide more information, or arrange for diagnosis to determine whether certain medications would be appropriate for an individual. ★

1 (facing page) One neat feature of the Zyrtec website is an interactive slider, a unique navigational tool that immediately captures the user's attention.

2 (facing page) Timely information, such as seasonal pollen counts, is provided. The objective is to offer the user some basic information, then encourage him to consult with a doctor.

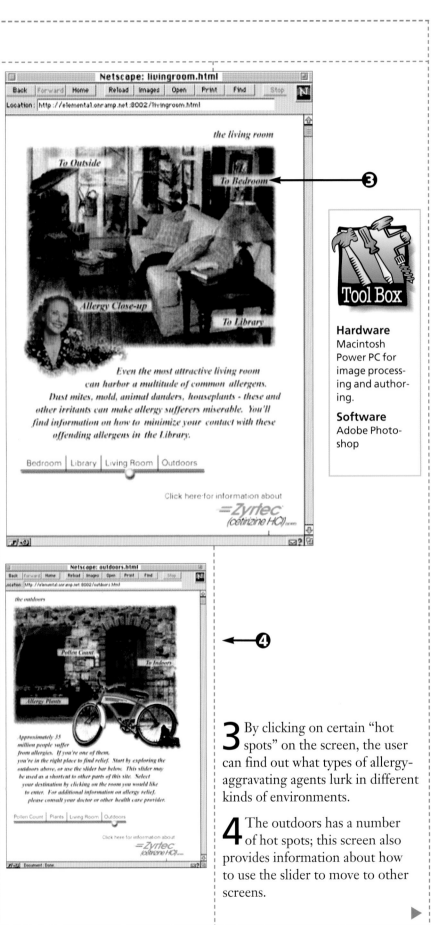

Tool Box

Hardware
Macintosh Power PC for image processing and authoring.

Software
Adobe Photoshop

3 By clicking on certain "hot spots" on the screen, the user can find out what types of allergy-aggravating agents lurk in different kinds of environments.

4 The outdoors has a number of hot spots; this screen also provides information about how to use the slider to move to other screens.

The IBM Electronic Annual Report— From CD-ROM to Website

Executive Arts, Inc.

It's only logical that a company with the technological legacy of IBM would publish its annual report using the latest technologies, i.e., a CD-ROM version and a version on the Internet.

Reproduced here are screen samples from two years' worth of high-tech annual reports—one produced on CD-ROM, the other published on the Internet. Both were designed and produced by Elemental, the interactive production division of Executive Arts, Inc.

In 1994, IBM first decided to publish their annual report in a new way—on CD-ROM—in addition to the usual print version. The year following the success of the CD-ROM, Executive Arts designed and deployed a website annual report for IBM. Graphics are bright, cartoony, fun and upbeat. And once again, the Web version pushes the envelope.

Site designers did their best work when they exploited the Web's most powerful feature—information on demand. The site is loaded with information and hyperlinks, including information that you could never convey in a printed piece. For example, users can actually access IBM's SP2 computer in Maui, Hawaii, to play with positionable wire-frame models and advance surface design software. ★

Executive Arts, Inc.

1 This first navigation page for the IBM Annual Report website takes you to three areas of interactive information: the year's highlights, charts and financial report data.

2 This is a screen called the Render Lab that connects the user with an IBM computer in Maui, Hawaii. You can manipulate a wire frame model and render its surface, giving users a taste of what is truly possible on the Web when talented programmers are employed.

Hardware

Macintosh Power PC for the bulk of program authoring and image processing. Cross platform work on a Pentium-equipped PC operating Windows.

Software

Adobe Photoshop for image processing, Macromedia Director for authoring. Adobe Premiere and After Effects for QuickTime video, Macromedia SoundEdit 16 for sound editing. Autodesk 3D-Studio for background scenes and introductory animation.

3 These screens are highlights from the CD-ROM. The program's most interesting feature is a surreal three-dimensional landscape reminding one of a sculpture garden. The "Myst"-like interface contains hot spots that transport the user to information and highlights of IBM's market segments or technical innovation successes over the past year.

4 There are some excellent animations, like this 3-D book in which pages turn.

5 IBM produced two identical versions of the annual report program: one for IBM compatibles and the other for Macintosh. Note the file structure on this Mac-compatible version of the CD-ROM.

6 Note the navigation and progress indicators which tell users where they are in the grand scheme of things.

behaves when it's digitized. Video resolution is measured in pixel depth (bits per pixel) and frame rate. An analog video signal, like an audio sound wave, is a continuous stream of waveform data on a video tape. However, when a video signal is digitized, it is converted to frame-based animation—a series of individually digitized pictures, or bitmaps, flying by your face at 10, 15 or 30 frames per second.

When installed in a computer, a video capture card does what an audio circuit board does for your audio files: It allows you to plug video source material—a video tape deck, video camera or even a TV—directly into your computer and capture a video signal frame by frame.

Video File Compression

Video files, when compared to sound files, have the potential to consume enormous amounts of disk real estate. But there is a solution: digitizing, and mathematically compressing the picture data, thereby reducing the file sizes required to store it. In the process of digitizing the data, it's compressed on the fly and stored, then decompressed when played. This compression/ decompression scheme is called "codec."

Compression/decompression schemes come in a variety of flavors. QuickTime, JPEG, MPEG, AVI and Indeo all describe different codec schemes and video file formats. (See the Reality Check on video formats and files on page 39.)

Selecting a Video Capture Card for Your PC

There are several viable choices in video capture cards on the PC side. Some of these are listed below, broken down according to price range.

Entry Level Boards

Video Spigot (also available on the Mac) is a very basic, very reliable video card that can capture 160 x 120 pixel resolution at 30 frames per second. *Intel Smart Video Recorder* and the *Super VideoWindows* card from New Media Graphics are also good choices in the affordable capture board category. (We're talking no more than $500 here.) Intel's product is excellent because it features real-time compression of incoming video at resolutions up to 320 x 240 pixels at 15 frames per second.

Video Blaster, from Creative Labs of Sound Blaster fame, delivers quarter-screen video at 30 frames per second for about $500. This is an extremely powerful board that is so well-engineered, it will even work on a lower-powered PC like a 386/33.

If you are just getting started with modest multimedia products, a conservative budget and you wish to create simple video-in-a-window clips from your camcorder, then invest in one of these modest capture boards.

Mid-Range Boards

Intel's Smart Video Recorder Pro is an under-$600 bundle of software, featuring a powerful program (Asymetrix's Digital Video Producer) to edit your clips, and Intel's high-quality Indeo codec. The card supports resolutions up to full screen (640 x 480 pixels). This system already supports MPEG video formats, and also AVI files, so you can produce video files that will be easily accessible to both Mac and PC applications.

If you are setting up to do multimedia productions for business, then you need one of these higher-quality and more feature-laden capture boards. Be prepared to spend $500-$1,000 for a mid-

range/premium board, but it will be worth it.

Higher-End Boards

Representing a higher-end video capture and editing capability are *Videologic's Captivator*, *Media Space* and *DVA-4000* (we're talking nearly $4,000 here). These represent high-end boards capable of delivering broadcast-quality results with special digital video effects (like video-in-a-window, special transitions, etc.) that you won't get with the more affordable capture cards.

Selecting a Video Capture Card for Your Mac

Some Macintosh and Power PC models are AV machines, meaning they are already video-ready, with built-in analog-to-digital converter chips on their motherboards, as well as all the appropriate jacks for video source decks and camcorders. If you have a non-AV Macintosh, you can buy any one of the video capture cards mentioned below.

Entry Level Boards

Video Spigot video capture cards start at about $100. They capture video from your camcorder, VCR or anything that runs video that can be plugged into the card, and the resulting video looks pretty good in a 320 x 240 pixel window. The next level up is the *Video Spigot AV* card (about $895) which captures full-motion (30 frames-per-second), full-frame (640 x 480 pixels). If you want to "print" your edited Quick-Time video back to tape, you'll need a *Spigot II Tape* card ($795), which gives you the option of showing your work on a video cassette that will play in any VCR.

Mid-Range Boards

One of the best-engineered digital desktop video systems is *Radius*

Videovision Studio. It provides everything you need in a box; it's plug-and-play, with a unique AV plug-in strip for a wide variety of video and audio sources, including camcorders, VCRs, CD players and tape recorders. It comes bundled with Adobe Premiere software. The whole package retails for about $3,700, but it's worth it. I know video production studios using this for video material that we see on broadcast television.

Another system in this category is the *Targa Mac* from TrueVision. TrueVision has a long tradition of quality, and this doesn't disappoint. At $4,500, the price is up there, but you get what you pay for with Targa.

Higher-End Systems

There are two mid- to high-range video editing systems that you should be familiar with as a multimedia producer. The first is *Avid's Media Suite Pro* (about $15,000) and the second is *Data Translation's Media 100* (about $25,000). The digital video editing ensembles of both represent a totally integrated turnkey system that includes the computer, the digitizing board, a digital audio card, two monitors (one for editing and the other for viewing your resulting edited material), miles of cabling and editing software. The only thing you need is a VCR for input and output. These editing systems produce excellent quality video assets, which are important to any studio venturing into the competitive commercial multimedia markets. When poor quality video gets compressed and dithered down for playback on CD-ROM, it looks even worse! Quality video means sharper clips on the computer.

There is an added advantage to having one of these suites available. Non-linear video editing gives you incredible creative possibilities with digital transition effects, multi-channel audio, animation and other special effects.

WHY YOU SHOULD GET A CD-RECORDER

A CD-recorder (CDR) has become an absolute necessity in the hardware suite of the serious multimedia producer. CDRs are not just for limited runs and distribution of your work, they are also for testing the functionality of your projects. A CD-recorder is simply the best way to test whether your program will run properly on a CD-ROM. Realize that CD-ROM drives are not the fastest-performing drives in the world. They may have capacity, but speed, even among 6X speed drives, does not match a quality hard drive. Even if your multimedia program or digital movie runs great on your internal hard drive, you simply must record it to a CD-ROM for the ultimate test.

A CD-ROM recorder is also the best and least expensive way to archive your accumulating mountain of assets. Another plus: You can create special hybrid disks of your favorite music files to play in your audio-only CD players. Yes, CDRs are relatively expensive (from $1,500 to $2,500 at this writing), but the cost per megabyte is much lower than traditional drives. (Because 680 megabyte blank CD-ROMs are about $7 each, however, it isn't a wise choice for a backup strategy since you can't overwrite the disk.)

Major makers of CDRs include Kodak, Philips, Reflection Systems, Ricoh and Yamaha. The technologies are distributed among several different brand names. Our studio uses a recorder with a Yamaha engine we chose after studying several reviews on reliability. It records quad-speed disks, and recording time is very speedy; at 40 megabytes per minute, a 680 megabyte CD can be recorded in approximately seventeen minutes.

Buying a CDR vs. Going to a Service Bureau

By the time our studio was considering the purchase of our own CD-ROM recorder, we had already spent a small fortune at a local CD-ROM service bureau. We sent CD-ROM "one-offs" to clients for beta testing, and, of course, we used the final one-off to send to the mastering company. (The one-off is the copy of your program from which the glass master is made.) So we found we were burning a lot of one-offs in the process of creating a multimedia title.

Also, we seemed to be always in need of specialized CD-ROM samplers of our work. Our sales representatives and prospective clients were always asking for copies of programs, animations and other "portfolio" pieces—whatever we could combine on a disk. We were running back and forth to the service bureau sometimes twice a day!

How You'll Know When to Make the Switch

We also discovered that when prototyping new programs to CD-ROM, we had to endure a few buggy copies before we got a good one. Most bureaus will tell you up front: An average multimedia program, especially one that contains animation or video clips, will almost never run properly on the first burn. One bureau told us anywhere from three to six burns may occur per program! So while most bureaus were reasonable and extremely helpful, it just became more practical to buy our own unit.

How will you know when it makes more sense to buy a CDR than to continue outsourcing?

Simple: Start keeping a record of how many trips you're taking to the bureau, and figure out your total expenses. How much are you paying per disk? What are the set-up charges? What about your time on the road and off production? Total it all up and project your costs on average for the next twelve to fourteen months. Now, compare these costs to a CD recorder, the anticipated number of blank disks you'll need, and the auxiliary drive that's recommended (probably a fast, 750-meg hard drive dedicated to serving the CDR will be essential for continuous data transfer to the CDR).

Magneto Optical Drives for Easy Access Backups

What equipment will you need to store your work in process? Magneto optical drives are the best means—but not the least expensive—for mass storage of work in process. Tape drives are good for archival, off-site back-ups, but not for primary, "second copy" backups to which you need ready access. (A tape drive is just too slow and cumbersome for retrieval of individual files.) Magneto optical drives are more expensive than tape drives, at approximately $900. The 5.25" disks are available from 600 MB to 1.3 gigabyte capacities (total storage on two-sided disks) and range in price from $80 to over $100.

My own fondness for these rewritable optical disks came about by accident when I had a main hard drive failure. I had a serious deadline and couldn't get a new hard drive fast enough. Fortunately, I had backed up my drive, including my operation system and software tools, on a magneto optical. As I was trying to revive my computer, I had popped in the optical cartridge to see if I could resurrect my files. My computer booted and ran off the optical, performing briskly, just like

the hard drive. The moral of the story is: Pick functional mass storage drives that allow for operating system backup in the event of a drive crash. I would not have been able to do this if I depended entirely on a tape backup drive.

Tape Backup Drives for Off-Site Storage

Backing up drives on a regular basis and transporting the disk off site is absolutely essential. The problem is, backing up is painfully slow unless you automate the process. With a good tape drive, you can do just that with the specialized backup software (FastBack or Retrospect) that usually comes with the tape drive you purchase. If you have more than one computer containing irreplaceable data, and you've networked the machines, you can back up all of the computers on your network.

In multimedia studios, however, it's unlikely that a single tape backup system will handle the volume of working files from more than say, two computers. This is why I'm a firm believer in a tape backup system for every computer. Most workstation class computers have the drive bay for them, and they're relatively inexpensive ($200 neighborhood, a small investment when compared to the value of your data). You should have two tapes—each one large enough to hold your most critical works in process—and should rotate them daily. Every night run your tape backup. Take Monday night's tape home Tuesday night, and Tuesday night's tape home Wednesday night while Monday's tape is back in the machine backing up Wednesday's files, etc. By rotating tapes nightly, and taking a tape home every night, you will always have a backup of your working files safely off premises in the event of fire or theft. You'll lose no

more than a day's worth of file data if disaster strikes.

Leasing and Renting Equipment

I'm no accountant, but I know when it's appropriate to rent equipment for short-term projects. If you have a very intense production project in the works where you may need some specialized workstations for just a short period of time, renting is an extremely viable strategy. There are more companies in this business than ever before, renting all sorts of specialized equipment from computers to video equipment. Our studio, for example, prefers renting video equipment whenever we have a need for it.

Leasing obligates you to a long-term relationship with the lease agency. This, too, may be a viable strategy depending on your accounting structure and cash flow. Leasing may be the only option you have other than purchasing when it comes to extremely high-end, specialized equipment like video, film and animation production systems, or Sun or Silicon Graphics workstations. Leasing makes sense, too, when you are working with technology systems that are prone to obsolescence and depreciation. Once again, cash flow is the critical factor here, and you must consult your accounting specialist and run the numbers to see what makes the most sense. Read the fine print on any lease you consider and consult with your accountant on the details. Not all leases are created equal, and some come with an extremely high tariff if you want to dump the machine early in the contract.

It's been my experience that only the large and extremely busy multimedia production studios can take advantage of leasing equipment. They have the new business and cash flow to support this strategy.

Computer Video Formats and Files Explained

QuickTime

Apple Computer was the first to successfully market a video capture and playback format for personal computers; it was called QuickTime. QuickTime video was often grainy and halting, and the audio was often out of sync. But then, the technology was introduced on machines that had a fifth of the power and speed of today's desktop computers. Despite the problems, the coolness factor—video running on a computer screen—overshadowed the fact that it was running in a window the size of a Post-it Note!

Today, QuickTime is at the heart of most computer-based non-linear editing software systems. Non-linear video editing is editing performed on a computer—until computers could assemble video segments digitally, analog video was edited in linear fashion using a playback machine, editing switcher and recording deck. Essentially, Quick-Time changes analog video into frame-based animation . . . frame after frame of bitmaps are stored using a variety of compression schemes available to the user. Different compression algorithms render different results. The quality of the compressed image is in proportion to the size of the file. The higher quality you want, the larger the file.

QuickTime files can run on both Macs and PCs with the proper software drivers, and because QuickTime runs on both systems, it makes a good choice for cross-platform video clip files residing on a CD-ROM intended to play on both computer types.

JPEG

One of the earliest codec schemes was developed by an engineering council called the Joint Photographic Experts Group, which was comprised of computer graphics hardware/software companies. This council adopted JPEG and Motion JPEG. Originally the JPEG compression scheme was developed for still images so they could be compressed to transmit over phone lines. Then it was determined that if a computer was powerful enough, and if the frame rate was fast enough, analog motion pictures, like video, could be digitized and compressed frame by frame on the fly. This is Motion JPEG.

This innovation contributed to the invention of the computer-based non-linear video and film editing software/hardware industry. To record, edit and play back JPEG video, you need special hardware, such as an Avid system or Media 100 non-linear video editing system. Since JPEG motion picture files are of such high quality, it is a popular engineering standard for video production houses and film studios using non-linear video editing equipment.

Avid Technologies, of Tewksberry, Massachusetts, is among the makers of JPEG boards with their Avid Media Suite Pro and Composer editing systems. Avid technology bundles their boards and JPEG codec editing software into Power PCs and PC/Windows computer platforms. The quality produced by these machines is so good it can be projected on a full-size motion picture screen. In fact, a good share of Hollywood's films these days are assembled on Avid systems. My studio owns a competing system, the Media 100, from Data Translations. Both Avid's and Media 100's features and capabilities are similar and competitive.

If you are doing a lot of digital video editing for computer applications, a dedicated, non-linear editing suite might be the most productive strategy for your studio. Because digital video effects often take a long time to render frame-by-frame on even the average desktop machine equipped with Adobe Premiere, demanding desktop video producers frequently graduate to such systems as the Avid or Media 100, applications that give you a number of choices among digital video file formats in which to export your work. This gives you power to choose the best file format (Quick-Time, Truemotion, Indeo, AVI, Cinepak, etc.) in which to optimize your video clips.

MPEG: The Emerging Standard

The emerging quality standard for computer-based video is MPEG. (MPEG stands for Motion Picture Experts Group, which is an industry council established by an alliance of manufacturers and developers.) MPEG (320 x 240 pixel resolution) is the consumer grade standard for video designed to play on such media as CD-ROM. MPEG II is the broadcast video standard; it's characterized by a higher resolution (640 x 480 pixels) with the sharpness of high definition television. This is the standard emerging for distributed system video, like motion pictures delivered on demand over fiber optic cable.

MPEG is a video file compression scheme that squeezes non-essential information out of a stream of video data, allowing it to play smoothly and effortlessly. In comparing MPEG to JPEG (or QuickTime), JPEG compresses video one complete bitmap frame after another in what's referred to as spatial compression. MPEG uses a temporal compression scheme where only *differences* in frames of video are compressed. ▶

MPEG evaluates a sequence of video and determines which pixels have changed from frame to frame and which have not. Little change in a video segment will compress to an even higher ratio than detailed movement. Consequently, MPEG can compress a video segment to a much smaller file than virtually any other compression scheme and still maintain a high level of quality.

At this point in the technology, a hardware add-on is required to compress and decompress MPEG files on most computers. But as computers become more powerful, MPEG codec will likely be accomplished entirely in software, just like QuickTime. In any event, the multimedia developer currently requires the appropriate hardware, primarily a computer with an MPEG compression board through which video clips can be streamed and compressed.

Truemotion

Truemotion-S, also known just as Truemotion, is a software-only video compression algorithm developed by Horizons Technology of San Diego, California. It features high-quality intraframe video compression with extensive control parameters. You can use this software in conjunction with your QuickTime video editing software by taking your video clips and exporting them to a compressed Truemotion format.

Truemotion utilizes an "intra-frame" compression scheme. Intraframe compression is when each frame of video is compressed and decompressed independently. By contrast, other compression algorithms, like Cinepak and MPEG, utilize interframe compression, which uses a keyframe scheme. For example, with Cinepak—a favored algorithm for video running on CD-ROM—keyframes are saved within the file. The compression algorithm then discards the pixels between keyframes that don't change. The more keyframes saved, the larger the files, but the higher the quality of the video—with less pixelation and artifacting. A lower keyframe rate will result in smaller files, lower quality and more pixelation.

The playback of Truemotion video is among the best quality available on today's computer platforms (without the aid of additional hardware). Plus, Truemotion videos can play on both Mac and Windows-based machines.

This product is among the hybrid software applications that require developers to pay a licensing fee to use. For Truemotion, the licensing fee is based on the number of CD-ROMs you are planning to produce and distribute.

AVI

AVI stands for "Audio-Video Interleaved." It is the format that Microsoft Windows uses for saving video and sound to the same contiguous file. When preparing videos to run in Windows applications on a PC, this is the video format to choose. Depending on what video window size you desire and the ability of the platform you choose, you may have to further compress the AVI files, and your video editing software will give you some options. Cinepak compression, for example, allows you to set the data rate to a variable that allows for smoother playback. It compresses video down to file sizes and data rates compatible with the slower CD-ROMs.

Indeo

Indeo is Intel's codec scheme—a file format optimized for play on computers equipped with Intel processors. It's extremely good quality video, but to create Indeo files, you need a special Indeo card or capture card and software that saves files in Indeo format. The problem with a format that works exclusively with one kind of processor? It only works with one kind of processor!

Cinepak

Originally developed by SuperMac Technologies for the Macintosh, Cinepak has become a cross-platform video codec for both PC and Macintosh platforms. Cinepaking video is a good strategy for compressing QuickTime video to files for smoother performance on lower-powered machines.

DVD: A Disk Format That Changes Everything

DVD, which stands for Digital Versatile Disk, is a standard adopted by the major manufacturers of consumer electronics, including Sony and Phillips, the co-developers of the original compact disk technology. It represents an entirely new compact disk format that significantly increases the capacity and speed of such optical storage media. A DVD holds 4.7 gigabytes per layer as compared to 680 megabytes per layer for a CD. Furthermore, DVDs allow dual layering which increases the capacity to 8.5 gigabytes on a single side. Initially, this technology is being applied to motion picture distribution, since you can use it to fit multiple formats of a full-length motion picture (letterbox or traditional video format), as well as multilingual sound tracks, subtitles, etc. If you add to this interviews with the director and principal stars, you have an enhanced experience that goes beyond just the movie. All of this material on one disk needs organization and a multimedia interface to tie it all together. Once again, more opportunity for multimedia designers. ■

CHAPTER 4

Multimedia Software

There are some core programs you will need to begin even the most basic multimedia production. I've provided a chart (page 44) that divides software tools into nine groups, or families:

1. Image editing and painting
2. Drawing applications
3. 3-D and animation
4. Sound editing
5. Video editing
6. Presentation software
7. Multimedia authoring (also known as multimedia assembly or multimedia production)
8. Special effects/utilities programs
9. Internet programs: page layout and/or HTML text editing

ESSENTIAL PROGRAMS

The typical multimedia studio will have to have at least one program, and sometimes several, from each of these software categories.

By the time you read this, there will certainly be newer, better and hopefully less expensive products (or versions of them) on the market. But as much and as fast as things change in this business, there are a lot of things that remain the same, like wanting to do business with reputable companies that will sup-port their software and provide you with decent upgrades.

IMAGE EDITING

Adobe Photoshop (Mac/Win): Photoshop is a marvelous image creation program that offers an array of drawing and painting tools. The undisputed champ of image editing programs for its intuitive tools, this program has also become popular among third party developers of image manipulation plug-ins and filters.

Photoshop's use of pressure sensitive tools—brushes and airbrushes—allows you to produce naturally rendered graphics. Compared to a mouse-driven program, there's more precise control with these tools.

Photoshop has cross-platform file support and the ability to use many different file formats. It allows you to open and save graphics in several formats, among them GIF, TIFF, PICT, JPEG, BMP, EPS, Targa, Scitex CT, PCX and Pixar.

Of all the applications we use throughout a day, we probably spend more time in Photoshop than anywhere else.

HSC Live Picture (Mac): This is

The Software in My Shop

Tool Box

Image Editing and Painting Programs:
 Adobe
 Photoshop
 Fractal Design
 Painter
 HSC Live Picture (Mac)
Drawing Programs:
 Adobe Illustrator
 Macromedia FreeHand
3-D and Animation:
 Autodesk 3-D Studio
 Elastic Reality
 Electric Image
 Specular LogoMotion
Sound Editing:
 Deck II
 Macromedia SoundEdit 16
Video Editing:
 Adobe Premiere
Presentation Software:
 Adobe Persuasion
 Astound (Mac)
 Microsoft PowerPoint
Multimedia Authoring:
 HyperCard (Mac)
 Macromedia Authorware
 Macromedia Director
 SuperCard
Special Effects/Utilities:
 Adobe AfterEffects
 DeBabelizer (Mac)
 HyJaack (Win)
 Kai's Power Tools
 KPT Bryce
 Microtek ScanWizard
 Morph
Internet Programs: Page Layout and/or HTML Text Editing
 Adobe Acrobat
 Adobe PageMill
 Adobe SiteMill
 Macromedia ShockWave
 Microsoft Front Page
 Netscape Gold

the first of a generation of image editing software that allows you to use a proxy of the image file to make edits, do image special effects and image compositing. It then applies these edits to the high-res image file in the background.

The advantage of this strategy is productivity. Virtually all editing occurs in real time so the "working copy" of your image file means you don't have to wait for the dreaded progress bar to crawl across your screen.

The best application for this software is in desktop publishing where you are working with memory-intensive, high-res images. In multimedia, you are more typically working in low resolution. I mention this software primarily as a good strategy for older, slower computers used just for graphics production.

Fractal Design Painter (Mac/Win): This program is much like Adobe Photoshop but with different tools and abilities.

Painter is referred to as "a natural media" drawing and painting tool. It was designed with a pressure-sensitive tablet in mind which, in my opinion, is an absolute necessity with this product. In addition, Painter has a wide variety of surface textures and lighting effects that can make images more natural and organic-looking and appear less "machine-made."

Plus, there are some special functions this program can perform, like allowing you to import a Quick-Time movie to use as reference for creating animations. You can actually trace or draw on a layer right on top of the movie frames to replicate more accurate movement.

Bottom-Line Recommendation: You absolutely cannot live without Photoshop in this business. From CD-ROM to webpage development, Photoshop will be the favorite horse in your stable. If you can afford to have another, get Painter.

DRAWING APPLICATIONS

Macromedia FreeHand (Mac/Win): Yes, this is a vector-based (i.e., line-based) drawing program. Isn't multimedia strictly a bitmap world of PICT files? It can be, but I can draw some objects faster in a vector-based program than a bitmap one.

Consider this: A line-based program allows you to assemble graphics from editable shapes comprised of lines and fills. You can change the characteristics and shapes of these components at any time. For multimedia, you will eventually have to export your drawings to a bitmap program (like Photoshop) to turn them into PICTs, but that's OK. Just preserve the original drawing files, and you can further edit the illustrations later.

Sometimes I create a graphic in FreeHand as lines with no fills or color. Then I export the shapes to Photoshop and that's where I color them. (You can do more subtle things with color in Photoshop.) Plus, there are some really neat image manipulation plug-in tools from third party vendors which allow you to do things like image warping in FreeHand.

But the main reason I like Free-Hand is that it gives me more power over type elements than in any other drawing program. FreeHand costs about $400.

CorelDRAW 6 (Win): Vector-based drawing is just one of the useful features of this software bundle. It's good software, but it's really the extras in the package that make it a good deal for the multimedia producer. Packaged (or "bundled") together are: 25,000 royalty-free clip art images and symbols, 825 fonts, plus clip sounds, clip animations and pre-defined 3-D models along with the drawing software. CorelDRAW 6 runs about $460.

Bottom-Line Recommendation: Other drawing programs include *Adobe Illustrator*, *Claris Draw* and *Deneba Canvas*. There are some differences in tools and features, and I try not to endorse one program over another, because it is such a subjective decision. I've noticed that most graphic designers stay with the program they learned first. I prefer FreeHand's intuitive

drawing tools, and it also does an excellent job of handling text elements.

3-D ANIMATION PROGRAMS

Specular LogoMotion (Mac): This is a stripped-down, easy-to-learn 3-D animation program that extrudes 2-D vector objects (such as EPS files from FreeHand and Illustrator), and lets you animate—or "fly"—the results. The quality of the final output is surprising when you consider the low price (approximately $130). Another inexpensive option is *TrueSpace/SE* ($99).

StrataStudio Pro (Mac and PC, $949), *Specular Infini-D* (Mac, $589), *Ray Dream Studio* (Mac/PC, $299) and *Macromedia Extreme 3D* (Mac/PC, $949) are some excellent mid-priced packages. All of them are capable of producing broadcast-quality animation on your computer, but keep in mind that rendering times, depending on the intended size of your animation, can be extremely long. For multimedia applications and short animation clips, these applications will do. But if you see yourself growing into longer, more involved animations, you'll need a more powerful combination of hardware and software.

Electric Image (SGI/Mac, $2,500) and *Autodesk 3D Studio* (PC, $2,500) are good high-end animation packages, and we have both in our studio. Electric Image is our favorite because it renders extremely quickly for the platform (PowerMac 9500) on which we operate the program. We run Autodesk on our Pentium machine.

Most high-end software companies offer some student discounts. These student versions of the programs sometimes support fewer features than the professional versions, and may lack high-resolution print-to-tape capability. Still, software priced at several thousand

dollars will cost less than one thousand dollars for a qualified student. Call the software company directly to find out about student discounts.

Bottom-Line Recommendations: If you're just starting on a shoestring, and you want to tumble a few 3-D logos, you can't miss with LogoMotion. There is a simple learning curve here, and you'll be pleasantly surprised by the results. However, if you are the least bit serious about 3-D animation, go for StrataStudio Pro, or one of the other mid-priced packages. If you plan on doing 3-D imaging as a full-time activity, then you won't be happy with anything less than Electric Image.

SOUND EDITING SOFTWARE

Macromedia SoundEdit 16 (Mac): This is what a great sound editing program is supposed to look and sound like. Good sound design is crucial to a quality multimedia experience, and SoundEdit delivers the goods. You can create, edit and add special effects to 16-bit, 44 kHz sounds for CD-quality audio. You can manage an unlimited number of separate sound tracks without the necessity of extra hardware. And you can convert sound files you produce on the Mac to Windows formats and vice versa. This program will turn your computer into a million-dollar sound studio for less than $300.

Deck II (Mac, $450): This is a great sound edit package. It's a little more robust and has more sound control than SoundEdit 16 and is just as easy to use.

VIDEO EDITING SOFTWARE

Adobe Premiere (Mac/Win): This is our QuickTime video editing workhorse. Premiere not only allows intuitive editing of videos, but also of QuickTime movie sequences we create in other applications like

Specular LogoMotion and Strata Studio Pro. It is also a superb audio file editor and mixer.

But what really takes Adobe Premiere to even higher creative levels is a host of plug-ins and graphic and transitional software filters that can add stunning visual effects to your work. Adobe Premiere can work in conjunction with a program called *TransJammer*, an under $100 application that provides 100 killer wipes, fades and animated transitions similar to those you see in the most professional video productions. *Adobe After Effects*, at $699, is another companion for Adobe Premiere. These digital effects enable you to do image compositing or layering as well as special animation effects. But perhaps the most important feature it has is that it makes it easy to combine computer graphics with your QuickTime video clips and animate them.

You can also use Premiere to edit audio music tracks, overdub sound effect tracks and employ some creative animation techniques.

Bottom-Line Recommendation: There are other digital video editing packages, but Premiere has set the standard. Aside from its excellent documentation and product support, Adobe has made Premiere a most intuitive application, especially for the novice digital video editor. If you do a lot of digital video editing, you will come to appreciate Premiere even more for its stability and flexibility.

PRESENTATION SOFTWARE

These slide presentation builders are easy to use, and you can create a straight slide show or an interactive program with animated transitions, screen tumbles, fades and wipes. Some support QuickTime video in a window, which is a nice touch.

Microsoft PowerPoint (Mac/Win): This is Microsoft's premiere

3-D and Animation	Image Editing	Sound Editing	Special Effects/Utilities	Internet Tools
Alias Sketch (Mac)	Adobe Photoshop*	Alchemy (Win)	Adobe AfterEffects*	Adobe Acrobat*
Autodesk 3D Studio (Win)	Fractal Design Painter*	AudioMedia (Mac)	Adobe Gallery Effects	Adobe PageMill*
Elastic Reality*	HSC Live Picture (Mac)*	Audio Shop (Win)	Adobe Fetch (Mac)	Adobe SiteMill*
Electric Image*	Macromedia xRes*	CyberSound FX	Adobe Texturemaker	Artbeats WebTools
Extreme 3D*	Picture Publisher (Win)	Deck II*	Adobe Type Manager	Macromedia Shockwave*
Macromedia Extreme 3D	SuperPaint (Mac)	Encore (Win)	Corel CD Creator	Microsoft Front Page*
MacroModel (Mac)		Macrom. Sound Edit 16*	DeBabelizer (Mac)*	NaviPress
Ray Dream Studio (Mac)		Master Tracks Pro (Win)	FontMonger (Win)	Netscape Gold*
Soft Image	**Video Editing**	Midisoft Studio (Win)	Fractal Design Poser	
Specular Infini-D (Mac)	Adobe Premiere*	Session (Mac)	HyJaack (Win)*	**Drawing Programs**
Specular LogoMotion	Media Merge (Win)	Sound Designer II	Kai's Power Tools*	Adobe Illustrator*
StrataStudio Pro (Win)	Transjammer Plug-ins	Sound Forge (Win)	KPT Bryce*	ClarisDraw (Mac)
TrueSpace/SE	VidEdit for Windows	TurboTrax (Win)	Kudo Image Browser	CorelDraw (Win)
Vision 3-D (Mac)	Video Director (Win)	Wave for Windows	Media Cataloger	Deneba Canvas
	VideoShop (Mac)		Microtek ScanWizard*	Macromedia Freehand*
			Morph*	Micrografx Designer (Win)
Presentation	**Multimedia Authoring**		Page/Edges	Multimed. Designer (Win)
Action (Win)	Apple HyperCard (Mac)*		Photo/Graphic Edges	Windows Draw
Adobe Persuasion*	Apple Media Tool		PhotoMorph (Win)	
Astound (Mac)*	Asymetrix ToolBook (Win)		Strata MediaPaint	
Charisma (Win)	Digital Chisel (Mac)		Strata Instant Replay	
Claris Impact (Mac)	Icon Author (Win)		TextureScape (Mac)	
Compel (Win)	Innovus Multimedia		Typestry (Win)	
Microsoft PowerPoint*	Macromedia Director*		Typo/Graphic Edges	
Softcraft Presenter (Win)	Macromedia Authorware*		UltiMatte (Mac)*	
	Oracle Media Objects			
	Strata Media Forge			
	SuperCard*			

The Nine Multimedia Software Families

Typical applications are listed for each of the nine major software families. I've put an asterisk by programs that I personally recommend.

presentation software and is ideal for most simple multimedia applications, thanks to its excellent graphics handling ability. We actually use this program to produce alpha prototypes of interactive software. It's a perfect tool to test and present the overall "looks" of a program.

There are some simple animation tools available in this package, too, for moving picture elements or type across the screen. You can even import QuickTime video and audio clips.

Astound (Mac): This is one of the highest-rated desktop presentation packages on the market. Among the reasons: lots more animation and transitional effects than many competing programs, plus a robust list of graphic rendering tools.

But Astound is more of a multimedia production program than it is a presentation tool. Animated 3-D charting, a built-in texture generator for custom fills and backgrounds, and the ability to handle QuickTime video all contribute to make this a must-try application if you're running a Power Mac.

Bottom-Line Recommendation: Astound is inexpensive ($170) and is just plain fun to work with. Power-Point is my workhorse second choice—I use it a lot.

MULTIMEDIA AUTHORING PROGRAMS

As a group, these may also be referred to as multimedia production programs or multimedia assembly programs.

Your choice here will depend on the applications you intend to develop. For example: If you are going to be doing straight presentation interactive products (like touchscreen kiosks with a limited number of interactive levels), then you could get by with an inexpensive application like Apple Hyper-Card or Allegiant SuperCard.

However, if you are going to venture forth into the world of computer-based training (CBT)—where you will need to combine diverse media objects, sounds and include testing and scoring modules—Macromedia Authorware is

the application I would recommend you use.

Macromedia Director:
In a Class by Itself

My advice to every multimedia producer is to buy and learn Macromedia Director. It is an essential piece of software for multimedia authoring, even if you have broad programming experience. It's not all that easy to learn, but it's extremely powerful.

Macromedia Director (Win/Mac, about $850): Macromedia is actually a frame-based animation program. It was originally designed by someone who applied animation cell management to a computer spreadsheet. Each cell of the spreadsheet contained graphic information in the form of a bitmap. Then, the spreadsheet became a "score." When the score's cells were automatically sequenced using the computer's built-in clock, the bitmap images would sequence on the screen in a window. There you have it . . . animation controlled by a spreadsheet.

To really unlock the power of Macromedia Director, you must understand how to do command scripting. Macromedia's scripting language is called *Lingo*. With Lingo, you can write scripts to control objects, branching and even outside devices—like disk players. But the best thing about Director is that you can create run-time versions of your programs, called projectors, that you can distribute freely. Anyone can run your projector, whether or not they have the program.

Director started out on the Macintosh platform, but it has grown more robust throughout its evolution to become a true cross-platform multimedia authoring tool. In order to create cross-platform applications, however,

you must have both the Windows and Macintosh versions in your stable. Macromedia offers a special package price for the two versions when they are purchased at the same time. [Call Macromedia for pricing: (415) 252-2000.]

Computer-Based Training and Authorware

Macromedia Authorware (Mac/Win): This is among the most expensive software packages we own ($3,000). And I recommend that you purchase the software from one of Macromedia's value-added resellers who include training right along with the software. This cross-platform authoring program uses an icon-and-diagram approach to laying out your interface objects. In the development of interactive training materials, this program is quite comprehensive.

Authorware has the ability to combine a broad variety of multimedia objects, videos and animations, but its real power lies in its ability to store and retrieve libraries of reusable test question models—a valuable feature for anyone involved in the ongoing production of computer-based training.

Once you create an application in Authorware, you can create run-time applications on both Mac and Windows machines. The distribution rights to applications created in this program are liberal, as is customary with Macromedia development products.

Innovus Multimedia (PC, $899): Amazingly powerful for the price. This tool does more than just allow you to combine text and graphics in an interactive program. It contains database access and is compliant with such database formats as Oracle, Sybase, Microsoft Access, dBase, Paradox and more. It also supports the OLE standard, allowing the developer to launch other

applications from within their training applications. For example, if you want to launch an Excel spreadsheet in your presentation, you can—and it's fully functional. The program's only drawback is that it cannot yet build cross-platform applications.

Another multimedia assembly software package to consider: *Strata Media Forge*.

Bottom-Line Recommendation: Macromedia Authorware is expensive, but if you can afford it, it's probably all the authoring software you'll ever need to produce computer-based training (or any other software that tracks user responses). On the other hand, Innovus Multimedia is worth a serious look, considering the price, unless you need to do cross-platform development.

Hypermedia Applications

Apple HyperCard (Mac): This extremely powerful application builder is very easy to learn and cheap (about $100), considering what you get. HyperCard is a rapid prototyper that uses a card/stack metaphor; it's great for slapping together a quick sample of how screens, buttons and text fields will be arranged on the screen. As you grow more proficient, you can assemble full-fledged run-time applications that you can distribute royalty-free.

HyperCard has grown up to support color, videos, and now that computers are a lot more powerful, HyperCard has become faster.

Allegiant SuperCard (Mac): At about $400, this is HyperCard on steroids. SuperCard crosses the threshold to become a programming environment. You can create run-time applications that don't look like they were prepared in a card/stack application. Of course, if you're talented and so inclined, you could do the same thing with HyperCard—the difference is,

SuperCard can create cross-platform applications and Hyper-Card cannot.

Oracle Media Objects (Mac/Win, $495): Originally, this application came out on the Mac platform. While it isn't nearly as easy to program as HyperCard, it has some qualities you might find useful.

Oracle's created SQL (system query language), an open architecture relational database environment. Since database compliance is something you must consider when building multimedia applications with large quantities of text and graphic data (like catalogs), Oracle Media Objects can be just the program you want.

Also, if you want to tie your multimedia application to the Internet—tying CD-ROM or LAN (local area network) server applications to even larger quantities of data on the Web—you should explore Oracle Media Objects.

Apple Media Tool (Mac, $499): This application allows you to build interactive multimedia projects for both Mac and Windows platforms. It's a visual authoring environment that requires no scripting for most simple projects. This is a very powerful tool that supports a whole host of technical capabilities that have been advanced by Apple and have found their way onto the Web and some of the most popular cross-platform applications. Apple Media Tool has been adopted by a variety of producers from gamers to custom business software providers.

Asymetrix ToolBook (Win, $700): This program is similar to Hyper-Card in that it provides you with object-oriented tools to develop software applications, but to call it a Windows version of HyperCard would be selling it short. ToolBook is a great development tool for Windows applications if you don't want to spend a lifetime learning

Visual Basic, C++ or some other cryptic programming language (which you will want to know, of course, if you intend to build your applications from scratch).

ToolBook has its own simple scripting language called Open-Script, which is similar to the reasonably plain English of Hyper-Card's HyperTalk. If you are going to develop on the Windows platform, ToolBook is a must-have software package.

Bottom-Line Recommendation: If you're going to be a Macintosh developer, then you should consider HyperCard or SuperCard. The counterpart in the Windows world is Asymetrix' ToolBook. Hypermedia applications are great for rapid prototyping, but you can also produce some full-fledged applications.

SPECIAL EFFECTS/UTILITY PROGRAMS

Corel CD Creator (Win, $95): One of the best third-party software programs currently on the market for recording CD gold masters. Its "Disc Wizard" interface allows you to organize your files using Windows' drag and drop feature. You can record data disks, audio disks, mixed mode and multi-session disks. It even has design templates on board to help you design your jewel-case insert.

Equilibrium's DeBabelizer (Mac, $269): Since most multimedia production, especially graphics, occurs on Macintosh platforms, it was neccessary for designers to convert Mac-formatted graphics into PC-compliant graphics. Similar file conversion gymnastics must occur to optimize graphics for performance on the Internet. In multimedia production, you might be faced with processing hundreds of bitmap graphics for reassignment on another platform, dithering down resolution, reducing color palettes or

converting TIFFs to PICTs, PICTs to BMPs, etc. Enter Debabelizer. Now the most useful tool (besides Photoshop) in any multimedia studio, it actually batch processes and automates the graphic conversion process. You specify which files to open, what operations to perform, and where you want the new graphics saved. Hit the execute button and go to lunch.

INTERNET PROGRAMS: PAGE LAYOUT AND/OR HTML TEXT EDITING

Many programs for Internet page layout are available as free trial versions on the web. Go to the publishers' websites and find out what's available.

Adobe PageMill: PageMill is available for both Mac and Windows environments, and is a more than adequate WYSIWYG webpage layout program. It's especially good for those of us who find HTML editing tedious, although you will still need to know your way around HTML to truly build a functional page. With its drag and drop graphics and graphics tools built into the application, it makes webpage production a fairly simple and straightforward process.

NaviPress (America OnLine): This is a wonderful HTML macro editor. You will still need to know some HTML, however, to really leverage this program effectively. NaviPress has an excellent interface with pull-down menus that allow you to select the type of text and graphic you wish to place in your document, and it generates the HTML tags automatically. You can toggle back and forth from authoring mode to preview, to see what you've created and to make the neccessary adjustments.

Microsoft Front Page (Microsoft): Perhaps the most comprehensive webpage authoring and site mainte-

nance application. I use this program on my Pentium PC to not only assemble pages, but organize my server's files and heirarchies. It's nearly WYSIWYG, but you'll still need to know some HTML code for creating more functional features in your website.

BUNDLES ARE THE BEST WAY TO BUY SOFTWARE

If you're starting from scratch, bundling is the best way to get a good deal on software.

For instance, Macromedia bundles four products into one package, called Macromedia's Graphic Design Studio. It includes Free-Hand, Extreme 3D, Fontographer and xRes, and sells for approximately $600. That's a good deal if you can use at least three of the four software programs, which usually sell for $200 to $350 each.

CorelDRAW, long a popular graphics package for the PC, currently comes bundled in a package called CorelDRAW 6. It includes a suite of different software programs Corel has either developed themselves or acquired from other developers. Here's the lineup: Corel-VENTURA desktop publishing software, CorelPHOTO PAINT, CorelCHART, CorelMOVE animation software, CorelDREAM (3-D software) and CorelSHOW presentation software. All this, plus a 25,000 image clip-art library, stock photos, animation clips, predefined 3-D models and 300 surface textures—on a disk for under $500.

If you can use most of the software included in the bundles, there are some great deals to be had.

Hardie Interactive

Eric Faramus
Media Designer, Hardie Interactive

It's a pretty good bet that most people who describe themselves as multimedia designers, producers or artists today did not study their trade in school. Most came to their careers thanks to the everchanging nature of the technology and the opportunities that came about because of it. That's how Eric Faramus, a media designer for Hardie Interactive, came to this point in his life. Born in Brittany, France, Eric studied art and painting in Paris. After a variety of jobs, he traveled to the United States in the early 1980s. It was a trip that turned into permanent residency.

One of Eric's first jobs in the United States was in the printing department of Lake Forest College, where he received his first exposure to desktop publishing. Later, Eric migrated from the Chicago area to the rolling hills of northwestern Illinois, where he plied his trade as a freelance illustrator before landing a job with Hardie Interactive.

Eric is involved in virtually all aspects of multimedia projects. He designs everything—from icons to screens, from buttons to background textures, as well as the interactive programming. He has the most creative fun doing 2-D and 3-D animation, and he can't pass up the opportunity to design audio tracks and music. Eric says that a good multimedia project is like a well-conceived musical composition. It has a discernible beat, and engaging and well-crafted harmonies.

His primary multimedia software environment is Macromedia Director. "I discover something new about this program every day I use it," says Eric. "It is a very vast and powerful program." ★

Portfolio: The Work of Eric Faramus
Eric Faramus

The work shown here is representative of Eric's practical, as well as artistic, approach to multimedia design.

With the Ertl toy catalog, the interface design allows the user to stay in one comfortable place using a consistent set of tools to reel information into the viewing area. This user-friendly format is repeated for the MicroComputer Consultants' Safety Officer II™. As the product name changes at the top, different data appears in the window labeled "hazardous ingredients." The data at the bottom right is information on the manufacturer. In other words, the program allows the main screen to function as a "dashboard" for a very powerful relational database. ★

▶

Hardie Interactive

Portfolio: The Work of Eric Faramus

1 An electronic catalog interface for the Ertl toy company. Eric employs a navigational panel that makes for easier catalog revisions without major and costly screen redesign.

2 Even though this catalog has four separate sections, one for each of four different toy lines, navigation tools on the left stay the same throughout the interactive experience.

3 A screen design for Micro-Computer Consultants' Safety Officer II™, an interactive program for managing Material Safety Data.

4 Buttons for Hardie Interactive's website were prepared from scans of actual torn pieces of paper combined with images in Adobe Photoshop.

Hardware
Macintosh Power PC 9500 for the bulk of program authoring and image processing. Microtek Scanmaker for photo digitizing. Media 100 nonlinear video editing system for QuickTime Video editing.

Software
Adobe Photoshop for image processing, Macromedia Director for authoring. Adobe Premiere and After Effects for QuickTime video, Macromedia SoundEdit 16 for sound editing. Autodesk 3D-Studio for opening animation.

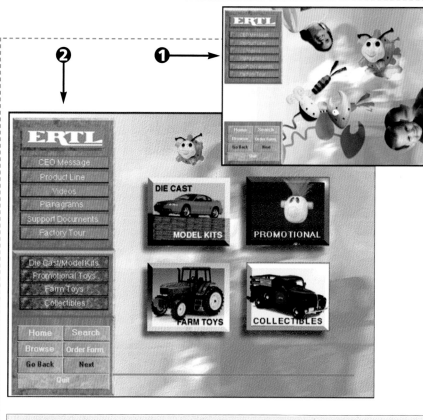

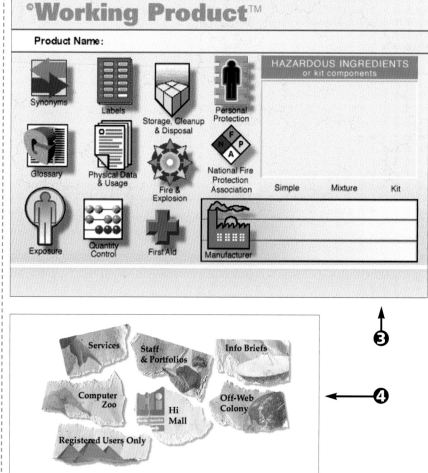

Julius K. Graves

Return

Hardware
Various; for a listing of some of Eric's typical hardware tools, see page 48.
Software
Various; for a listing of some of Eric's typical software tools, see page 48.

Tool Box

CD-ROM

The Dubuque Business Hall of Fame: History Comes to Life

Eric Faramus

The Dubuque Business Hall of Fame is a touch-screen kiosk designed for display in a museum exhibit. The program is rich with video clips featuring local historians telling anecdotes about the honorees. The colorful storytellers were shot in a Ken Burns documentary style.

There are vast amounts of image data within the program comprised of photographs and illustrations obtained from local historic archives. Many images, especially photos, were filmed using a video camera, the footage digitized and then compressed into QuickTime video clips. This method resulted in some of the program's most engaging moments. Static images suddenly come to life as the camera pans across the surface or zooms into specific details like a face or hands.

The kiosk is powered by a Macintosh 840AV with internal 750 megabyte and external 750 megabyte hard drives, and a 17-inch Microtouch touch-screen.

The entire production took less than eight weeks to build with a crew of four—three designers and one programmer. ★

1 With so much material, it was difficult to organize the information into logical chunks. To maintain easy navigation and put as much information as possible at the user's fingertips—without requiring the user to navigate several different screens—Eric designed a timeline along which clearly marked story tags were arranged in chronological order.

2 The background, which features a lightened halftone image of a vintage photo of Dubuque, remains a constant throughout the program. As the user presses buttons along the timeline, images appear in windows featuring animation and video clips.

3 To view other sections of the archive, a panel of photographs is provided; touching these brings up additional program segments.

1• earth GRAPHICS

ProFile

Jay and Lisa Harris
1• earth GRAPHICS

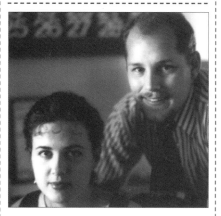

Jay Harris is president and creative director of 1•earth GRAPHICS, an information design studio that recently added "new media" to the list of its design offerings. Jay is a graduate of the Columbus College of Art & Design with a B.F.A. in Advertising Design. Before opening 1•eG with his wife Lisa, he worked as a designer at The Pipkins Group, and as a designer at Gibson Greetings, both in Cincinnati.

Lisa Harris, the art director at 1•eG, received her training in illustration and fine art at the Columbus College of Art & Design, and at the Art Academy of Cincinnati. She also specializes in illustration, and is experienced in design and development of marketing materials and advertising campaigns.

1•earth GRAPHICS has three designers, an office manager and a freelance writer. An important objective in its information design strategy is to capture the viewer's interest immediately—to provide the visual incentive to explore the important marketing information. "This kind of information design has become second nature to us in print," explains Jay, "but designing for new media is more complex and seems to require a larger number of specialists."

Some of 1•earth GRAPHIC's clients include Huffy Bicycles, Evenflo, Dolly Toy and The Berry Company. 1•eG markets its services directly to the client via direct mail campaigns and follow-up phone calls. Jay is the primary contact, and he often calls on new prospects with Lisa. "Most of 1•eG's clients use other creative sources and have some kind of marketing agenda in place," says Jay. "We're usually called upon to more closely focus a project for a specific market as well as work on the design concept."

1•eG, located in Troy, Ohio, occupies a studio that overlooks the town square from the second story of a historic building (the windows are ten feet tall). "With three suites and 1,400 square feet of office space, this location is very conducive to creativity," adds Jay.

Jay sees his firm with a staff of five designers inside two years. "We are serving clients with a need for very creative solutions," says Jay. "We are driven by our clients' needs."

"And their needs are changing so rapidly, we always seem to be driving very fast." ★

CD-ROM

The Art Center Dayton Commemorative CD-ROM: A collaborative Project
1•earth GRAPHICS, Greg Vennerholm and Mazer Digital Media

The Art Center Dayton Commemorative CD-ROM was a project coordinated by Jay Harris of 1•earth GRAPHICS to commemorate the fiftieth anniversary of the art center. Jay, in turn, called on Greg Vennerholm, a Dayton area graphic designer, and Mazer Digital Media to do the program authoring and the recording of the CD-ROM.

The main purpose of this program is to provide an electronic tour, with appropriate guidance, through a body of creative work. The structure is a typical interactive presentation design, and is targeted to an audience of Art Center Dayton patrons and associates, mostly people ages eighteen to fifty.

The program contains photography, design and other visuals created by local artists and members of the organization; the text was written by Lisa Harris and was purposely kept brief to keep viewer interest. The primary means of navigation is 3-D buttons that animate (with music, too) when the cursor is placed over them. But there are also hidden hot spots that take you to humorous places, or activate humorous sound effects, as well

as alternate navigation paths to accommodate true interactivity.

The final program runs on a Macintosh (7.0 or higher), and has a total size of 62 megabytes—relatively small, proving once again that with smart use of video and audio, a quality progam is not necessarily measured by the megabytes required to contain it. The screen size is 640 x 480 pixels (at 72 dpi resolution), with 16 bit audio, and video is QuickTime digitized from VHS format. All of this, and the entire project (design *and* production) was accomplished in just ten weeks. ★

1 This is the primary navigation screen.

2 In touchscreen applications, it's wise to keep levels of interactivity shallow, with more information choices at one's fingertips. In this case, the user is always a click away from the main screen.

3 Still frames of video clips invite the user to learn more from the program's participants.

Hardware
Macintosh Power PC for all stages of design, manipulation and authoring.

Software
Adobe Photoshop for image processing, Macromedia Director for authoring. Adobe Premiere and After Effects for QuickTime video, Macromedia SoundEdit 16 for sound editing. Animated 3-D renderings were created in Ray Dream Designer. Elastic Reality for morphing animation.

CHAPTER 5

Building the Multimedia Team

You have your research behind you, and most of the visual assets in hand. Now, how do you get the job done within a reasonable amount of time? If you're used to being a solo performer, you may have to change your paradigm as you become involved in multimedia.

MARSHALLING YOUR CREATIVE FORCES

As few as five people—for example, a writer, a multimedia designer, a computer programmer, an animator and a graphic designer—can comprise a core multimedia production group. Any one of these members may also serve as the producer/director. In a team of this size, the director would actually serve multiple roles: He or she might also be the project manager—handling scheduling, estimating and budgeting—and would also be responsible for any clerical chores, such as handling permissions.

In my world, which is building customized interactive multimedia, electronic catalogs and computer-based training, I feel it's neccessary to have a core team that's a little larger than this. Ideally a team should number ten people for a

company producing around ten projects a year. It's particularly important to have a larger team of specialists on staff (or at the ready) when you are working on multiple or overlapping projects. And of course, the clerical support is crucial and should be handled by a competent administrative professional.

THE CORE MULTIMEDIA TEAM

Following are ten titles and job descriptions for key players in a typical multimedia production team. The organizational chart (page 53) also shows the hierarchy at work, and additional working relationships between members of the team. These are suggestions, based on my experience; certain responsibilities can shift from one team member to another.

TEN KEY PLAYERS

• *The Producer:* This is the top person in the organizational hierarchy. The producer is like the company president—he or she arranges the finances and pulls the design and production team together. In some cases, the producer will also be the person who has the overall vision for a project; in other cases, the writer will be the one to create this

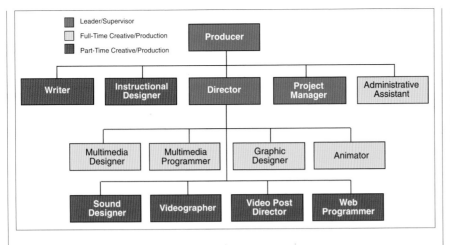

Legend:
- Leader/Supervisor
- Full-Time Creative/Production
- Part-Time Creative/Production

Producer

Writer | Instructional Designer | Director | Project Manager | Administrative Assistant

Multimedia Designer | Multimedia Programmer | Graphic Designer | Animator

Sound Designer | Videographer | Video Post Director | Web Programmer

The Multimedia Team Organization Chart
The first three levels of this hierarchy show ten key positions of a core multimedia team. The fourth level shows four design and production specialists who may join the team on an as-needed basis.

vision. Depending on the scope and budget of the production, the producer may also be the director.

• *The Director:* The director provides work direction to all the production team members, and makes sure everyone has the tools, content and assets they need when they need them. The director is responsible for maintaining the overall vision for the project as created or defined by the producer or the writer. The director keeps the project and team on task.

• *The Writer:* This talent writes the treatment, screenplay and virtually all of the words written and spoken in the program. The writer's chief responsibility is creating (or at least interpreting) the overall vision of the project.

The writer may, in some cases, be the natural leader as far as actual program content, and may determine the program's objectives, organization of elements and how the interactive branching will work. It depends on the project and the writer; if the program is purely computer-based training (CBT), this overall responsibility would be deferred to an instructional designer.

Or, in other cases, the writer may simply submit the script upon completion and depart to work on other projects.

• *The Instructional Designer:* If the project is CBT or another program designed to transfer learning, a qualified instructional designer will be involved. If the ID is new to the process of CBT, he or she may involve a writer or subject expert who is more qualified. But typically, the ID is charged with writing the entire program's content.

The instructional designer may be more involved with the team during the creative stages than during the actual production phase, but will return at the alpha and beta test stages to perform follow-up work.

• *The Project Manager:* The project manager (also known as the Project Coordinator) maintains contracts, sets the schedules and does most of the project's math, including estimating, budgeting and cost tracking.

In addition, this person secures permissions for use of talent and intellectual property to be incorporated into the project from other sources. Also, the project manager makes sure that assets and content created by the team are protected through the application of copyrights, trademarks and patents. In larger productions, intellectual property responsibilities will be turned over to a specialist trained in rights and permissions law, perhaps an attorney or paralegal.

• *The Multimedia Designer:* The multimedia designer is responsible for story boards, interactivity and the tactile feel of the interface. He or she, working with the graphic designer, conceptualizes the screens, backgrounds, buttons, window frames and text elements in the program.

In a small production group, this talent may handle the graphic design, photography, and direction and editing of the video, audio and animation used in the production. In a larger group, the multimedia designer would consult with those responsible for the additional aspects of the program—collaborating with the sound designer on the music and sound effects, for example, and working with the multimedia programmer on functionality issues.

• *The Multimedia Programmer:* Programming multimedia is every bit as much an art form as graphic design. The multimedia programmer's world is filled with code strings, score sheets and authoring models. This is the person responsible for the program's functionality. In the most productive teams, programming is treated as a highly specialized and separate discipline.

• *The Graphic Designer:* Graphic design and art production consume the largest amount of time in the

CKS Interactive

Art Kilinski

CKS Interactive, Cupertino, California

As an Art Director at CKS Interactive, Art Kilinski is responsible for working with a creative team to develop ideas that both communicate and innovate. After an eight-month gig at CKS Partners (working on projects for such clients as Apple, Nextel and Radius), Art says, "I became infected with the multimedia virus." At CKS Interactive, he's had the opportunity to work with such clients as Time Warner Interactive, U.S. Robotics, Symantec and Micro Focus.

Art's background includes a degree in graphic design from San Jose State University and his work has won awards from *HOW* magazine, *Print* magazine, Macromedia and Gilbert Paper.

CKS Interactive's forty-person staff is composed of art directors, designers, writers, 3-D artists, production specialists, C++ programmers and account management people. The group is located in Cupertino, along with the company's headquarters, CKS Group, which also has offices in London, San Francisco, Los Angeles, Portland, New York City and Washington, DC.

Art's primary focus as a multimedia designer is to use technology in exciting ways to convey a compelling message. With the ever-changing dynamics of multimedia being what they are, Art admits there are several things about multimedia creation that excite him, including the opportunity to work with animation, which he says is "fun." He also enjoys "engaging the audience and getting them to interact with the message. . . . I love collaborating with writers, 3-D artists and animators, especially when they're professional and creative. They always bring a fresh viewpoint to a project." ★

The Primal Rage Road Show
Interactive Sales Presentation for the Home Version of a Popular Arcade Game
CKS Interactive

This interactive sales presentation was created for Time Warner Interactive to launch the home version of their popular arcade game, "Primal Rage." The presentation was geared toward buyers at large retail chains.

Most artwork for the presentation was repurposed from the original game, including some unique and unexpected touches: animated dinosaurs, complete with "tail whooshes," were used for navigation buttons, and the main menu uses the game logo as an interface. QuickTime and QuickTime VR window frames were created with "bones and blood" from game backgrounds. Other animation includes a brief full-screen piece at the beginning of the presentation, and animated poses sequenced to slash open the TWI logo—like slashing open an eyeball—at the end of the presentation.

A virtual store was created to allow retailers to view all the marketing elements available for the game (posters, shelf signs, etc.) as well as a QuickTime VR view of the game packaging for different platforms. (Three-dimensional packaging models were created from electronic artwork.)

All of the integrated marketing materials and the entire advertising campaign, including two television commercials as well as behind-the-scenes footage, were incorporated into the presentation. Music was created to be used in both the television commercials and the presentation, and audio also included sound effects from the video game itself. Customizable projected sales figures were also provided as part of this program.

To avoid a generic feel, the presentation was made customizable to incorporate information specific to TWI's individually targeted retailers. It was originally designed to run on a PowerBook 540c with 32 MB of RAM and a 500 MB hard drive, and was to be shown on a 20-inch monitor at 256 colors for an audience of no more than six to ten people. Production time for the project was four weeks. ★

1 Some really exciting graphic designs and sounds were taken straight from the "Primal Rage" game and applied to the interactive sales presentation.

Creative Director: Jim Vandegrift
Art Director: Art Kilinski
Designers: Art Kilinski, Gustaf Fjeldstrom
Interface Design: Art Kilinski
Writer: Matt Davis
Animator: Gustaf Fjeldstrom
Producer: Tom Zazueta
QuickTime VR Producer: Brian Behl
3D Illustrator: Randy Bruck
Musicians: Art Kilinski, Tim Levy
Backgrounds: Time Warner Interactive Primal
 Rage Co-op Team
Account Manager: Daniel Miessau
Client: Time Warner Interactive

Hardware
Power Macintosh 7500/8500s, 80MB RAM, 2GB external FWB Sledgehammers

Tool Box

Software
Adobe Photoshop, Illustrator and Premiere
Macromedia Director and SoundEdit
Strata Studio Pro
QuickTime VR toolkit
Equilibrium DeBabelizer
Microsoft Word

CKS Interactive

U.S. Robotics Website: A Unified Corporate Identity

CKS Interactive

U.S. Robotics is among the largest and most successful sellers of computer modems in the world. Naturally, if your company's mission is putting customers online, you would also be motivated to provide some suggestions of interesting and useful places to go once they get there. A good share of the company's business is people who are using a modem for the first time. So U.S. Robotics set up this website as a sort of "launch pad" to other interesting sites on the Internet.

The opening screen provides users with five directions in which to go, in addition to listing four navigational aids in the upper right-hand corner. These five destinations provide content for each of the company's different audiences —the business user, the home and small office user, the portable computer user and so on. Since the company's product offerings are also divided along these lines, the site serves as a metaphor for U.S. Robotics' corporate divisions.

The site has lots of features that make it attractive and user-friendly, such as simple and direct navigation, large graphics with intelligent color reduction to speed downloading and a site map that's always accessible.

An important role of any company website is to provide the customer with support, so technical support documents and feedback

Tool Box

Hardware
Power Macintosh 7500/8500s, 80MB RAM, 2GB external FWB Sledgehammers

Software
Adobe Photoshop and Illustrator
Macromedia SoundEdit 16
Microsoft Word
Equilibrium DeBabelizer
Web Weaver
Simple Text

Other
Lots of marker paper, Liquitex Matte Medium and Letraset Bristol Board for collages

opportunities were made available. To satisfy potential investors and attract new customers, the site also contains press releases on new products and white papers on technological advancements.

Total production time for the project was nine weeks. ★

Art Director: Art Kilinski
Designers: Art Kilinski, Gustaf Fjeldstrom
Interface Design: Art Kilinski
Writer: Jillian Cipa-Tatum
Information Design: Reed Maltzman, Jillian Cipa-Tatum, Art Kilinski
Producer: Melissa Kabli
Associate Producers: Margot Chow, Ann Marie Michaels
Project Manager: Reed Maltzman
Client: U.S. Robotics

1 The opening screen shows five directions visitors can choose to go. In addition, U.S. Robotics' product lines are represented and there's information about the company as a whole.

2 The "Home & Office" hot links page provides a "launch pad" to quality sites on the Web that might be of interest to various groups working (and playing) at home. No matter where you find yourself in the site, the four key navigational buttons are still in the upper right corner. Note the instructions linking you to the Real-Audio tour.

project schedule, especially in programs rich in original illustration, so this is a critical position. Working with Adobe Photoshop as well as other graphics production programs, the graphic designer's responsibilities include not only rendering all of the buttons, backgrounds, text and graphic elements, but scanning and optimizing photographic assets, cataloging all images, backing up the files and transferring them to the programmer.

• *The Animator:* This person is responsible for all 2-D and 3-D animation. This art form is becoming a specialized and essentially a separate craft from other multimedia disciplines because of its propensity to consume large amounts of time. Even among the most accomplished 3-D animators, animation is often a long, tedious process; experience is the greatest contributor to productivity.

If only a small percentage of a project requires animation, the animator may be a part-time consultant rather than a full-time team member.

• *The Administrative Assistant:* The clerical responsibilities of even a modest multimedia production can be daunting. Keeping track of all of a project's assets, expenses and contracts in a spiral-bound notebook is not a serious, nor will it be a successful system. It's important to keep track of events that will help you properly plan your next production, including a reasonable estimate of your time and costs; this is the job of the administrative assistant.

This is the core group of administrators and creatives for a typical multimedia project. Even in larger, more commercial enterprises, a team might not necessarily grow beyond this small core group. How-

ever, there are some specialized talents who may come and go at strategic times during the creative and production processes.

FOUR KEY SPECIALISTS

As projects become more sophisticated, and time frames shorter, more talent can be brought into the picture.

For example, if canned production music doesn't quite fit your vision, you could employ a musician; if your production requires specialized programming (like game code), a programmer could join your core group for a brief period. After these specialists work their magic, they bug out to their next gigs. Here are four types of specialists who may need to join your team on a temporary basis:

• *The Sound Designer:* Good sound design makes great multimedia; poorly engineered sound is distracting. Music, narration and sound effects should not be left to the unskilled or untalented. The sound designer doesn't neccessarily have to be on hand throughout the entire creative design and production process, but it's a good idea to involve this person as early in the process as possible—provide him or her with a script, storyboard and alpha prototype. Experienced and talented sound designers have established production tricks and techniques that they carry from job to job.

• *The Videographer:* If video is integral to your program, you may wish to seek the talents of a videographer. True, video post production and editing is getting a little easier to do in the digital domain, but in my experience a good videographer, like a good photographer, possesses a gift. Knowing how to correctly compose a shot, frame a close-up and execute smooth, fluid camera

movements is an artistic talent that only a few possess. A videographer may also be a good post-production engineer.

• *The Video Post-Production Director:* Depending on the sophistication of your video content, a post-production director may be necessary. It's often easier to produce video special effects on a dedicated editing system than trying to execute them with less powerful software. Also, if you must repurpose video that has already been shot, you may have to secure the services of a commercial studio just to edit or convert the material to the format you require for the final project. This is one area of multimedia production that can be seriously enhanced by using a talented post-production director with access to high-level, high-priced equipment.

• *The Web Designer/Programmer:* If your project is being prepared for the Web, or if you're planning a hybrid application on CD-ROM with hooks to perpetually changing information on the Internet, you will need recruit a Web designer early in the creative process. The Web has become an important consideration in multimedia projects, and this person might become a regular team member.

Considering all of these talents and responsibilities, where do you fit into the process? If you have the managerial skills, how do you coordinate all of this talent? Multimedia management administration is an art form unto itself, and is addressed in the next few chapters.

CHAPTER 6

Managing the Multimedia Design Process

We've discussed assembling the multimedia team. Now how do we apply this talent and knowledge to creating a multimedia project? You don't even want to *think* about creative development, much less production of a product, until you talk with the customer, client, or whoever commissioned this work and is paying the freight.

EVERYONE HAS A CUSTOMER, AUDIENCE, SCHEDULE AND BUDGET

Everyone has a client—someone who wants the final product and is willing to pay for it.

Yes, we've all heard the story about the two brothers who created "Myst," toiling away for two years in their garage. Well, if you have a meal ticket (like those brothers did, trust me), plenty of time and talented friends who'll work for free, go ahead and skip this part on money.

But all of you who look upon multimedia as the career path to Cashville will need to be interested in such mundane matters as talking price with clients, presenting a written proposal and signing a contract before you begin.

TIPS ON TALKING PRICE

Let's say you've discussed an idea for a multimedia project. You have a client with a story to tell, and some intellectual property ready to repurpose into a multimedia title. The client asks the most important question on the face of this earth, "What's it going to cost?" Believe me, your project will live or die depending on how you handle that question.

1. Initially, don't be too quick with a price. If you answer too quickly with a ballpark figure, that crazy, groundless figure will stick in your client's mind like it was attached with SuperGlue. Your negotiating edge is already close to being shot.

2. Don't hem and haw. Smart customers will try to obtain an early cost estimate. This is a critical moment in establishing your credibility with the person holding the purse strings. If you say something imprecise like, "It's difficult right now to come up with a price because I've got to discuss it with my partners, and we really need a grocery list from you describing what you want, and to determine that we need to do a needs analysis . . .," quit babbling. You're in trouble.

True, it is impossible to indulge in cost estimating from the little information gathered at a first meeting. You need more time, but you want to look confident and encouraging as you say so. Try this:

"Our next step is to develop the cost estimate. Before we take that next step, I need some more information from you about this project. It won't take long, and when we've completed this process, we will submit a formal proposal to you. When that proposal fits your objectives, we draw up a formal contract and get the project on track. Is that agreeable to you?" The customer has to say "yes," which is a great way to conclude this first fact-finding session.

THE PROPOSAL

You may want to present a two-stage proposal to your client. The first stage would give the client several options; for example, you might propose three possible options—one at moderate cost, one at medium cost and one that's more comprehensive and more costly than the other two, but is worth every penny. This is the art of *price ranging*, and it can really help you negotiate.

This is followed by the formal proposal with contract. This phase includes the presentation of a full-fledged concept (including prices and a production schedule) plus a formal contract.

There are five parts to a client proposal:

1. The statement of communication objectives
2. The project's treatment
3. The project's components
4. The cost summary or budget
5. A production schedule of events

Most good multimedia proposals cover these items in about three to six pages. Central to the proposal is the project's treatment, which you will produce after an initial creative brainstorming session.

The Statement of Communication Objectives

Who is your audience, and what do you want them to know? These two objectives must be clear and to the point. An objective statement like this one: "This interactive product is designed to teach kids about Mississippi River ecosystems," is too general.

To be more specific, say: "This interactive multimedia product is designed for fourth through sixth grade natural science students to inform them of the five primary causes of river pollution in North America: agricultural chemical, erosion, urban effluent, river craft and industrial chemical. It's a combination information data resource and pictorial learning tool featuring the six primary Mississippi River ecosystems: headwater, watershed, main channel, backwater, dam sites and southern delta."

Using quantifiable descriptions—such as "five causes" and "six ecosystems"—makes your ideas less abstract, and you'll have a better chance of living up to your client's expectations.

The Project's Treatment

The treatment is typically less than a page and describes precisely what the project is, who it's designed for, how it works and (roughly) what it looks and feels like.

Let's keep going with the concept we described above:

"The learning metaphor is a specially equipped, state-of-the-art houseboat/laboratory that the student will pilot down the Mississippi River in search of the source of pollutants that are fouling the river. The student-scientist will have an interactive crew of specialists avail-

Proposal Brainstorming

The proposal brainstorming session is a brief meeting aimed at envisioning the client's initial wish list. The goal is to get something on paper that illustrates the project's main points and features and motivates the client to sign a contract. (A second brainstorming takes place after the contract is signed.)

A typical proposal brainstorm might involve as few as two or three creative staffers and go anywhere from thirty minutes to an hour. You'll want to get a proposal to the client as soon as possible to show enthusiasm for the project.

Once the communication objective is stated by whomever is running this session (typically, it's the production manager) the creative forces can begin firing away. As with any brainstorming session, the idea is to write everything down—no censorship, no debate. Later, through the distillation process, you'll come up with a workable concept. ■

able to consult. The houseboat will be equipped with video monitors and special tracking devices that show still images and video clips of river plants and animals. There will be on-screen user-animated laboratory equipment with which the student can measure critical data like oxygen and chemical levels in the water, as well as air and residual compounds that may be in the plant fibers and animal tissue.

"The objective of this voyage is for the user to search for the primary causes of pollution that are

affecting the river's many and varied life forms. In the process, the student learns how to conduct scientific measurement, and discovers the five primary causes of pollution. The consulting scientists offer a variety of solutions from which the student can choose to pass along to environmental authorities."

The Project's Components
Once again, let's continue with our river project. Here's how the project's components would be listed in the client proposal:

"The product contains the following components:
- Nearly three hundred still images of plants and animals
- Approximately twenty-five video clips ranging from thirty seconds to one minute in length produced specifically for this project
- Approximately fifty audio clips obtained from sound effects libraries
- A ten-second opening, featuring a 3-D animated logo
- User-animated lab instruments in the form of 2-D illustrations, including a spectrographic computer for analyzing chemicals and tissue samples, a microscope, a centrifuge and a thermometer
- Screen designs depicting approximately four interior scenes in the lab boat
- Script or author-ready narrative
- Storyboarding
- Computer programming
- Package and instruction sheet design
- Layout for jewel box (four-color process)
- Printing and assembly of packaging materials
- An initial run of five thousand PC-compatible CD-ROMs"

It's also important to specify here which items will be provided by the client, and which items you will provide. You might even break your list into two parts, the obligations of the client and the obligations of the producer. For example, will the client supply any photos, film footage or archival materials? Or will they supply training content for the production of the program? Also list what the production firm will provide, i.e., "An interactive catalog interface; image database to accommodate three hundred images, and five thousand CD-ROMs."

The Cost Summary
It can be very difficult for an inexperienced proposal writer to come up with accurate cost estimates. But with a little logic, a little fact finding and knowledge of the client's budget, you can work backwards.

The key to closing a deal with a client is to provide what the customer has asked for. If you've listened to your client's ideas about a project and return with your own incredible vision, you're probably not going to be successful. No matter how good your idea is, this type of approach illustrates that you are more interested in your own ideas than you are in solving your client's problems. If your client wants a simple electronic version of his print catalog, don't try to sell him a CD-ROM version of the Home Shopping Network that would obviously cost a fortune to produce. Experience in this realm is valuable, because you can compare this project with others you've done before. Of course, it all boils down to that most precious commodity—time. How much do you have? How much is it worth? It's your ability to estimate the time it takes to do something that will make or break you every time. (The nuts-and-bolts of job cost estimating is covered in chapter seven.)

A Production Schedule of Events
The proposal should contain an approximate production schedule of events, listing in chronological order what happens when. It can also be interpreted as the "list of deliverables." Since design is a service business, deliverables are for services rendered, meetings held, consultations made, documents delivered and asset production completed.

This crucial exercise of proposal writing solidifies the project into something substantive. If the proposal is accomplished well, the language can be ported right into the contract.

THE CONTRACT
May you never have to find out the hard way how important a contract is! The contract should be rather easy to prepare once you and your client have completed the proposal, since it essentially contains the same information, plus a few additional details—a more detailed production schedule, the final quantity of product to be delivered, the total price and the terms of payment. Here is a short list of what is contained in the contract:

1. The operative and descriptive title given the project. For example—"The Basketball Coach's Playbook."

2. A brief but detailed description of the project's components and its salient features. Most of these can be lifted directly from the proposal.

3. The quantities of delivered product. Is it five thousand CD-ROM disks or ten thousand—and does your agreement include packaging design, packaging and assembly of components?

4. A production schedule that spells out intermediate dates. For example, "Customer to deliver SVHS video clip, one minute in

length, of the CEO for the opening by February 16, 1999" or "Alpha test will be delivered on March 16, 1999, and evaluation must be completed by the client by April 1, 1999." You must also include the delivery deadline for the design document, and finally, include the final delivery date for the finished product.

5. A payment schedule. For example, you might divide the total into three payments. The first payment can be due within ten days of signing the contract, the second payment in another thirty days, and the final payment within thirty days of product delivery.

In the sample contract provided (pages 62-63) note that there are two sides. The front is for the details of the contract, and the back is reserved for the legal interpretation of the contract in terms of liabilities, ownership of intellectual property, provisions in the event obligations cannot be met, etc.

THE DESIGN PHASE AND THE PRODUCTION PHASE

After you've signed the contract, you're ready to *really* get started. So where do you begin?

There are two phases to every multimedia project, the design phase and the production phase. A multimedia rule of thumb: 75 percent of your total time should be spent on design, and the remaining 25 percent in production time. These are not rigid numbers, but they illustrate an important concept of multimedia development: Your design time is always less expensive than your production time. The more you can resolve in the design phase, the smoother your production run will be.

The design phase is the comparatively lower-cost "thinking time" spent on behalf of the project, and the production phase represents

the higher-cost time: the we're-renting-this-equipment-by-the-day-and-it's-expensive time.

CREATING THE DESIGN DOCUMENT

The design document is the binder or folder in which all of the descriptive paper pertaining to the project is inserted. It serves as the project's blueprint—a guide to keeping everyone on time and on budget. The design document is distributed to each production team member and to the client. It performs two critical functions:

1. It contains the treatment and descriptions of each of the project's components—from the script, the information map and the storyboards, right down to details such as sample screen designs, button and icon designs and color treatments.

2. It provides an opportunity for the client and team members to sign off on critical developmental stages of the project as it progresses.

As the components of the design document are prepared and completed, usually concurrently, copies are made and distributed to all of the team members and the client for inclusion in their own design documents. The responsibility of maintaining these books usually belongs to the administrative assistant.

The best way to keep a project on schedule with a minimum number of revisions is to involve the client as much as possible in the process. There are many opportunities to do this during the proportionately longer design phase.

THE CREATIVE BRAINSTORMING SESSION

This is where your project actually begins: the design and production teams getting together for a creative brainstorming session to conjure up more details of the project. A good brainstorming session is a boiling

 Resolve Creative Issues Before Production Starts

Since design time is less expensive than production time, this is where you can afford to be really creative. In fact, by the time you enter production, all creative issues should be thoroughly resolved.

For example, imagine working on a complex interactive program, having postponed designing the screen backgrounds until the production phase. The project has now been thoroughly programmed. Your client sees the backgrounds for the first time in the beta test and informs you that the colors do not conform to corporate standards. The color scheme for the entire project will have to be changed. It will take incalculable hours, include reprogramming, and will send your schedule and budget completely out of control. We're talking lost profits here.

The Two Essential Control Issues: Can We Be On Time and On Budget?
Since expensive equipment and talent are secured for the production phase, your goal is to have people produce their specific services on time and on budget. To make sure this happens, you'll want to resolve all of your creative issues during the design phase. The design document is the blueprint of the project that will help you do this. ■

stew of ideas enthusiastically thrown in with no judgment, debate, censorship or restrictions except time. The best byproduct

A Sample Contract

The contract should contain the following features: 1) the title of the project, 2) a detailed description of the project's components and features, 3) the quantity of the final product to be delivered, 4) a production schedule and 5) a payment schedule.

SAMPLE CONTRACT

DESIGN/PRODUCTION AGREEMENT

Hardie Interactive
1690 Elm St.
P.O. Box 855
Dubuque, IA
52004-0855
Ph: 319-556-4444
Fax: 319-556-0648
www.hardieint.com

Client: _____ Date: _____

Project Title: _____

Project Description: _____

Schedules/Dates:

Work to be Completed:

❑ Video
❑ CD-ROM, CDi
❑ Supplemental Material/Print
❑ Concept/Script/Storyboard
❑ Needs Analysis/Instructional Design

❑ Graphics/Interface Design
❑ Program Authoring
❑ Animation
❑ Video Production
❑ Other Services:

The selling price is based on the original job assignment. Any additions or changes made to the original assignment will be estimated in writing to the Client for approval prior to Hardie Interactive initiating new work.

Payment: All invoices are due and payable ten (10) days after the date of billing and all terms are net cash. Invoices not paid within thirty (30) days of the invoice date are subject to a 1½% interest charge per month on the unpaid balance. This agreement is subject to the terms and conditions on the reverse and is non-cancellable. Payments will be made in increments corresponding to the services described below:

Payment to initiate project: _____ $ _____
Services completed: _____ $ _____
Services completed: _____ $ _____
Total Selling Price: _____ $ _____

Hardie Interactive

Account Executive _____

Date _____

Manager Approval _____

Date _____

Client (Corporation, Partnership, Sole Proprietor)

Printed Name _____

Signature _____ Date _____

Street _____

City, State, Zip _____

Telephone _____

of this process, besides fresh ideas, is the opportunity for members of the team to buy into the project.

Who attends the brainstorming session? At minimum, the producer and director, the project manager, the writer (or instructional designer), the multimedia designer, graphic designer, animator and programmer. In other words, the whole "core" team should be there.

In addition, the administrative assistant can join in, as well as the specialists, who may not otherwise be involved in the project for several days yet. If you're a creative agency, invite your account representative along to share the client's agenda. The more you can involve the individual craftspeople, the more

opportunity you have for cross-pollination of ideas.

Should the Client Be Part of Creative Brainstorming?

Should you involve the client? It depends on how much of the nitty-gritty creative process you want to share with them. After all, you were hired to come up with solutions. If the client thought they could come up with something better, they wouldn't have hired you. In a moment, we'll talk about critical times to share information and ideas and when it's appropriate to solicit client input.

The producer/director may facilitate this second brainstorming session, but it could be anybody

who knows how to run a productive meeting. You start things off with a loose concept, theme or a statement of the problem the team needs to solve through multimedia. Have flip charts with lots of brightly colored markers on hand for writing down ideas and concepts as fast as they occur. The director (or another member of the team) should facilitate, and write and handle the flip charts.

The four essential objectives of creative brainstorming are:
1. Identifying the audience
2. Envisioning how the product will work
3. Establishing how the product will look and sound
4. Naming the product

SAMPLE CONTRACT (REVERSE SIDE)

TERMS AND CONDITIONS

1. **Grant of rights.** Upon receipt of full payment, Hardie Interactive grants to the Client rights in the project for use as described on reverse. If the client wishes to make any additional uses of the designs, Client agrees to seek permission from Hardie Interactive and make such payments as are agreed to at that time.

2. **Ownership rights.** Hardie Interactive retains ownership of all original assets whether preliminary or final.

3. **Cancellation.** In the event of cancellation of this project, ownership of all rights and the original assets shall be retained by Hardie Interactive. A cancellation fee for work completed, based on the contracted price and expenses already incurred, shall be paid by the Client.

4. **Delay of project.** In the event of a delay of the project on the part of the Client for more than thirty (30) days, Hardie Interactive reserves the right to invoice the Client, and the Client shall pay for all work completed and expenses incurred to date.

5. **Releases.** Client shall indemnify Hardie Interactive against all claims and expenses, including reasonable attorney's fees, due to uses for which no release was requested in writing or for uses which exceed authority granted by a release.

6. **Arbitration.** Any disputes in excess of the maximum limit for small claims court arising out of this Agreement shall be submitted to binding arbitration before the Joint Ethics Committee or a mutually agreed upon arbitrator pursuant to the rules of the American Arbitration Association. The Arbitrator's award shall be final and judgement may be entered in any court having jurisdiction thereof. The Client shall pay all arbitration and court costs, reasonable attorney's fees, and legal interest on any award of judgement in favor of Hardie Interactive.

Identifying the Audience

Who precisely is the audience and what information are you trying to transfer to them? Such demographic targets as age, gender and preferred operating platform are revealed to the multimedia team. For example, "This is a basketball coach's playbook on CD-ROM for PC and Macintosh. It's aimed at middle school and high school athletes, not just coaches. It is to be filled with fundamentals of half-court and full-court strategic play. The objective of the product is to impart the advantages of strategic play and especially the importance of teamwork."

Envisioning How the Product Will Work

Let's continue with the basketball coach's playbook example. The team leader puts at the top of the first flip chart, "How will the product work?" This is an interactive product, so how will the user interact with the information? Thus begins the process of interactive design. Some of these ideas might include:

- Have well-known coaches like Vivian Stringer of Rutgers or Lute Olson of the University of Arizona describe their fundamental strategies.
- Include video clips showing actual plays executed on the court.
- Use animation showing plays executed on a blackboard with the coach's narration explaining the offensive or defensive setup and execution.
- Have a "You Be the Coach" module where you have to make coaching decisions based on a given set of circumstances and where the outcome changes depending on the choice you make.
- Include a personal playbook in which users can diagram their own plays and print them.

Some ideas that come out of this brainstorming session might be unworkable, but you should resist debate and censorship. Let the ideas flow freely, and write every one of them down.

Establishing How the Product Will Look and Sound

Here again, write down everyone's ideas as fast as they come. Pay attention to ideas from non-graphic designers in the group too, as they will be able to contribute information about functionality. Some possible ideas for our coach's playbook might include:

- Background is an embossed, textured, monochromatic photo of players mixing it up on a court.
- Each section will have a different background that will depict the section's content.
- There is a navigation panel that looks like a scoreboard.
- The entire interface looks like an arena scoreboard, complete with video panel.
- Buttons can be little 3-D basketballs hovering just off the surface of the screen. The drop shadows behind them will denote that they're buttons, and titling will explain their function.
- One button sound can be the arena horn users will hear when they press a certain button or want a time out.
- Music will be played by the arena organ, of course!
- Additional resources, like additional plays, can be downloaded from an accompanying website directly accessible from the program.

Naming the Product

It's not too early to hang a name on the project. In fact, creating a name tends to make the project less abstract. Naming the product also gives the designer a chance to play with tangible design elements that will not only be used in the product but also in the packaging and support graphics.

Continuing with our example, the team might come up with names such as:

- "The Basketball Coach's Playbook"
- "The Basketball Strategist's Notebook"
- "The Coach's Secret Files"
- "Basketballarama!"

As your brainstorming session progresses, begin gathering consensus on key items to include in the treatment of the project. A quick polling of participants on such ideas as "the buttons are 3-D basketballs" and "have a 'You're the Coach' learning module" will signal their inclusion in the design document's treatment section.

WRITING THE FINAL TREATMENT

The treatment is usually no more than a page describing the entire multimedia concept, including what the product is; who it's designed for; how it works, looks and sounds; and the operative name. The final treatment is designed to provide everyone, including the team and the client, with a basic vision. Here's how the treatment might read on our basketball project:

The product is called "Basketballarama." It's an interactive basketball coach's playbook on CD-ROM for PC and Macintosh. Aimed at middle school and high school athletes as well as coaches, it is designed to be a resource filled with fundamentals of half-court and full-court strategic play. The objective of the product is to impart the advantages of strategic play and the value of teamwork.

The product will contain the basketball knowledge of two of the game's great college coaches, Vivian Stringer and Lute Olson. Their lessons will be contained in the form of video clips. Two-dimensional animation will con-vey play strategies, and video clips of actual game situations will be used to illustrate various court strategies.

The user will navigate through the content of this CD-ROM with the use of a navigational panel in the appearance of a scoreboard. Area scoreboards today have a video component, and so will this interface. This is where the coach's content, videos and animation will run. Additional navigation buttons will be in the shape of 3-D basketballs. Besides the coach's soundtrack, sound effects such as arena crowd noises and the scoreboard horn will be heard when certain user actions take place.

The program will contain the following components:

- *The coach's individual basic playbooks for offense and defense.*
- *Animated diagrams describing the plays, with coach's narration.*
- *A "you call the play" module allowing the user to apply the knowledge he's gained listening to the coaches.*
- *A personal playbook, allowing the user to compile his own favorite plays in a printable format.*

Assessing the Client's Content and Assets

Typically, the client will have some pre-existing materials they want you to use in their multimedia program. Assessment of these project assets should occur as soon as possible in the design process. This will include reviewing any documents, text, art, graphics, photography or existing film or video footage the client may want to use. At this point in the history of multimedia, a lot of existing material is getting repurposed. This isn't always ideal from a creative standpoint, but it's a fact to be dealt with.

Everything from logos to videos needs to be reviewed, numbered and cataloged, preferably in a database where the material can easily be cross-referenced and retrieved.

One of the best applications for cataloging graphic elements, including digital video and animations, is a program called Fetch (Adobe). But any database program that can contain graphics files will work.

INFORMATION MAPPING

The next step in the compilation process of the design document is information mapping. In most cases, this is accomplished through the collaboration of the director, the writer and/or instructional designer, the multimedia designer and the programmer. The information map is precisely what the name implies. It's a map, or more accurately, it's an information tree that looks like an organization chart (see page 67).

Note that the lines connecting various portions of the map are very specific; they don't merely connect the screens, but connect specific button actions to their results. Note, too, how assets are numbered to maintain continuity from the screen to the assets that can be reached through that screen—e.g., from the Topic 1 screen, you can choose to see clip 1.1, 1.2 or 1.3.

SCRIPTING

Even though multimedia is more story-doing than storytelling, you still need to use a very linear approach as you write down what happens when. But rather than capturing the details for one scenario, you need to capture the details for *all* possible scenarios. In the words of Dr. Joe Henderson: "All of my interactive projects start out as a screenplay. I'm still telling a story, even though the story can unfold a number of different ways depending upon the actions of the user."

Scripting for multimedia is completed early in the design stage of

The Three Categories of Intellectual Property Rights

There are three categories of intellectual property rights for which you, as a multimedia producer or publisher, are responsible. They cover each and every text, visual, audio and motion picture element that comprises the project you are creating.

1. **Reproduction Rights:** Reproduction rights must be secured for all previously used and/or previously copyrighted materials that were created by others and have found their way into your production. This includes images, text, audio and video clips, music, stock images and sound effects.

2. **Permissions:** Permissions must be secured on all newly created materials, performances, images and otherwise previously *undistributed* content. Clear ownership or copyright must be determined, because you can't use someone else's work without it.

 Performance and image permissions, traditionally called talent releases, are secured from the performers in your production (actors and voice talents for example), regardless of whether or not they are compensated. Your legal rule of thumb should be: Never assume you have rights or permissions to use any content without documented proof.

3. **Copyrights of Original Material:** The multimedia project you're creating also needs to be copyrighted. You have your own creative work and content, the rights of which you must protect from unauthorized reproduction.

 All reproduction rights and permissions must be secured before you begin the production phase of your multimedia project. From an administrative task point of view, copyright of your original material is the easiest and least costly right to secure. But because multimedia is often comprised of previously copyrighted material *inside* of your *original* material, you must devote much more time, money and energy to securing those reproduction rights.

 One unauthorized use of an image or a few bars of music can tie you up in a court case for an interminable amount of time. If your product is a commercial venture, an injunction would remove it from the marketplace and could effectively put you out of business.

 I had the opportunity to talk about intellectual property administrative costs with Suzanne Gunther of Media Logic, in Syracuse, New York. She said some projects they produce for the recording industry require intense budget analysis. According to Suzanne, "Intellectual property rights could represent as much as 35 percent of the project's total budget. In some cases, it represents the single largest cost item."

Be Assured: Copyright Laws Are Enforced

This is not a law book, nor is it an attempt to interpret the law. Suffice it to say, intellectual property rights laws are enforced. There are no copyright cops to enforce these laws, but there are hordes of lawyers who wield the threat of lawsuit with potentially devastating results. Protection is extended beyond our nation's borders through a complex network of international agreements (although these agreements are somewhat unevenly enforced from country to country).

The growth of multimedia and the Internet has caused a sharp rise in copyright-related litigation, and so the intellectual property law field has also grown.

At a recent Comdex computer exposition in Las Vegas, there was at least one law firm that set up a very classy looking booth on the convention floor. The attorneys were glad-handing convention attendees, passing out their business cards and brochures, letting everyone know they were one of the oldest law firms in the business specializing in intellectual property law, a veritable one-stop-shop for all your copyright needs. Business was booming at their booth.

Factor In Your Legal Chores

Securing intellectual property rights means clearly defining the tasks involved in securing these rights, and assigning them to an experienced rights and permissions staff. Most crucial of all, you must factor these legal chores into your cost estimate. Here's a legal checklist to get things started:

• All contracts with performers and subcontractors, including writers, designers and programmers, must have clearly defined language that states precisely who owns the reproduction rights of the product you want to use. This includes any special programming code. Some artists may demand that they maintain certain rights to images or melodies they create while on contract, or they may want specific language in their contract to address licensing issues and royalties. All of this must be addressed up front and spelled out in precise language.

• Performance or talent releases should be on hand throughout the production and promptly signed by any and all incidental performers who are seen and/or heard in the course of production. ▶

- You must create a comprehensive list, preferably in computer database form, of all copyrighted material intended for inclusion in the production. Each entry should include the status of the rights as they pertain to this production, i.e., whether or not they've been secured and royalties paid, and any specific language that must accompany the material when reproduced.
- This list of permissions and copyrights must be conspicuously attached to the finished piece, both in digital and printed forms. Somewhere on the program or on the website is a "credits" button that rolls the credits listing the permissions. The same list is published on the CD-ROM packaging and in any accompanying manuals.

There are several excellent books on intellectual property law that you can consult; you simply must protect yourself with a knowledge of current copyright law. ∎

the project, and is really no different than script preparation for a video or motion picture. The conventional format is the same: two columns per page with the left column describing the action, sound or music taking place, and the right column containing the dialogue or narration.

When scripting is done for computer-based training, the script is called an author-ready narrative. For CBT projects, the instructional designer often develops the author-ready narrative practically alone. Such a specialized task requires a person who is uniquely qualified to perform his craft, whether through formal, certified training or quantifiable experience in instructional design. Essentially this skilled person digests the material that comprises the course, considers the learning objectives, the audience's learning capacity and a whole host of considerations, and creates the author-ready narrative. It might be compared to the process of writing a textbook combined with creating a movie script.

STORYBOARDING

As the script or author-ready narrative describes in words what is happening with this product, the storyboard shows the action with visuals, typically simple sketches.

What exactly do you storyboard? You can storyboard anything you believe requires strict adherence to a particular vision or element of the script. Our production group storyboards original videos and animations since these are sometimes produced out-of-house. Specialists or other freelancers need to have a feel for the look and pacing of the segments for which they are responsible.

For the most part, a design team can get by with a quick-to-reproduce storyboard sheet on 8½" x 11" paper. Three or four frames are outlined on each page with a few lines beneath the frames for descriptions of the action.

My thing is 2-D animation. I love to do cartoons. I do key frame drawings, usually right on the computer. I do a drawing of where the character starts in the frame and where it ends up. Scene changes and backgrounds are drawn on separate layers, and a small color swatch test on the character and on a corner of the background is all that's usually necessary.

THE ALPHA PROTOTYPE

An alpha prototype is the "first draft" of a multimedia program; it shows the basic composition as far as screens, buttons, etc., and should also have the basic functionality of the program in place. It can be a small, interactive screen test created in Macromedia Authorware, Apple HyperCard, Gold Disk's Astound or Asymetrix ToolBook that shows relative position of buttons on the screen, and may have placeholders (such as colored squares) representing photos or videos.

I don't mean to imply that the alpha prototype is fully functional. Remember, this is primarily something to show the customer and creative team to establish the look and feel of the information design. Think of it as an architect's rendering of a new building design with some interior views, color swatches, furniture layout and on-premise signs.

The real value of the alpha prototype is the opportunity for client approval. You can show the client all kinds of paperwork (including layouts and a script), but there is no substitute for the alpha, where the customer presses a button and is actually transported to the next level of interactivity.

"That's just how I had hoped it would work!" your client may exclaim. Or you might hear, "No, this isn't what's supposed to happen here. Can we change this button and this result?" In any event, this alpha prototype should be included in the design document, along with the script, storyboards and the information map.

The alpha prototype is sometimes referred to as a "disposable prototype"—a term I don't care for because it implies that it will be trashed after the client approves it. Actually, the alpha prototype may survive completely intact and be transplanted into the final product.

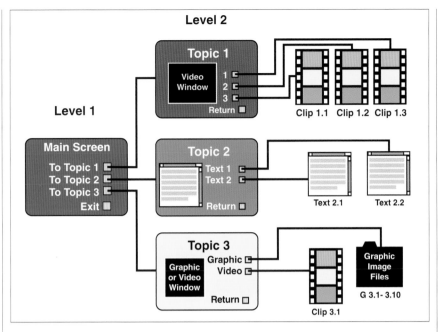

Level 2

Topic 1
Video Window
1
2
3
Return
Clip 1.1 Clip 1.2 Clip 1.3

Level 1

Main Screen
To Topic 1
To Topic 2
To Topic 3
Exit

Topic 2
Text 1
Text 2
Return
Text 2.1 Text 2.2

Topic 3
Graphic or Video Window
Graphic
Video
Return
Clip 3.1
Graphic Image Files
G 3.1- 3.10

A Simple Information Map
This information map, featuring two levels of interactivity, was created in a computer drawing program. Icons were created to symbolize screens, windows and types of files—graphics, films, text files—connected to certain screens. Note that the lines don't merely connect the screens, but connect specific button actions to screens. Note, too, how assets are numbered to maintain continuity between each screen and assets to be shown on that screen.

Client Script Approval and Request for Changes

The program content, which is presented in script and storyboard form, plus the alpha prototype, are all presented to the client for approval. Information maps are also included that describe the various interactive functions of the program. This is the first crucial client approval. There will be changes (there always are), and you should welcome them at this stage.

How to Manage Client Changes

You'll need to prepare a standard client approval form and attach it to the design document. This form will require a client's signature and the date before any substantial changes take place.

Changes during the design phase of the project should be expected, and in fact should have been accounted for during the cost estimating process. But what if the client demands excessive changes—to the point of busting the budget or erasing your profit margin?

If you've been keeping your client involved in the process so far, the client should feel he has a stake in the work that's been completed.

If for some reason the client has not been available, and now he's demanding major changes, you must handle these conflicts as quickly and as diplomatically as possible. The first thing you must produce is the contract. If the changes the client is requesting exceed what's provided for in the contract, then it's time to explain to the client the necessity of a revision agreement.

The Revision Agreement

The revision agreement is like a mini-contract. It's actually a simple one-page list of revisions and their costs, with spaces for signatures and delivery dates. It requires signatures of both parties: the production head and the client.

If everyone fulfills their obligations through the design document and alpha test stages, a revision agreement is seldom necessary. But if your team has started production (at which point changes are much more costly) and revisions are demanded, then revision agreements are absolutely essential. Alas, even though we have immersed ourselves in a high technology enterprise, the need for paper is ever-present. It is the best legal evidence that jobs have been performed and have been approved.

Never be afraid to ask for signed approval. It brings a sense of urgency and importance to every stage of the process and it also gives the client an opportunity to speak up. If the client has to have certain changes, sooner is always better than later.

THE DESIGN PROCESS IS COMPLETE

The design document is complete, and the design components have been approved by the client. The alpha test was successful, and now you can transfer those graphics and codes to the final project. The video is being shot, the animator is starting the pencil roughs, and the multimedia designer is conferring with the programmer on a particularly tricky bit of computer code. Everyone knows how many hours they have to complete their tasks, and they feel comfortable.

If you've done everything correctly up to this point, the production phase will be like a walk in the park. OK, maybe not a walk in the park; there is always the unexpected. But if you've done a good job on the design document, you will be better prepared for the unexpected.

Marcolina Design

Making the Transition
From Print to New Media

The Marcolina Design gang

Marcolina Design, Inc., was formed by Dan and Denise Marcolina in 1990. Since that time they have grown from a partnership of two to the current team of seven. The company is a hybrid communications firm offering distinctive, linear and nonlinear design solutions. Because of their relatively small size, they can listen closely and act quickly.

With fifteen years' experience in traditional corporate design, Marcolina Design was well-versed in concept and typography. Always interested in tools and toys that would make it easier to reach their ideas, the firm moved quickly to exploit the Macintosh in the early years for print work and digital manipulated imagery. Once experienced in moving pixel-based images around in a multitude of programs, it was natural for them to move into interactive programs.

Everyone at MDI is dedicated to providing their varied clients with

exceptional design solutions executed on time, on budget and with close attention to all of the client's needs. They currently apply this philosophy to such well-known clients as Apple, AT&T, BF Goodrich, BusinessWire, CompuServe, GTE, Kodak, Letraset USA, Novell, Sun MicroSystems and Unisys.

The studio's design work, digital illustration and multimedia titles have appeared in *Graphis* annuals, *New York Art Directors Annuals*, AR 100, AIGA shows, *Communication Arts*, *Print* regional annuals, the *Publication* design annual, *Step-by-Step*, *Publish*, *MacWorld*, *MacWeek* and *The Mac Bible*, as well as many other national and international publications.

The driving force behind Marcolina Design is the husband-and-wife team that co-founded the studio: Dan and Denise Marcolina. Dan, the president of MDI, has fifteen years' experience in the field of graphic communication, and has established himself at the forefront of design, gaining both national and international recognition for his award-winning design, photo illustration and new media work. Never one to rest on his laurels, he is constantly exploring new technologies to provide his clients with the best thinking and design innovation possible.

Denise, who is vice-president, secretary and treasurer of MDI, is the business side of the partnership, complementing and harnessing Dan's creative genius. In the fifteen years she spent setting up and managing specialty stores for Children's Place, she helped the chain grow from seven stores to more than three hundred nationwide. Denise also holds a degree in fine arts from

Rowen College.

The rest of the staff is rounded out by Dermot MacCormack, senior art director and designer; Sean McCabe, designer; Rebekah Higgins, senior production/technical coordinator; Quinn Richardson, graphic designer; and Vikki Wright-Adams, office manager.

Marcolina Design currently works their magic in a space located just west of Philadelphia on the banks of the Schuykill River in a restored tire factory. They occupy a 3,300-square foot loft, including a conference room/gallery space, video/sound production room and a rooftop porch. ★

Digital Dexterity: A Stunning Self-Promotion

Marcolina Design

"Digital Dexterity" was a project with a clear goal from the outset: to promote the various design and multimedia capabilities of Marcolina Design by showing work from some of their best illustration and design projects. The result is a visual masterpiece; a culmination of all the talents in Marcolina's studio that truly captures the company's personality. As Dan Marcolina says, "The user can come away with a strong impression of not only the kind of work we do but also who we are."

The title "Digital Dexterity" refers to a number of interrelated

concepts: that of using the hands, the design craft and the concept of traditional design, and thinking with the new digital tools used to the extreme.

The words that glide through the opening film also have dual meanings, like "resolution," which can refer to pixels-per-inch or reaching a decision, and "interpolation," which has to do with doubling the information in an image or making visual sense of a client's complex information.

There's more than meets the eye in other ways, too, since this CD-ROM isn't *just* a collection of MDI's work: "Individuals can peer into our portfolio, watch a movie or play with some hidden electronic toys," according to Dan.

"We had grand plans to add morphing heads and other items of intrigue," explains Dan, "but we decided to finish [it in time] for the *New Media Magazine* Awards, [so] we made it cross platform and pressed one thousand CDs in a hurry. When word came in that we were chosen as one of the winners we were surprised and very excited. . . "

Marcolina sent the piece to potential clients—including those who might be interested in print design as well as potential clients for multimedia projects—and to design awards programs. The response so far has resulted in several leads, new work and over $20,000 in hardware and software prizes. In client presentations, the piece is shown on a PowerBook even if the firm is going after a print job and not a multimedia project. "If the client knows that down the road they may need to electrify their capabilities brochure or catalog, we've already convinced

them of our technical expertise. This has led to Web design work. In two years, I see the business of multimedia more focused on the Internet." ★

1 The main navigational screen serves as a stage upon which the content—QuickTime movies, portfolio pages, etc.—performs.

There are some obvious buttons in the lower right-hand corner of the screen, but most are hidden for the user to discover.

2 Clicking on the fingers of the hand in the main screen rewards you with a card trick, in which you pick a card—any card!

Marcolina Design

Digital Dexterity:
A Stunning
Self-Promotion

3 Vintage movie clips are used throughout the environment to illustrate points about creativity.

4 The "lips" button in the lower left-hand corner of the screen indicates an audio clip is available.

5 "Digital Dexterity" features several illustration and design projects, among them CD music covers, like this one for Placido Domingo's recording of *Faust* with the London Philharmonic.

Hardware

The primary hardware equipment used was a Macintosh 840 AV with Spigot AV card in addition to 64 MB of RAM. For production purposes a Macintosh Quadra 840 AV with 56 MB of RAM for both high and low resolution versions was used. For animation a Power Macintosh 7100 with 16 MB of RAM was used. The programming was completed on a Macintosh IIci with 20 MB of RAM.

Software
Adobe Premiere, Cosa After Image, Macromedia Director and SoundEdit 16, Specular Infini-D and Adobe Photoshop.

❸ →

❹ →

❺ →

the WEB

Portfolio: More Work From Marcolina Design, Inc.

Marcolina Design, Inc.

The following are screens from a variety of webpages designed by Marcolina Design, Inc.

Note the incredible depth and atmosphere of these graphics, including the way their surfaces appear to shimmer with light. ★

1 The floating sphere serves as a visual metaphor for the world of Lucas Bear.

2 This home screen for the Corestates Bank website also makes use of 3-D objects that appear to "pop" off the screen.

3 This page banner for the Lucas Bear website has a number of 3-D shapes in the design that help to add depth to an otherwise two-dimensional graphic environment. Note, for example, the dramatic effect of the "floating" pyramid.

❶→

❷→

❸

Marcolina Design

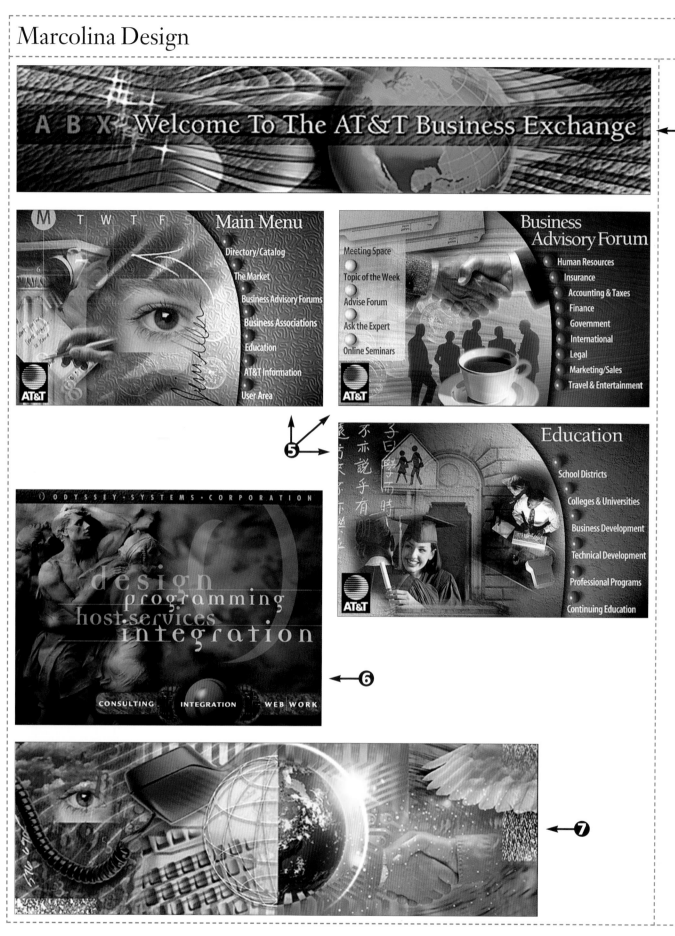

V I R T U A L · M A N A Y U N K

VM

HELP

Hardware
Macintosh
Power PCs

Software
Adobe Photoshop
and Illustrator,
Specular Infini-D and
Collage.

Tool Box

4 The banner illustration for AT&T's Business Exchange

5 Take a look at these three navigational screens for AT&T's website. Buttons are in a consistent location on each screen, as is the arrangement of graphics, providing for visual continuity and fast user assimilation throughout the experience.

6 This screen is a webpage for Odyssey Systems, a consulting firm specializing in computer system integration and website programming.

7 This AT&T Web banner features a montage of images that suggest the multifaceted world of AT&T communications.

8 A navigation panel for Odyssey Systems.

Media Logic

ProFile

Media Logic— Albany, New York

The Visual Side of the Music Business

Media Logic, Inc. is a twelve-year-old, full-service marketing, advertising and design company. According to Media Logic's project director, Suzanne Gunther, "Three years ago we became active in Internet and online services and began developing, designing and programming interactive and multimedia files."

"One of our early projects was for Warner Brothers Records. They asked us to develop an IPK, or interactive press kit, to introduce four bands performing at Lollapalooza '94. We created a very funky, fun, new-tech montage of photos, sounds and graphics. Later we worked with A&M Records producing an IPK for the CD release of Woodstock '94. Here we forged deeper into interactivity and incorporated a game into the file.

"In between the IPKs we continued to do electronic magazines of up-and-coming bands for a variety of record labels. This work led us to a screensaver project for Nick at

Nite. We have also done product demonstration files and, of course, websites."

Media Logic employs about twenty-five people with diverse skills and talents. The creative/graphic department is comprised of a creative director, new media

The staff at Media Logic.

director, art director, production manager and several artists, some of whom do multimedia programming. Additional departments include account services, administration, media planning and buying, print buying and accounting. The company even has its own audio recording facility and video editing suite.

Media Logic has grown considerably in the last several years, according to Suzanne. "We credit our success first and foremost to the results-driven marketing we do. If our clients weren't satisfied with our product and service, we wouldn't be able to continue working with them—or anyone else, for that matter.... We have implemented an ongoing self-promotion communications program with our current clients and potential clients. We also receive a great deal of recognition through media placement of press releases, and we have on staff a director of business development who is responsible for overseeing our sales efforts." ★

▶

CD-ROM **theWEB**

Media Logic

Woodstock '94 Press Kit Captures the Chaos

Media Logic

The 1994 revival of the Woodstock music festival had to deal with a monumental legacy. Woodstock . . . the name evokes memories of the legendary peace-and-love tribal event of the '60s that became the most significant cultural influence on music, art and style for the Baby Boomer generation.

To promote A&M Records' double CD and double cassette "Woodstock '94," Media Logic created the Woodstock '94 Interactive Press Kit. The file features samples from many of the songs on the album, stage announcements, pictures, background information and even a video game in which users "mosh" to their favorite band. The file was designed to evoke the feel of the actual event—crowded, noisy, muddy and a little disorienting—making it a powerful way for music lovers and the media to experience the album. The Mosh Game promoted repeated access by users, thereby increasing exposure to the advertisement for the "Woodstock '94" album.

The completed file was distributed on floppy disk to media representatives and record store buyers, and uploaded to the Internet and commercial online services, where it was immediately embraced. AOL members alone downloaded the file over 4,600 times in four months, making it one of the most popular files online at the time. ★

Factoids:
- Total attendance was about 350,000 with more than 200,000 tickets sold.
- There was one unconfirmed birth. The closest that doctors saw was a false labor. "If they had it without us, God bless 'em," said Dr. Ferdinand Anderson, medical director at the show (Daily News).
- Up to 30 percent of all injuries were due to moshing, leading one reporter to write "In 1969 it was bad acid. At Woodstock '94, it was bad dancing" (Brian Ballou, New York Newsday).
- 3000 press passes were issued.
- There were 18 couples who said they got married during the festival.
- Concertgoers consumed about 71 miles of hot dogs, 100,000 bagels, 31,250 gallons of coffee

① **②**

1 Like the event itself, the visual effect and functionality of this program can best be described as controlled chaos. There is no consistent control panel; instead, the program relies mainly on the user's intuition to discover how to navigate. The graphics, icons and buttons look like a cross-pollination of modern grafitti and ancient cave art.

2 The screen backgrounds are dithered bitmapped photographs taken at Woodstock '94. Faces loom in the background in tones of red, pumpkin yellow and purple. This approach not only looks interesting, but also represents an economy of color in terms of palette depth, ensuring small graphic file sizes and faster loading. Most backgrounds are comprised of only two colors, but the stochastic screening of the dithered pictures provides wonderful depth and contrast to the layered objects and text.

3 This is the title screen with some not-too-obvious instructions to the user about functionality.

4 Is this program entertainment? An information resource? A work of art? It's all three and more—after all, it's multimedia, which combines graphics, sounds, motion pictures and text. The text in this case is presented in scrolling windows.

5 The whole point of this piece is to promote A&M Records' Woodstock '94 album.

6 A screen from the video game, in which users "mosh" to their favorite band.

7 Extremely subtle contrasting colors characterize the graphics in this program.

MOVE MOUSE HERE OR HERE

woodstock 94

Hardware
• Macintosh computers for graphics production and a PC with Windows for cross-platform work. All machines are networked for ease of file exchange. MacRecorder for sound digitizing, Omnimedia image and slide scanner.

Software
• Macromedia Director (Mac and Windows versions)
• Adobe Photoshop and Illustrator for screen creation, Macromedia SoundEdit Pro for sound editing

Tool Box

← **3** **5**

November 1994
WOODSTOCK '94

On November 8, less than three months after 350,000 exhausted yet exhilarated rock fans made their way home from the muddy fields of Winston Farm, A&M Records will release **WOODSTOCK '94**, a 27-track collection of the music that made the weekend memorable. The definitive musical document of the most famous rock festival this side of 1969 will be available as a double-CD and a double-cassette. The two-CD configuration will come with two booklets -- a 12-page compendium of track information and credits, and a 24-page, four-color folio of photos from the festival.

The artists included in the package offer an illuminating ride through a variety of contemporary pop styles, including rap, heavy metal, and alternative rock. Also on board are singer-songwriters and rock bands whose fame stretches back to the time of the original Woodstock festival. Here, in order of appearance, is the mind-bending roster of **WOODSTOCK '94**: Live; Blues Traveler; Melissa Etheridge; Joe Cocker; the cranberries; Blind Melon; Green Day; Salt-N-Pepa; Red Hot Chili Peppers; Porno For Pyros; Primus; Jackyl; Aerosmith; Nine Inch Nails; Metallica; Paul Rodgers Featuring Slash; Jason Bonham, Neal Schon & Andy Fraser; The Neville Brothers; Sheryl Crow; Crosby, Stills & Nash; Violent Femmes; Collective Soul; Candlebox; Cypress Hill; Rollins Band;

4

"The making of the Woodstock '94 album stands as the largest, most complex live event recording in history. A lot of talented people worked hard to make this happen and, in my opinion, did a damn fine job."
- Larry Hamby

YOUR SCORE 1

LiFe aT WOODsTOCK '94

← **6** **7**

Lollapalooza '94 Interactive Press Kit

Media Logic

Today, music is as much about visual art as it is about the art of making sound. Even the most counter-culture groups aggressively pursue a certain look that will put them in a visual category compatable with their fans.

It's generally acknowledged that the phenomenon of music-inspired art began in the 1960s, when long-playing records needed provocative, elaborately designed jackets to appeal to their audiences. When CDs eclipsed LPs, the opportunity for stunning visual packaging shrank with the new jewel box packaging. Now, high-energy graphics are roaring back into the music business, not necessarily in the packaging, but on the CDs themselves, right along with the music (to see them, you have to put the disk into your computer's CD-ROM drive) and in another very challenging new medium—the World Wide Web.

Before Lollapalooza 1994 blew through the United States, computer users could get a taste of what to expect at the show with Warner Bros. Records' Lollapalooza Interactive Press Kit (IPK). This multimedia magazine was created to promote four of the bands appearing at that year's Lollapalooza festival: L7, The Flaming Lips, Green Day and the Boredoms. The audi-

ence included online distribution via the Web, plus CD-ROM distribution to retailers and media representatives. In addition, the Macintosh and Windows versions of the kit were available to anyone with a computer and access to an online service such as AOL or CompuServe.

Media Logic's goal was to present a large amount of information with exciting animated design and plenty of sound, while not exceeding the size of one high-density computer disk. To achieve this, they used as few full-color images as possible, opting instead for smaller black and white graphics that were then colorized in Macromedia Director. They also used programming to add more depth to the file. The final result is more like four mini-files that are accessible through one interface. ★

Hardware
- Three Macintosh computers (IIci with various amounts of RAM and graphics accelerators) and one PC/Windows computer (486/66 with about 16 MB of RAM), all connected via network

- MacRecorder for sound recording

- Omnimedia XRS image and slide scanner

- Miscellaneous other equipment, such as SyQuest drives and a 28.8 modem to transmit files via the Internet for approval and distribution

Software
- Macromedia Director (Macintosh and Windows versions) for file authoring

- Adobe Photoshop and Illustrator for image creation, preparation and manipulation

- Macromedia SoundEdit Pro for sound editing

1 (facing page) The home screen for the Lollapalooza '94 interactive press kit. You not only get a listing of the bands that are covered, but a teaser that Green Day's "Mad Bomber" is included, as an added incentive to explore.

2 Note the "graffiti-esque" addition to this screen.

3 Keep in mind that at least part of the audience for this interactive press kit is retailers and media representatives—i.e., people who want to know if there's money to be made from this event. Thus, this quote is of particular interest to them.

4 What's to say? This is just a really cool screen for the Flaming Lips.

Media Logic

5 Another screen where the graphics say it all.

6 The site includes the "Green Day Mad Bomber," a game that allows users to "bomb" characters off the cover of one of Green Day's albums.

CHAPTER 7

Multimedia Pricing and Project Control

Multimedia demands a lot of skills, including graphic design, photography and videography. But it's probably cost estimating that's the most difficult skill for many creative people to acquire. In multimedia production (as with graphic design) strategic partnerships between strong creative types and equally strong business types is a very popular business model.

HOW DO YOU CHARGE FOR CREATIVITY?

The model for a multimedia production staff is comparable to that of a film or video production staff. This means, for one, that the producer manages the money while the director manages the people—the ideal division of labor. Of course in the real world, such pure division of labor seldom exists. Everyone has to be concerned about the financial as well as the creative picture.

The question, therefore, is how do you charge for creativity?

PRICING YOUR WORK

Time is at the heart of every practical pricing model. You have to charge for the time you spend on behalf of a client's project.

Our firm consulted several multimedia professionals and companies when we were first planning our original pricing model. The problem we encountered was that everyone priced jobs differently! Some companies had an hourly formula, but others didn't, and just estimated their prices based on what they thought the customer could pay—or on what competitive companies charged for similar projects. In other words, they let someone else do all of that meticulous work and, in effect, went with a market price.

It's OK to use a market price, or "benchmark pricing" at first, but at some point you will have to carefully analyze your own costs or you'll never know what you have to make for *you* to be profitable.

Cost Estimating: An Hourly Rate

In multimedia production, there are two kinds of time spent on behalf of a client:

1. *Think time:* Difficult to estimate and to be compensated for since many creatives think about a particular project all their waking hours.
2. *Task time:* Easier to estimate and

charge for because it represents specific actions required to complete a job.

This probably sounds impossible, especially to people with an aversion to numbers, but you actually can and must charge for creative think time. Hardie Interactive does it by breaking the process into individual and group creative sessions. Then we formulate a per-man-hour shop rate, multiply that by the number of hours spent in creative brainstorms and other creative sessions, and that figure is how much we charge for creativity.

You have to count not just actual hours spent, of course, but calculate how many people are spending those hours. For example, if five team members are brainstorming for one hour, the shop rate is multiplied times five for that hour.

To create an hourly shop rate, you need to factor in all of the typical doing-business data—salaries, overhead, desired margin of profit, etc. Basically, you need to come up with a rate per hour that will cover all your costs and provide you with a profit after all your expenses are paid. If you need some help in this area, your accountant is the best consultant to help you formulate an appropriate shop rate.

There are a number of different production tasks that also require creative thinking, but can be more easily defined by how much time will be required, e.g., interface design, button design, script writing, storyboarding, disk label design, animation and so on. A certain number of hours are budgeted for each of these creative tasks, *including an appropriate amount of time to think and plan before beginning*, then the number of hours is multiplied by the shop rate to cover the creative phase of the job.

It's All a Matter of Time

During the time estimating stage, everyone can join in the process of estimating how much time they need to do each task. This estimating can be, at times, the best example of artful negotiating, especially between the project leaders (producer, director, project manager) and the creative team.

If someone isn't immediately enthused about a project, or has difficulty visualizing the concept, it's a natural response for them to ask for more hours. Sometimes, that's all right. It's only when the team's lack of interest swells the project's projected time and/or cost budget to the detriment of the company's competitiveness that negotiation heats up.

Pricing Also Depends on the Project

If estimating the cost of a multimedia project was strictly based on calculating labor or shop hours, this process would be simple. However, would you price a project that will be mass-marketed to millions of customers, with the potential of generating huge revenues, the same as a one-time-only touch-screen kiosk for a small museum? Of course not. Sure, you would try to be competitive in your pricing for the mass-marketed project, but you might also build in a royalty agreement or a percentage of sales, because a project of large income potential has more intrinsic value.

One contractual question that has an influence on pricing is, "Who will ultimately own the intellectual property?" Do you sign over all of the reproduction rights to the client? If so, this should be spelled out in the contract, and the price of the product should reflect the transfer of ownership. Or you can negotiate a one-time or limited-use contract where you maintain ownership of your original design.

In multimedia you have the potential of producing a variety of extremely valuable intellectual property, including computer code, which can and should be copyrighted. At my studio, not a computer disk nor a single piece of paper goes out the door without a copyright symbol affixed to it.

SO WHAT ARE ALL OF YOUR COSTS?

Perhaps the best multimedia cost models are borrowed from the motion picture industry, which has similar production costs. In fact, with multimedia production, you may have all of the costs associated with a small motion picture, plus computer programming.

In the case of a film, you'll have a fairly comprehensive task list, including each and every cost, or "cost bucket" encountered in a production, from crew wages to set construction materials, from union dues to Panavision camera rental. They call them "cost buckets" because you're rarely looking at a fixed amount—instead, costs may rise or fall as you pour water from one bucket to another.

Your cost buckets are best managed by compiling them in a computer spreadsheet (Microsoft Excel or Lotus work equally well). Each of these cost buckets can then be assigned a cost code number, which will be used on your time sheets to determine how much time is actually being spent doing various tasks.

But before you track how much time you spend, you need to have estimates as to how much time you *should* be spending. The spread sheets you create can be used for cost estimating, and printouts of the blank forms can be used as very portable work sheets for drawing up preliminary cost estimates.

The example shown on pages

82-83 is an actual cost estimating worksheet that is used by Hardie Interactive.

AFTER COST ESTIMATING COMES COST CONTROLLING

In a truly integrated production team, *everyone* is responsible for cost controls. This is not some theoretical business hokum, but practical, workable operational management. Since most multimedia production companies are small businesses, everyone likely has a stake in the success of the business. When you have a stake, you care about costs.

TIME SHEETS

The most practical and effective way of controlling costs is to require (make that *inspire*) every team member to maintain a daily work diary. Call it a time sheet if you want.

A daily work diary should be extremely easy to maintain, and can even be computerized, but it certainly doesn't have to be. My own firm distributes simple time sheets on gummed tablets that team members carry everywhere, even into meetings.

I keep accurate track of my time, both productive (on behalf of client and internal projects) and non-productive (downtime due to repairs, for example).

The good time sheet contains five columns:

1. Time of Day: You can run each day's business hours in quarter hour increments down the left side of the page, then draw lines across the page to block off chunks of time.

2. Client Name: If it's an internal project, by all means put down your own company or department.

3. Project Number: This corresponds to the accounting program that will help compile the progress report and invoice.

4. Task Number: A three-digit code should be assigned to describe every possible task associated with a project. Codes will be assigned to tasks that are directly productive (audio mixing, graphics search, graphic production, storyboarding, etc.) and tasks that are necessary to the project, but not directly productive (creative meeting for a proposal, for example). This way, creative think time is covered, as well as task time.

5. Description of Work: Tell what was done in plain language. The data captured from the team members is collected on a daily basis, and entered into a cost management spreadsheet program. The spreadsheet is formatted to accept the three-digit codes and, of course, the hour totals. Then, on demand at any time during the course of the project, an hour-by-hour summary can be printed and reviewed to see how much progress has been made, and what areas of work are taking the most time.

Where Is Your Time Going?

This is not information you share with a client, but it needs to be shared with team members so they will know how they're doing. As you analyze the data, warning signals may begin to appear: "Uh-oh, we're going over estimated hours on the animation!" Or you may read good news between the lines: "We have graphic production hours to spare since we bought that new, faster scanner last month!"

With this data, you can plan better, estimate your proposals better and operate your creative company on facts rather than assumptions.

MAINTAINING CONTROL OF MULTIPLE PROJECTS

How do you handle multiple projects? As you become more successful, you will no doubt have the opportunity to do more than one project at a time.

What Does Multimedia Cost?

In negotiating with clients, the pressure is intense to simplify or standardize the pricing of multimedia, but doing so is very difficult. For example, you will often get questions like, "How much for a thirty-second animation?" or "How much for a program with only three levels of interactivity and twelve film clips?" Such questions are difficult to answer, because multimedia—like advertising or graphic design—is not just a product, but a service where each product is tailor-made for each customer.

The fastest growing segment of the multimedia market is custom multimedia business applications. What's exasperating about this market is that many clients have yet to be acclimated to the price of the technology. They may have a difficult time grasping the cost/benefit scenarios we so artfully devise, and, quite frankly, multimedia producers often do a less than exemplary job of selling multimedia.

One Midwest multimedia studio noted that customers whose experience in budgeting creative projects was no more sophisticated than a slide show or brochure had more difficulty adjusting to the price of multimedia, even though multimedia is proven to be extremely effective in transferring information. However, clients who had engaged in professional video production were a lot closer to understanding the costs associated with multimedia, and, subsequently, price was less of an issue. ∎

MULTIMEDIA PROJECT COST ESTIMATING WORKSHEET

Job Estimate	Design	Shop Hrs. Est.	Shop Hrs. Actual	Shop Cost Est.	Shop Cost Actual	Shop Sell Price	Outside Est.	Outside Actual	Total Sell Price Est.	Total Sell Price Actual
Client:										
Address:	101 Needs Analysis									
	102 First Meeting/Research/Concept/Treatment									
	103 Instructional Design/Subect Matter Expert									
Phone:	104 Information Mapping									
Job Project #:	105 Scriptwriting (includes one revision)									
Date Initiated:	106 Script Rewrite									
Est. Due Date:	107 Interface Design									
Staff:	108 Storyboard Design/Production									
	109 Client Meetings/Client Approval									
	110 Production Planning									
	111 Graphics Search/Design									
	112 File Management									
	113 Music Selection/Composition/Sound Effects									
	114 Auditioning/Talent Selection									
	115 Location Scouting									
	116 Program Authoring									
	117 Project Design Document									
	118 Other (specify)									
	Production	Shop Hrs. Est.	Shop Hrs. Actual	Shop Cost Est.	Shop Cost Actual	Shop Sell Price	Outside Est.	Outside Actual	Total Sell Price Est.	Total Sell Price Actual
	201 Sound Work									
	202 Still Photography/Slide Work									
	203 File Management									
	204 Graphics Production/Scanning									
	205 Program Authoring									
	206 Animation/Rendering									
	207 Producer/Director									
	208 Asst. Dir./Tech. Dir./Prod. Asst.									
	209 Camera Operator									
	210 Lighting Director									
	211 Gaffer/Grip									
	212 Equipment Packing/Shipping/Receiving									
	213 Non-Linear Editing									

If you think of your projects as single, separate events to be done in a linear fashion from start to finish, and then on to the next one, you are limiting your growth and capabilities. If you are running a tight ship and have a good work process in place that everyone is comfortable with, you should be able to do several projects simultaneously. This will keep your team working on projects continuously. If the workload becomes too much to handle, you can always expand your staff.

Once again, you must think and plan strategically for the eventuality that you will be successful and grow. I once took a small-business administration course, and the lesson that sticks in my mind twenty-five years later is the following: "It's not a lack of business that causes many businesses to fail. It's an inability to handle growth."

For one team to handle multiple projects doesn't necessarily put additional strain on the creative and production team members. Down-time on one project just becomes time to work on another project. But multiple projects will certainly put stress on the project manager and administrative assistant; they will have a lot more balls to keep in the air. In fact, if and when you eventually confront staff growth issues to deal with the increase in multimedia sales, the most logical new staff member is another project manager.

The Nitty Gritty of Project Management

I've had the opportunity to confer with several multimedia producers, and all of them handle multiple projects differently. Some use those big porcelain marker boards with all of the little boxes on them—a low-tech solution to manage a high-tech process. Then there are those who rely on any one of the computer-based project management software programs on the market. Programs like MacProject and Microsoft Project are robust entries in the arena, but the problem with software project managers has been that they make you conform your work style to accommodate the software. Yes, the manuals tell you how intuitive, flexible and customizable they are, but the learning curve is generally steep, and the software requires a tremendous amount of work inputting, inputting, inputting data. It can be exhausting. Several well-meaning managers have purchased project manager software only to put it back in the box and go back to their marker boards.

Try Using a Day Planner

Another option is one of those full-sized Franklin Planners: those personal planning books in which you document every occurrence in your life, your goals, your appointments and your vital medical data. This is a system I can actually recommend. The success of the Franklin Planner is not just a specific format (any planner will work if you know how

MULTIMEDIA PROJECT COST ESTIMATING WORKSHEET

Job Estimate Pg 2		Production (continued)	Shop Hrs. Est.	Shop Hrs. Actual	Shop Cost Est.	Shop Cost Actual.	Shop Sell Price	Outside Est.	Outside Actual	Total Sell Price Est.	Total Sell Price Actual
	214	Printing to Tape									
	215	Outside Post Facility/Special Effects									
	216	Audio Mix/Edit									
	217	Credits/Graphics									
	218	Supplemental Materials									
	219	De-Bugging									
	220	Packaging									
	221	Revision									
	222	Other (specify)									
		Support	Shop Hrs. Est.	Shop Hrs. Actual	Shop Cost Est.	Shop Hrs. Actual	Shop Sell Price	Outside Est.	Outside Actual	Total Sell Price Est.	Total Sell Price Actual
	600	Engineering/Production Support									
	700	Presentation Activity									
	800	General Support									
	900	Administration									
	910	Other (Specify)									
		Total									

to use it), but the time management philosophy behind it.

A day planner can be a task tracker, but it's also a tremendous documenter of details such as phone numbers and conversations, and all of those little notes that quickly begin to accumulate around every project. If the book accompanies you to every meeting, every event, everywhere you go, you will never again find yourself looking for a piece of paper or a misplaced note. That's control!

More Than One Person Needs to Know the System

No matter how good your production manager is, and no matter how good the management system, one resourceful and conscientious team member is not enough for your production management needs. If you were to overly depend on one person's system, what would happen if that person were to suddenly leave the team? Would your system remain intact?

You need to have a production tracking procedure that can be managed by more than one person. It's of strategic importance to your organization to have a system in place that can survive catastrophes. Such a system is like your tape backup system that protects your work at the end of every day.

Creating a solid production management plan is something you as a team must devise and tailor to your organization's culture. It can and will evolve as you acquire more experience and more projects. Hopefully, your growth will be well-managed, and you'll find yourself doing more of what you really got into this business to do—create really neat multimedia!

A Cost Estimating Worksheet

Before you track how much time you're *actually* spending on each task, you'll want to make reasonable estimates about how much time you *should* be spending.

MetaDesign

MetaDesign

Design as an Intellectual Process

The staff at MetaDesign

MetaDesign is a multi-disciplinary design firm with offices in San Francisco, Berlin and London, with a combined staff of over 120 designers, technologists, planners and implementation specialists. The company is committed to the idea that design is primarily an intellectual process. "We like to think about our projects before we decide how they're going to look," says Meta-Design's partner and team leader Bill Hill. "But we also know that to communicate an idea we need to give it an exciting and innovative visual language."

MetaDesign San Francisco opened for business in 1992 under partners Bill Hill and Terry Irwin. Since then, they have pursued their philosophy of using a collaborative, hands-on approach with a mix of traditional and new media design projects. ★

VizAbility: Teaching Students to Be Visual Thinkers

MetaDesign

Visualize this: A program originally developed for college-level engineering, mathematics and computer science students becomes a success with high school kids and teachers as well as with management and group training seminars. MetaDesign's Bill Hill, executive producer of VizAbility, explains that it was a challenge to develop a multimedia product designed to encourage one's natural visual abilities.

"It was not just a product to teach drawing," says Bill, "but rather to open the possibilities for invention by introducing the user to the environment and culture of visual thinkers via audio/video interviews and visits with a product design

engineer, a second grade teacher, a scientist and a multimedia developer." The CD-ROM is actually part of an entire learning kit that also contains a handbook and a blank sketchbook.

The CD-ROM was built in two stages. The first stage included fairly extensive prototyping in Apple HyperCard and an earlier version of Macromedia Director. In the second stage, the prototyping was finished in Director 4.04. (Director was chosen for its compatibility with both Mac and Windows platforms.)

Faced with Director's steep learning curve, MetaDesign began by generating basic screens in Adobe Illustrator and Photoshop, leaving scripting to expert programmers brought in from outside. ★

1 The sections of the program are depicted in the main menu with both pictures and titles. There are also navigation buttons that take you to the program's introduction or to an orientation.

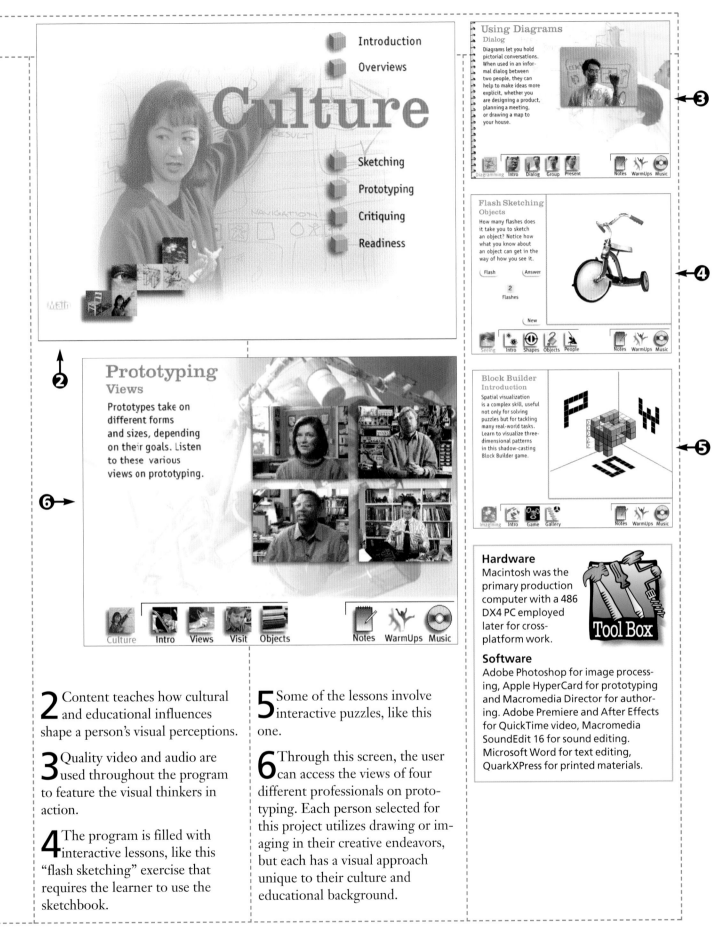

Introduction

Overviews

Culture

Sketching

Prototyping

Critiquing

Readiness

Main

Using Diagrams
Dialog

Diagrams let you hold pictorial conversations. When used in an informal dialog between two people, they can help to make ideas more explicit, whether you are designing a product, planning a meeting, or drawing a map to your house.

Diagramming Intro Dialog Group Present Notes WarmUps Music

Flash Sketching
Objects

How many flashes does it take you to sketch an object? Notice how what you know about an object can get in the way of how you see it.

Flash Answer
 2
 Flashes
 New

Seeing Intro Shapes Objects People Notes WarmUps Music

Block Builder
Introduction

Spatial visualization is a complex skill, useful not only for solving puzzles but for tackling many real-world tasks. Learn to visualize three-dimensional patterns in this shadow-casting Block Builder game.

Imagining Intro Game Gallery Notes WarmUps Music

Prototyping
Views

Prototypes take on different forms and sizes, depending on their goals. Listen to these various views on prototyping.

Culture Intro Views Visit Objects Notes WarmUps Music

Hardware
Macintosh was the primary production computer with a 486 DX4 PC employed later for cross-platform work.

Tool Box

Software
Adobe Photoshop for image processing, Apple HyperCard for prototyping and Macromedia Director for authoring. Adobe Premiere and After Effects for QuickTime video, Macromedia SoundEdit 16 for sound editing. Microsoft Word for text editing, QuarkXPress for printed materials.

2 Content teaches how cultural and educational influences shape a person's visual perceptions.

3 Quality video and audio are used throughout the program to feature the visual thinkers in action.

4 The program is filled with interactive lessons, like this "flash sketching" exercise that requires the learner to use the sketchbook.

5 Some of the lessons involve interactive puzzles, like this one.

6 Through this screen, the user can access the views of four different professionals on prototyping. Each person selected for this project utilizes drawing or imaging in their creative endeavors, but each has a visual approach unique to their culture and educational background.

ProFile

Susan E. Metros

Media Designer/Educator

"If you want to learn something—try to teach it," says Susan Metros. "Nobody learns as much as the teacher!" Although she has worked in the industry as everything from a sketch artist for a Styrofoam cup factory to an art director for an international trade association, Susan's heart and soul is in teaching. She is currently a professor of art at the University of Tennessee in Knoxville, where she also works as a faculty associate for the campus computing center.

Susan began her teaching career at Michigan State University in 1980, then migrated south in 1984 to enjoy the warm climate, the mountains and the opportunity to build a computer-enhanced design program for the University of Tennessee's Department of Art. Today, the school offers both an undergraduate and a graduate degree in a program that stresses concept over product, and creative thinking over pure craft. The program has grown to include courses in desktop publishing, digital photography and typography, multimedia design, design for cyberspace and even a course titled, "The Book and Beyond," which combines the traditional methods of printmaking with new electronic media.

Susan has been invited to serve as a visiting scholar and lecturer across the United States, Europe and Australia; she also consults with education, industry, business and the government on issues concerning

Susan E. Metros

graphic design, creative problem solving and interactive multimedia.

"When in Australia, I primarily work with the Interactive Multimedia Lab at the University of Wollongong as their principal graphic designer. I'm part of a multidisciplinary team creating educational CD-ROM titles," explains Susan, who designed the screens for the award-winning "Investigating Lake Iluka."

"My most recent interactive multimedia CD-ROM, 'Good Daughter, Bad Mother, Good Mother, Bad Daughter: Catharsis and Continuum,' I consider to be a work of art and, hence, I offer it for purchase only as a signed and numbered limited edition pressing. Currently, I am working on a website that will describe my eighty-five-year-old father's life as a soldier during World War II. I am working with him to augment his vast collection of wartime snapshots with a personal narration." ★

CD-ROM

Good Daughter, Bad Mother, Good Mother, Bad Daughter: Catharsis and Continuum

Susan Metros

For Susan Metros, multimedia is more than just an educational tool. In "Good Daughter, Bad Mother, Good Mother, Bad Daughter," the medium is transformed into a highly personal work of artistic self-expression.

As Susan explains, "My mother died suddenly of a heart attack in 1993. To work through my grief, I chose to explore our relationship using interactive multimedia. Like many mothers and daughters, our relationship was volatile in nature and ran the gamut from love to hate. I used an image of a closed locket (given to me by my mother) as the introductory image to reinforce the concept that the viewer is entering a personal and private space.

"A typographic main menu provides choices between seven sets of polarities that bound our mother/daughter relationship: I loved her/I hated her, She had faith in me/She smothered me, She was proud of me/I never could please her, I could confide in her/She didn't understand me, Generous/Tightfisted, Selfless/Self-centered and I wished she would die/I want her to live forever."

This award-winning CD-ROM incorporates thirty-five years of diary and journal entries, correspondence, collected quotes, family photos, home movies and videos. To complete this project, Susan reveals, she worked alone over the course of one summer and spent about $1,500, including the purchase of a flatbed scanner.

"Good Daughter, Bad Mother, Good Mother, Bad Daughter" was first shown at the Faculty Art Show at the Ewing Gallery at The University of Tennessee, and has since been exhibited at the SIGGRAPH 95 Art Gallery in Los Angeles, and at media shows and festivals across Australia and Europe. ★

1 Button navigation is underplayed to emphasize the more artistic elements, and also to operate more efficiently in a public kiosk environment. Some of the screen navigation is non-linear; sometimes a snapshot, a sound or an old 8-mm home movie clip is triggered by simply rolling the mouse over a live area.

2 The QuickTime movies are silent and flicker in an uneven frame, like the Super-8 movies that they are derived from. They are composed of snippets from an early 1950s Thanksgiving dinner, a beach holiday, Susan's mother holding her when she was a newborn, Susan chasing after her mother up the stairs of a summer cottage.

3 Graphics include personal photographs, her mother's death certificate, a 1964 written reply from Ann Landers, the hospital's plastic bag containing her mother's personal effects, a letter from a stranger who comforted Susan on the airplane ride to her mother's funeral, and her mother's grave marker.

4 The look and feel of the interface is based on the actual handwriting from Susan's diaries and journals. In this way, the text is used as both an aesthetic and a contextual element.

5 This screen shows excerpts from a 1978 letter. Sounds throughout the piece include a baby's incessant crying, a whisper of "please get well," a ringing telephone, a heart monitor, the admonishments of a "Jewish mother" and Susan's father reciting the Kaddish prayer for the dead.

① ② ③ ④ ⑤

Hardware
The work was developed and produced on a Macintosh Quadra 800 with 24MB of RAM. Images and other materials were digitally inputted using a Mirror Technologies, Inc. 300 dpi flatbed scanner and an Apple QuickTake Camera.

Software
Apple Media Tool for authoring, Adobe Photoshop for image processing, Adobe Premiere for QuickTime video, Macromedia SoundEdit 16 for sound editing, Adobe Fetch for image database organization.

CD-ROM

Investigating Lake Iluka: Exploring a Coastal Lake Environment

Susan E. Metros

Susan Metros

The graphic design concept for this project was developed by Susan Metros working with a team from the multimedia lab at the University of Wollongong, Australia. "Investigating Lake Iluka," which simulates a coastal lake environment, complete with four ecosystems, is designed to support the teaching of ecology within a secondary-level biology curriculum. What makes "Investigating Lake Iluka" so illuminating is its level of interactivity and student engagement.

The student measures, records, analyzes, interprets, evaluates and presents data in order to explore ecological relationships. Additional information about Lake Iluka may be gathered from online databases, online illustrated reference books, newspaper clippings, audio clips simulating radio news reports and QuickTime television news broadcasts, and informational video clips. The student can enter information by keyboard or copy it from this wealth of resources and paste it directly into a personalized notebook that ultimately serves as the basis for individualized reports.

This CD-ROM was originally designed for senior high school students, but is also appropriate for junior high school grades studying

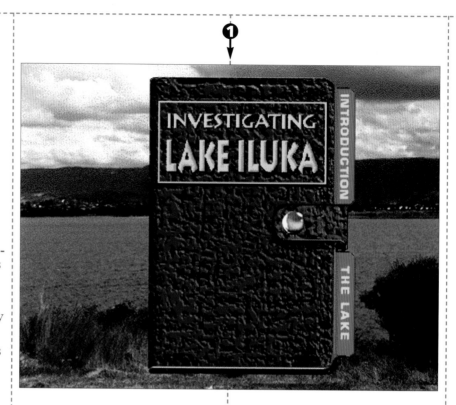

ecology or mass media. "Lake Iluka" was originally intended for an Australian audience, but has been distributed successfully worldwide. The program was selected by Apple Computer, Inc. to be included in the Macintosh LC 520 Secondary School Bundle for Australia, and the High School Biology Bundle for the USA. It was awarded the 1994 Best Educational Software Award by the Australian Interactive Multimedia Industry Association, first place in the "Computer Software" category and Premier Award for the Most Innovative Product by the Australian Society for Educational Technology in 1994. ★

1 The opening screen of "Investigating Lake Iluka."

2 This is the main navigational screen from which you can explore the lake, rummage through your testing gear or adjourn to your research center. Buttons are large and clear, and the navigation panel stays in the lower right-hand corner of the screen throughout.

3 The notebook is a powerful feature. It lets you take your own research notes, and it even plays video clips.

4 News clippings reveal some of the problems Lake Iluka has experienced over the years.

5 This pop-up lab kit contains a light meter to help measure the atmospheric pollution. This screen also shows the notebook being used to take notes.

6 This screen is actually a complete, online reference library, including reference books on animals and plants. Virtually everything in this room is clickable and useable. For example, if you click on video tapes, you have a choice of several videos; you can select and play one in the VCR.

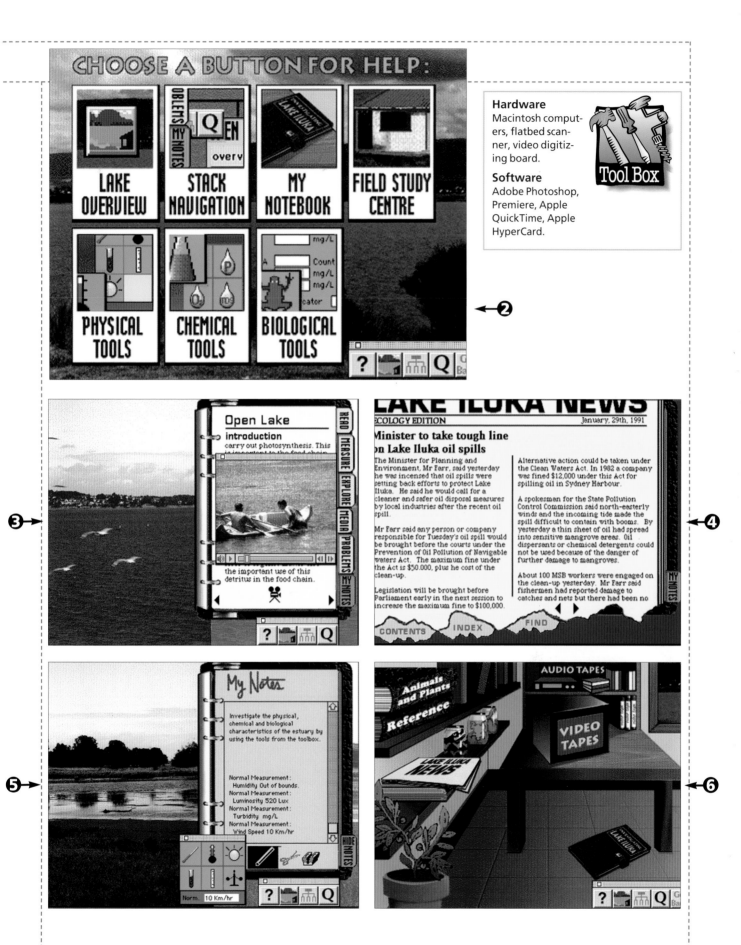

CHAPTER 8
Information Design

IN THIS CHAPTER YOU WILL LEARN:

- Two strategies for transferring information to the user: direct access and random access
- The four kinds of multimedia applications and information design strategies for each
- What conventions are used in information mapping: including radial branching, linear branching and linking
- How to establish your list of learning objectives
- How to provide functionality and control for all your program users: beginners, intermediate and advanced users
- What types of feedback to provide—and when to provide it
- Four guidelines for button design
- What a sample portion of a typical author-ready narrative looks like
- How to prepare storyboards
- How to select an appropriate design metaphor
- The importance of color palette management
- Key objectives of the alpha prototype

When you turn on a computer in a really quiet room, you notice the most peculiar sounds emanating from the machine: boop, boop, booop, click, click, clickety, click, click, boop, boop, booooop. The hard drive hums and the little green disk activity light blinks. Every time I turn my machine on, it reminds me that this device is merely a mechanical contrivance—a very sophisticated one, but a machine just the same.

But when I gently slide the CD-ROM into its tray, and begin making my way through the award-winning *Passage to Viet Nam* with Mike Smolan and his team of Day-in-a-Life photographers, I'm not sitting in front of a computer anymore. I'm in Vietnam. The program is so compelling, the images so beguiling, the sounds so hauntingly clear and otherworldly, I forget I'm at a computer.

In designing multimedia, your objective is to transfer information and make the experience so intuitive and so compelling that the user forgets a machine is involved. Let's start with one of your most basic considerations.

TRANSFERRING INFORMATION

There are two basic information design strategies an interactive project can take: direct access and random access.

Direct access is the simplest form of interactive design with the fewest navigational steps. A program consists of a home screen with all further screen choices branching directly from that screen. The user makes a choice and navigates to the appropriate next screen. Once the information is absorbed, the user can only return to the home screen.

One variation is a program with a home screen the user never leaves— information (text, pictures or videos) is brought right to the home screen in a viewing window. A simple catalog program might use this format.

Random access is a more complex form of interactive design, in which the user can navigate virtually anywhere within the program to access information in whatever order he chooses. Links are provided throughout the material to connect information and provide the user with the power to navigate at will without necessarily returning to a home screen.

Because information is absorbed

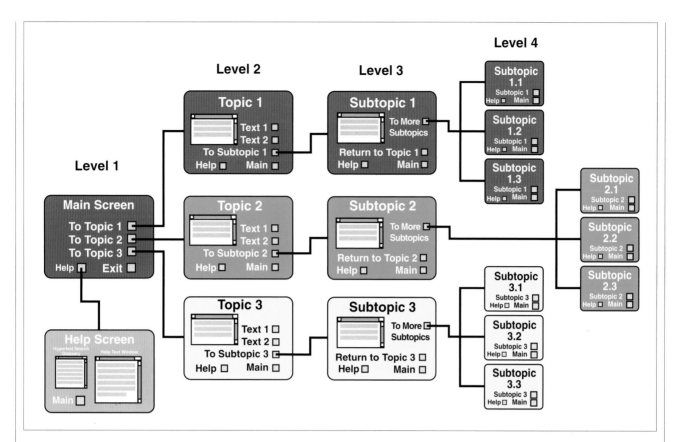

The diagram shows a hierarchical information map with four levels:

Level 1 — Main Screen: To Topic 1, To Topic 2, To Topic 3, Help, Exit. Help Screen (Hypertext Search, Glossary, Help Text Window, Main).

Level 2 — Topic 1, Topic 2, Topic 3, each with Text 1, Text 2, To Subtopic, Help, Main.

Level 3 — Subtopic 1, Subtopic 2, Subtopic 3, each with To More Subtopics, Return to Topic, Help, Main.

Level 4 — Subtopic 1.1, 1.2, 1.3; Subtopic 2.1, 2.2, 2.3; Subtopic 3.1, 3.2, 3.3, each with Help and Main.

selectively at one's own pace and via one's own path, no two people navigate through the program the same way or at the same speed.

Which Design Strategy Should You Choose?

Direct access, is best used in cases where the user may have limited time to obtain information, and wants a simple way to access it. For example, it would be the best choice for a touchscreen kiosk in an airport used by arriving passengers to determine the best mode of ground transportation from the terminal to area hotels.

"Which bus takes me to my hotel? Where do I catch it and how much does it cost?" are questions that should be answered in one touch. An appropriate information architecture for a kiosk of this type would be a radial map with a single level of interactivity radiating from the home screen. If there are six pieces of information radiating

from the screen, there are six buttons on the screen, each plainly labeled (Bus Stops, Cab Stands, Train Stations, Shuttle Buses, Hotel Livery, Rapid Transit).

On the other hand, for people on lengthy layovers hanging out in the airline's preferred passenger club, you might provide a touchscreen kiosk tour of great restaurants and nightclubs in the area. This is random access.

The program in this kiosk could contain access to video clips of local chefs in their kitchens—actually preparing dishes while they talk. While you are listening to the chef, a button labeled "Review the Menu" appears next to the video window. You touch it and see the restaurant's complete menu and prices! Even though you are on this menu screen, you have access to a city map where you can see the locations of other restaurants in that part of town. At the map, you press on a particular street, and a pop-up

Information Map With Four Levels of Interactivity

Information maps can become extremely complex, and the user will become impatient if lost in the maze. One solution is to provide buttons to return to a main menu or help screen from wherever the user is in the program. No matter how deep users go, they're always just a single click away from the main menu. Anytime you can reduce user navigation steps back home, you speed their productivity and the program's functionality.

Radial Branching
Radial branching provides access to all second-level screens directly from the home screen.

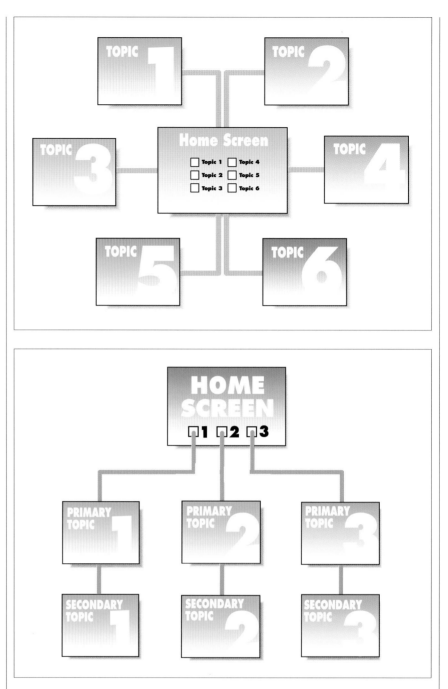

Linear Branching
Linear branching provides the user with three or more levels of interactivity—each level accessible from the previous level.

list of restaurants appears for that district. You touch one and you are now looking at a different menu. The button, "How to Get There" prints out a map, address and phone number. An interactive restaurant guide is a perfect subject for a random access information design strategy.

Types of Information Maps
• Radial Branching Maps: In a radial information structure, the

user has a single home screen that displays several individual choices in the form of buttons, and the user navigates to one choice at a time. He can only return to the home screen to make another choice. This is single level interactivity (see illustration on top of page).
• Linear Branching Maps: A linear information structure features multiple levels of interactivity but information is organized in straight lines where the user navigates from a

home screen to a series of screens. These screens are labeled topics, and sub-topics (see illustration above).
• Linked Information Maps—A linking or non-linear branching structure: Random access interactive designs are more complex and are required to make sense out of larger amounts of information. This information must be grouped into logical sections. The user is given the navigational tools to go any-

where in the program he chooses. Information linking can be employed using a variety of strategies including anything from ordinary buttons to hyperlinked text, which is the popular strategy for designing interactivity on the Web (illustration, page 94).

In non-linear information structures, it becomes crucial to have a robust navigational panel that is consistent throughout the program. In other words, the buttons look the same and appear in the same location on every screen, making for a productive human interface.

There really is no limit to the number of levels you can provide, but it's advisable to provide shortcuts back to the first level (home screen). If the user must navigate backward, as with linear branching, through screens already covered, your program becomes tedious and the user can become lost.

To summarize the two ways to organize information:

1. Direct access interactive information structures include linear or radial information maps.

2. Non-linear, random access enables you to manage large amounts of information by providing the user with various entry points or jumping off points within the program to other information without requiring him to return to the home screen.

How to Select the Best Information Structure

After you've established your solid information objectives, you can begin designing your information map. It's a road-map or organizational chart . . . a visual representation of which screens are provided at each level and what paths of navigation are available to connect these screens. Try to envision your information in physical terms: Imagine a

The Customer Is Always Right

Hardie Interactive prepared a presentation package for a technology firm in the health care field. When the client came to us, he was using a slide show that was extremely successful for him; he showed it on a notebook computer for audiences of one to a hundred people by merely attaching it to a VGA projector. It was strictly linear, one slide after another, with no animation, no videos, all prepared in Microsoft PowerPoint. Our job was to repurpose the program into a multimedia experience complete with interactivity, random access to information and video clips of company representatives telling their own stories at appropriate points in the presentation.

When we completed the alpha test to show the client, his apprehension was apparent. "Why all of these buttons?" he asked. "Can't I have just one button and cycle through the information one slide after another?"

"Well, that wasn't the original idea," we said. "This is *interactive* multimedia where the user is free to navigate anywhere he pleases."

"But that will mean they may miss critical information," he worried. "And besides, our first objective is to show this program at a trade show with me in command of the program."

"Eventually, you will want to create this material as a stand-alone product to be distributed to your customer prospects, correct?"

"Yes."

"Well, what if we develop for both applications . . . linear presentation and interactive random access?"

"You can do that?"

"Yes," we replied, "and we might even go one better: a version of the program that runs by itself."

Just how were we able to do this? Our authoring software, Macromedia Director, allowed us complete flexibility to produce three different programs on one CD-ROM. In the introduction of the program we provided three buttons:

1. Linear: This allowed the salesperson (or any other user) to run the program like a slide show . . . click the mouse button and the next view appeared.
2. Non-linear interactive: This allowed the user to access the information randomly. Navigation buttons were added to the screen for this version.
3. Automatic: One click of the button and the program took off like a video.

The customer was delighted with the notion that he got three programs for roughly the price of one. From the developer's point of view, the customer's fears were turned into an opportunity for us to exceed his expectations. Finally, the program benefited from choices that literally empowered the user. It raised the program's comfort level by providing for all three types of user: beginner, intermediate and advanced. ■

Linking or Non-Linear Branching

Linking, or non-linear branching, provides access to various locations in the program without requiring the user to navigate back to the home screen (or an earlier level) first.

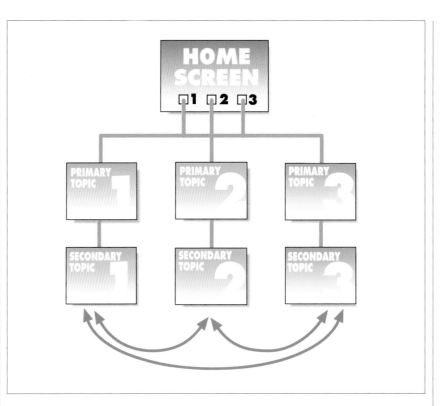

three-dimensional space, as if you were a in multistoried warehouse, with your information in boxes piled on every floor. You can explore your inventory floor-by-floor by using a conveniently placed elevator. No matter where you are in the maze of boxes and floors, you have a button at your disposal to return you to the ground floor (the home screen) or to leave the warehouse completely (quit).

In the illustration on page 91, you can see a typical information map for a program with four levels of interaction. There are several conventions by which these levels are labeled and navigated. For example, the Home Screen is always your first level of interaction. You can leave this screen by pressing a button, which allows you to navigate to the next level (Level 2). You can also see that each button represents a pathway to another level.

THE FOUR CATEGORIES OF INTERACTIVE PROGRAMS

There are four categories of interactive programs: presentations, catalogs, games and computer-based training. The following are thorough descriptions defining each category. Your information, audience and project goals help determine the most appropriate design model.

1. Presentations: At its core, the interactive presentation is show-and-tell. Marketing and sales presentations fall squarely into this category. You have information to convey or a story to tell; user input is less than with other applications. Material can be presented in a linear or non-linear fashion, using either direct or random access.

Like computer-based training programs, interactive presentations are really learning experiences for the user. So, if you're preparing an interactive marketing presentation, you might want to borrow some strategies from computer-based training (see page 95). But since the audience is under no obligation to absorb anything, and may not be highly motivated, you must make the material memorable, entertain-ing and, most important of all, simple to operate.

An information map for a presentation-style interactive segment is shown on page 95.

2. Catalogs: A catalog format is perfect for a direct access information design. For instance, you might design a single home screen with a single set of navigational tools, a display window and text windows. Without ever leaving the home screen, users could import product specifications and prices, calling them in from the appropriate database files.

The two distinctive characteristics found in an interactive catalog are:

A. A search engine: A software code that enables the user to access information—in the form of text, images or videos—from a text field or hypertext-linked index. A large index could be presented as a scrolling field of choices the user can select from. As a choice is made, the image and text data for that choice are retrieved and displayed

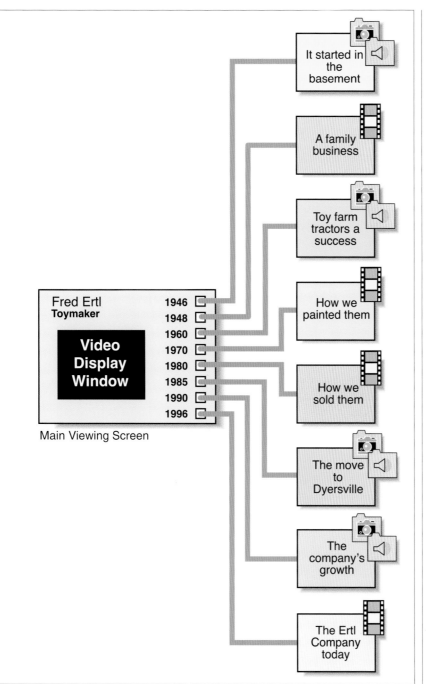

Fred Ertl
Toymaker

Video Display Window

Main Viewing Screen

1946
1948
1960
1970
1980
1985
1990
1996

It started in the basement

A family business

Toy farm tractors a success

How we painted them

How we sold them

The move to Dyersville

The company's growth

The Ertl Company today

Information Map for The Ertl Company

This is a presentation-style interactive segment. The assets on the right are not separate screens, but represent images that will display in the window of the main screen. Icons have been added to the information map symbolizing video clips or still images to be displayed.

in the designated viewing areas of the screen.

B. A transaction component: Consumer merchandise and business-to-business catalogs benefit from providing the user with the tool to actually select and buy items (this is often referred to as a shopping cart). It's always been my opinion that an electronic catalog is, at its best, a virtual store, always ready to do business, make a sale, and

collect and deposit the remittance. Catalogs on the Internet are always ready to make a transaction online. But on a CD-ROM, you must include a programming hook to an online service or an Internet server that can process the order with the touch of a button. You can build these software components from scratch, or even better, you can obtain them from an Internet or online service provider to include

on your CD-ROM. Ideally, it shouldn't cost you a penny to include this on your disk since the online provider is adding to his "community." But if there are big-money transactions anticipated that could seriously put a load on the provider's server, a percentage of gross sales might have to be factored into the equation in exchange for the service provided.

3. Computer-Based Training (CBT):

Reality Check

Guidelines for Button Design

• Buttons should be big enough to see and easy to click on . . . not too small (or it will be hard to position the cursor) and not too large (or they will take up valuable screen real estate).

• Icons or graphics that appear to hover just above the screen (with those soft drop shadows) better be buttons. Computer users have come to expect buttons when they see icons that hover. If the user clicks on one and nothing happens, he'll think the program is frozen.

• On-screen buttons should provide some visual or audible feedback when the user touches them. As you press a button, you might hear a click, or else the button should detent or change color.

• It's a good strategy to locate your navigational tools in one section of the screen, and keep them there throughout the entire program. This is called the *navigational bar* technique. Providing a consistent location for buttons allows the user to become more productive and gain speed with continued use of your program. It really doesn't matter where you locate your navigational bar, as long as its position is consistent from screen to screen. ■

Computer-based training covers any application that provides a very specific learning agenda for the user. Information is absorbed at the user's own pace, as he advances through new levels of information only after mastering previous levels, thereby qualifying that learning has taken place. There are two charac-teristics that distinguish computer-based training:

A. Simulation of real-life events: The ability to simulate real-life events is one thing that makes computer-based training so valuable. Consider programs used by doctors or pilots in training. Simulation is a risk-free way to learn; mistakes can be made, but they aren't fatal.

B. Scoring: True CBT programs will include the ability to record user responses and measure user progress.

4. Computer Games: Computer games are the parents of today's multimedia industry, and computer gaming continues to add fuel to the popularity of computers. One wry industry observer has said that all computer-based multimedia is in reality computer games. "You provide a graphical environment in which to navigate, you require the user to manipulate a mouse, which requires some dexterity, and you have a game. It's unavoidable."

There are many types of computer games, but most fall into five basic categories:

A. Twitch games. These are games requiring eye/hand coordination, such as the popular "Doom," in which you explore a treacherous environment of bad guys, and it's kill or be killed.

B. Simulation games (or games of skill). These include flight simulation and driving skill games, as well as games that simulate running and jumping.

C. Quiz or puzzle games.

D. Exploration games. Games involving navigation and discovery, with some elements of quiz and puzzle games. Some examples are "Myst," "The Seventh Guest" and "Where in the World is Carmen San Diego?"

E. Intelligent agent games. Intelligent agent games are evolving as computers become more powerful and programming more advanced. This is interactive simulation at its most sophisticated level. You play a role, become a character and interact with other characters in the game environment. The key to intelligent agent games is that the computer-generated characters increase in intelligence as you interact with them. They watch and remember your moves, respond to your input, and change their personalities and actions to complement or contrast with yours. As you grow in intelligence playing the game, your enemies and allies become smarter, too.

The objective is simple for the computer game designer: *Extended play value.* As the user becomes proficient, the game should become more challenging. Every budding multimedia designer can learn something from playing computer games of all types.

Also, note the similarities between games and CBT: Both types of programs transfer skills to the user during the course of "play." It might be wise to consider aspects of game design in your development of CBT as well as presentation projects.

START WITH A LIST OF LEARNING OBJECTIVES

Writing down a clear list of learning objectives is the most logical place to start your information design. Decide what you want your user to learn from the program. One should be as specific and quantifiable as possible in establishing information or learning objectives. For example, an unacceptable objective for a CBT program might read:

"Using this program, the user will know how to deal with customer complaints."

The term "will know" is vague

and subjective. How and what will they know? And what kind and how many different customer complaints are we going to cover? Furthermore, how will everyone associated with producing this product know precisely what information we want to convey?

Here's the same objective, but with more specificity:

"The user is provided with five of the most acceptable ways to manage the four most prevalent customer complaints in our business. Included are five tips on how to turn complaining customers into valuable opportunities for information gathering and positive customer outcomes."

FUNCTIONALITY

In writing a book, producing a film or telling a story, the author, director or storyteller, respectively, are in control of events as they unfold. But in interactive multimedia, the user is in charge. The user is given control and, in fact, demands control. If you deny or limit control, you are effectively turning an interactive experience into a passive one, and that won't fly with the user.

Give the User Control of the Program

In designing interactive information, the three most important things to consider are: the user, the user and the user. Specifically:

1. The Beginning User: Although it's less likely today than it was just a few years ago, this may be someone who has never touched a computer before. For this user, you need to make sure your program's navigational tools are intuitive. Is this a button or is it just text in a box? If I press the button and nothing happens, does that mean the program is frozen?

The interactivity shouldn't be too complex—you don't want to place any obstacles between the user and the information. For this user, you may want to limit the number of interactive levels you provide to three, tops. Also, make sure the user can navigate the program without formal instruction, a tutorial or (worse) a book nearby.

The beginning user likes step-by-step navigation. Direct access is preferred to random access. Your program should be explicit or obvious in its organization of content, navigational tools and pathways. Finally, you must provide feedback for moves the user makes in the program.

2. The Intermediate User: This user is not an expert, but will be insulted if the program is too basic. The key to appealing to this user is flexibility. Provide some basic, entry-level aids (like a Help button, a guide map or an introductory video clip), but also provide a way of bypassing the basic stuff. This is particularly important for programs that will be accessed more than once, such as a CD-ROM presentation, resource or catalog application. Don't make users sit through a lengthy introductory video without a skip switch. In a phrase, provide the intermediate user with *random access*—the ability to skip ahead or go anywhere in the program they might want to go.

3. The Advanced User: This user has the same needs as the intermediate user, and more, but you should never make your interactive design challenging just because you want to appeal to the advanced user. In fact, you should endeavor to make your program even simpler. What does this mean in the context of the advanced user?

Less is more. Simple is elegant. Speed and efficiency of use mean productivity to the advanced user. And, in the final analysis, when your program works well with beginning and intermediate users, they all quickly become advanced users.

How to Make the User Mad: Deny Control

When you deny control over events on the screen, the user becomes impatient, bored, or worse, powerless and angry. There are many ways a poorly designed program can deny user control, but these are among the most common:

1. Playing a song or running a video clip that cannot be turned *off* by the user at any time. It's relatively easy to install an off or volume control option. With movies, the user should always have a means to click off or, in the case of QuickTime movies, the ability to advance the clip, replay it or click to specific parts.

2. Denying access to the program's main menu from anywhere in the program. Every screen should display a "Return to Main Menu" option. The main menu is a secure zone, a hill with a vantage point, the fountain at the shopping mall where everyone meets his or her spouse. (The main menu is also where you go to find the Quit button.)

3. Not providing your user with a map. Especially in complex, multi-leveled interactive programs, users can lose a sense of where they are. Having a map button handy tells them where they are, where they've been and where they want to go.

THE IMPORTANCE OF PROVIDING FEEDBACK

Interactive multimedia designers know that a good program is more than just elegantly designed screens, interesting buttons and fascinating animations and video clips. There is the user feedback issue. Granted, you can go overboard with beeps, boops and happy tunes, which makes it nice to give the user the

option of turning down the sound or turning it off completely. However, lack of sufficient feedback is a more serious problem.

Audible and Visual Feedback

Most programs apply audible feedback to users when they press buttons; a simple clicking sound usually suffices. But there are graphic as well as audible feedback methods.

For example, buttons that are used very frequently may use visual feedback as the preferred strategy. Navigational buttons (Page Forward and Back, Return to Main Menu, etc.) should probably *not* be assigned sounds because the user clicks on them so frequently. As the mouse cursor passes over the button, it should perhaps change color. As the user clicks it, it detents like a real push-button; these are called "roll-over" buttons.

Where audible feedback makes sense is in cases where the program needs a moment to load something into memory: a complex graphic, a large volume of text or maybe a video. Depending on the responsiveness of the computer, it may appear to the user that nothing is happening while the program accesses the file on disk, and he may become impatient or conclude that the program is frozen.

How serious a problem *is* lack of feedback? I've seen users click furiously on a button that did not respond or cause a response immediately, and that's a bad sign. If you run into such behavior, it might be wise to provide an intermediate response to a button action . . . maybe a combination audible and visual feedback. (Think of how both Windows and the Mac operating systems provide the little wristwatch or hourglass to let you know immediately something is happening and that you'll have to wait a bit.)

NAVIGATIONAL TOOLS

Navigational tools, usually in the form of on-screen buttons, are essential to the interactive experience. You'll want to develop a consistent, familiar, easy-to-recognize functionality in your button designs and placement.

One way to do this is through the use of icons. These are pictorial representations that immediately convey a meaning to the user, for example, a little house button that means "return to the home screen," or arrows pointing forward and backward to indicate "Move ahead to the next page," and "Move back to the previous page." If you do provide these graphic elements without providing written labels, your button better look like something that's familiar to the user. As a test, ask yourself if the icons you're using might be easily understood by someone who doesn't read or speak English.

A SAMPLE AUTHOR-READY NARRATIVE

Once you have your information map, you're ready to develop your screenplay. (You'll probably want to have your map first, since this will keep your narrative on task.)

One big difference between a movie screenplay and a screenplay for a multimedia program is that an interactive program may not be linear. In other words, there's a story to be told, but the user is free to determine the order in which parts of this story are told at any given time. Does this make it difficult to write a multimedia screenplay? It shouldn't. If a user action has several different outcomes, each potential outcome can be described, one after the other, in a traditional linear sequence. It's actually easy once you've established your information map.

The following portion of an author-ready narrative is based on the information map for a program about The Ertl Company. This information map is shown on page 95.

The History of The Ertl Company Section 1, Background 1

Main Screen:

The screen contains the image of entrepreneur toy manufacturer Fred Ertl. Next to his portrait is a time line containing significant years in the history of The Ertl Company: 1946, 1959, 1970, 1975, 1985, 1995. Buttons along the time line read:

- *It started in the basement*
- *A family business*
- *Toy farm tractors a success*
- *How we painted them*
- *How we sold them*
- *The move to Dyersville*
- *The company's growth*
- *The Ertl Company today*

Button Action:
1. It started in the basement:

Visuals: *Fade portrait of Ertl as movies pop up in viewing window, but return it to the screen when program idles following all segments. In a 320 x 240 pixel display window, cross fade the series of family photos of the Ertls making toys in the basement of their home on Algona Street. (Photos E1, E2, E3, E4, E5, E6, E7, E8.)*

Audio Segment 201: *It all started in the family home on Algona Street in Dubuque, Iowa. Fred Ertl was a journeyman molder for the Adams Company, one of three metalworking plants that joined in a city-wide labor strike in 1946. Faced with being off work for several weeks or perhaps months, Fred Ertl decided he would do a little experimental work in his basement. He obtained some scrap aluminum: war-surplus airplane landing gear components. He also found a source for fine foundry sand. His plan was to melt the*

aluminum in his basement furnace. He skillfully crafted sand molds on the basement floor into shapes of miniature cars, trucks, airplanes and tractors.

His timing couldn't have been better. World War II had just come to a close. Toy factories in Germany and Japan, which had been converted to war-time weapons manufacture, had been destroyed by victorious allied forces. There were no toys to be had anywhere.

Button Action:

2. A family business:

Visual: *Fade portrait and display the 320 x 240 window; in this, play the video segment EV1, Bob Neuwoehner's recollection of when he first met the Ertl family. Running time, approximately 45 seconds.*

Display: *Below window while video is playing, display the following text element:*

"Bob Neuwoehner, Retired Manager, Georgia Pacific Container Division"

Button Action:

3. Toy farm tractors a success:

Visuals: *In a 320 x 240 window display, using cross fades, show the photo series of early toy tractors from the Ertl museum and archives. (Photos E9, E10, E11, E12, E13, E14, E15.)*

Animate and synchronize with the appropriate passage in audio segment 202 a John Deere Logo (EG1), an International Harvester Logo (EG2) and a Ford Logo (EG3).

Audio Segment 202: *It was the toy tractors that became the most successful early products of the Ertls', perhaps because their business was in the middle of Midwest farm country. Their work impressed such manufacturers as John Deere and International Harvester, with whom the Ertls entered into some of the first trademark licensing agreements in the toy industry, entitling Ertl to gain access to detailed tractor drawings direct from the manufacturers.*

His first company slogan was "Built like the big ones for the little ones."

HOW TO PREPARE STORYBOARDS

Storyboards are essential for the motion picture and animation portions of your multimedia program, but they're also an excellent strategy for laying out screens, backgrounds and buttons.

Traditionally, in film, the most important function of the storyboard is to help the key production staff—like the director, camera person, actors, set decorator, prop, costume and makeup people—set up all the necessary elements in each scene to be shot. Storyboards for multimedia perform a similar function when you have video, film, animation or even still photography to be produced and incorporated into your program. As with film, your multimedia storyboards will be of interest to a number of people.

Storyboards can also be used to show button positions, text field locations, video window positions and navigational graphics.

Storyboards Communicate Complex Ideas

Storyboards help communicate complex ideas, including the sequence of visual events, to both the team and the client. Here are some pointers to keep in mind as you begin to create storyboards:

• Well-developed storyboards can help the camera person, animator or media designer frame the compositional elements in the scene.

• Animators can use a key frame sequence, and may only show (1) where an object or character starts in the frame and (2) where that object or character completes the movement.

• Detailed storyboards save on production costs. Video and film as well as graphic production time are just too costly to execute without some sort of plan.

• Storyboards give everyone associated with the project a chance to share and understand the visual concept the director and writer are after. If a scene works on paper, chances are it will work on video.

My own company uses a pre-printed storyboard tablet on an 8½" x 11" page (illustrated on page 100), which you are free to appropriate for your own production design. There are four windows per page and spaces for production notes. You can include information on color schemes, lighting, sound, anything that makes sense to you. The little squares alongside the screens can be used to better describe the buttons on the screen. The dotted line identifies the screen's "safe area" in the event you plan to run your program on a television monitor that over-scans your screen image, cutting off objects close to the edges. Information outside the border, like text or navigational buttons, will be off the screen. Finally, there are some blank lines provided with each window for your summary of the action in that frame or scene.

SELECTING AN APPROPRIATE DESIGN METAPHOR

Look through virtually any multimedia program that sports a graphical user interface and you will likely see a visual metaphor. Whether extended (present in various ways throughout the program) or an individual, one-time use, metaphors are a way to convey not only usability but functionality. The reasoning is that, if it looks and works like the user's real world, then it will be a comfortable and productive environment.

Your computer operating system (if you are using Windows or a

STORYBOARD FORM

Hardie Interactive Storyboard	Pg.

Project Name | **Project #**

Segment Title | **Version #**

☐ Video ☐ Film ☐ 2-D Animation ☐ 3-D Animation | **Designer** | **Director**

Action Overview

Scene #	Action
Screen #	
Audio Segment #	

Scene #	Action
Screen #	
Audio Segment #	

Scene #	Action
Screen #	
Audio Segment #	

Scene #	Action
Screen #	
Audio Segment #	

A Storyboard Form

This 8½" x 11" page is a storyboard form that Hardie Interactive uses. Putting four windows on a page this size is just about right, and allows enough room for both the visuals and pertinent written information.

Macintosh) already has a built-in metaphor, the "desktop." Your programs and files are represented by icons of desk accessories: file folders, notepads, etc.

Even Navigational Buttons Are Metaphors!

Even buttons on the screen are metaphors, since they aren't literally buttons. I'll never forget showing a non-computer-using acquaintance an interactive program I was working on. I had spent a lot of time on the buttons, making them appear three-dimensional. The user didn't know that the program was driven by a mouse, and tried to press the buttons on the screen! I was thrilled and, at the same time alarmed. Needless to say, my friend was disappointed and felt a little foolish. Yes, my design worked—perhaps too well, because you don't want to embarrass the user.

Interactive multimedia has the potential for high visual content, but it plays on a computer—and many people still find computers difficult to approach, much less operate. A good strategy for the designer is to create an interface that not only conveys the look and feel of the program's content, but also has a comfortable, approachable organic appearance.

For example, if your program is about the history of baseball, then balls, bats and bases are likely objects begging to be used in the interface. Baseballs, or bases, can make excellent navigational but-

tons, and the home plate can be the button that takes us to the home screen.

TIPS IN CREATING BACKGROUNDS

Backgrounds in screens are always a challenge, especially if you are going to project other graphic objects or text upon them. Background colors in such instances should be subtle, muted and light in color to ensure enough contrast for readability. Some designers like to create textural backgrounds, which is easy to do with such programs as Fractal Design Painter. Or you may want to use soft images in your backgrounds—a look that's become quite popular. Just be careful not to interfere with the display of type. Readability must be a priority.

COLOR PALETTES

If you're designing your multimedia to play on a variety of platforms, including the PC, your color choices are critical. In handling color, you will again be reminded that all computers are not created equal.

Even computers capable of displaying the minimum palette of 256 system colors often display shades differently from machine to machine. The strategy here is to install your alpha test on the lowest common denominator platform that can play your program, to see how it runs and what it looks like.

Most multiplatform developers have developed a standard palette of computer colors they use from machine to machine that, after tests, have proven to hold up reasonably well. I recall my own experience when our studio developed a computer-based training interface for a PC that used a beautiful maroon color as a background for navigational buttons. We developed the palette on a Pentium PC, but when

Making the Most of 256-Color Palettes

If you know your destination platform has a 256-color limitation, there are steps you can take now to maintain a quality look to your screen backgrounds, photographs and videos. Here are some tips.

• The easiest way to avoid disappointment is to develop your graphics on a 256-color palette PC system. If you don't have one of these "old" machines available, then reprocess your graphics with DeBabelizer, which does an excellent job of dithering down full-color images to limited palette applications.

• Avoid expansive graduated tones in your graphic elements. They become stepped or banded when converted.

• Photographs that are overall well-lit tend to reproduce the best. Dark continuous tones will lose detail, and become mottled and even darker. As a rule, high-quality photographs still look pretty good even after their colors have been reduced.

• QuickTime movies, especially those that have been transferred from the full-color Macintosh platform, can look horrid when dithered down to 256 colors. The best advice is to re-edit the video in Indeo or a complementary PC video application. If you can't do that, keep your video display window small. ∎

we played the program on an old 386, the maroon changed to an icky brown or a worse shade of purple. It was very costly to change that color since many of the assets were developed before the test occurred. Live and learn.

Color palettes in multimedia design have always been a hassle because of the need to limit colors to operating systems such as those found on older PCs, which only support 256 colors. Color palette management is not as much trouble on the Macintosh or new 32-bit PCs whose graphic components support thousands to millions of colors even in QuickTime video clips. I can't tell you how many hours I've spent dumbing down graphic palettes so my images (originally prepared on a Mac) could display properly in a PC project. Thank goodness for DeBabelizer, a utility program that batch converts graphics for conversion to limited bit depth. Nonetheless, it's still a hassle.

Regardless of advances in operating systems, we will still be minimizing graphics for some time since the installed base in the real world is still running 256 colors. The same is true with preparing graphics for the Web. Until band width becomes more accessible, it will be a while before full-color graphics can be displayed on a webpage.

But even though your target platform and your multimedia authoring software can address full-color images, you may still have to work in 256 colors or less, especially if you are delivering multimedia on CD-ROM. Animated graphics and videos may be impaired if the color depth exceeds eight bits per pixel. Optimizing performance means reducing color information since it represents the largest segment of your program's overhead.

PULLING IT ALL TOGETHER: THE ALPHA PROTOTYPE

The alpha prototype is one of the most exciting aspects of the creative process. It's when figments of the imagination and fragments of ideas come together to form something real. Some of the visual assets and computer code developed during this process are sure to migrate to the final product. But you don't want to get too carried away, because a prototype that's too sophisticated or finished-looking may shut out further idea development, or you may feel less inclined to accommodate changes that are suggested.

Choose Your Prototyping Software Carefully

Alpha prototypes can be very quick to do if you choose the right prototyping software. You may be thinking, "Prototyping software? I've got to buy more software?" But you may already have that software in hand. It's your business presentation program... Microsoft PowerPoint, Aldus Persuasion, Astound, or you can also use Apple HyperCard, Allegiant SuperCard or ToolBook. Personally, I prefer the presentation package for rapid prototyping. It's amazing how powerful these applications are in their ability to assemble visuals.

It's also interesting to note that many business presentation packages are getting even more robust, with genuine multimedia features. You can even do branching (though it's not absolutely necessary for prototyping) and animated screen buttons.

If you want to show program functionality and branching without actual branching, you can design the prototype as a linear presentation with simulated branching. For example, to show what happens when you press a particular button, you can give the appearance of going to the next screen, then pressing a button and returning to the main menu. But you don't really "return" to the main menu, you just duplicate the main menu in your sequence of visuals to create the illusion of going back to it.

The Key Objectives of the Alpha Prototype

• Show the basic compositional elements on the screen, including locations for buttons, windows and graphics, all of which can be represented by simple shapes and text labels.

• Test functionality of the program's information design. What happens when you press this button? Where do you go? What screen is this? How do you get back?

• Test color schemes and button sizes and designs.

• Begin to develop a style or look. Begin using some of the display typefaces (or other typefaces) you have in mind. You can also reveal your border concepts or background textures. And don't forget sound effects and music tracks.

• Take risks! Experiment! This is the time to try your most creative ideas.

• If you are prototyping in the authoring software you'll be using for the final, do an initial test for functionality on the user's computer. There's no better time than now to bring in the target system, load the code and do an actual test drive. If you intend to feature video or animation in the application you're building, this is the time to test the target platform's ability to run such assets.

• It's presentation time! The alpha prototype is an opportunity for the client to sign off on the design and grant permission to proceed.

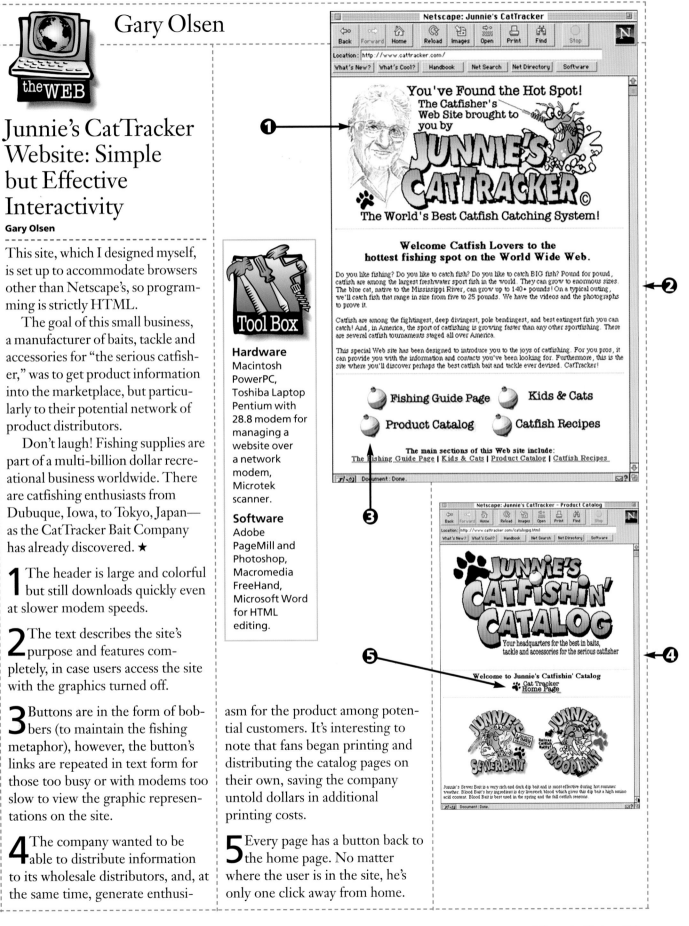

Gary Olsen

the WEB

Junnie's CatTracker Website: Simple but Effective Interactivity

Gary Olsen

This site, which I designed myself, is set up to accommodate browsers other than Netscape's, so programming is strictly HTML.

The goal of this small business, a manufacturer of baits, tackle and accessories for "the serious catfisher," was to get product information into the marketplace, but particularly to their potential network of product distributors.

Don't laugh! Fishing supplies are part of a multi-billion dollar recreational business worldwide. There are catfishing enthusiasts from Dubuque, Iowa, to Tokyo, Japan—as the CatTracker Bait Company has already discovered. ★

1 The header is large and colorful but still downloads quickly even at slower modem speeds.

2 The text describes the site's purpose and features completely, in case users access the site with the graphics turned off.

3 Buttons are in the form of bobbers (to maintain the fishing metaphor), however, the button's links are repeated in text form for those too busy or with modems too slow to view the graphic representations on the site.

4 The company wanted to be able to distribute information to its wholesale distributors, and, at the same time, generate enthusi-

asm for the product among potential customers. It's interesting to note that fans began printing and distributing the catalog pages on their own, saving the company untold dollars in additional printing costs.

5 Every page has a button back to the home page. No matter where the user is in the site, he's only one click away from home.

Tool Box

Hardware
Macintosh PowerPC, Toshiba Laptop Pentium with 28.8 modem for managing a website over a network modem, Microtek scanner.

Software
Adobe PageMill and Photoshop, Macromedia FreeHand, Microsoft Word for HTML editing.

Step-by-Step Development of a CD-ROM Project

STEP 1 **GATHER INFORMATION**

Through initial client contact, you begin to get a clear handle on the client's precise needs. One project we did (for Barnstead Thermolyne) was an employee orientation program on CD-ROM. The goal for this project was to deliver consistent information to new hires and to serve as an information resource of the company's history, organizational structure, goals and governing values.

STEP 2 **WRITE UP A PROPOSAL**

This is done in two stages:

A. Provide preliminary information and price ranges.

B. Write up a formal proposal—Provide full-fledged, specific information about the project, prices and production schedule. A formal contract is also drawn up and presented.

STEP 3 **BEGIN THE DESIGN**

Develop the concept and treatment more fully. Work with the client to organize information and assess any project assets (such as books, art, graphics, photography or video footage) that's to be repurposed. For our employee orientation CD-ROM, we were given an employee orientation procedure manual, a collection of catalogs and some historical files containing vintage photographs. We also requested a corporate style sheet.

STEP 4 **GET INITIAL CLIENT APPROVAL**

Approval of concept and treatment is crucial at this stage. You meet with your client to present: (A) a handout carefully detailing program features, and (B) some artist concepts of screens. Your material should be neat but not so finished that it squelches any new information or ideas the client may have. The goal of this meeting is to get a green light to proceed.

STEP 5 DO ALL NECESSARY WRITING

Scriptwriting, information design, storyboarding and information mapping are completed. In the case of an interactive learning program (which is the way we handled our Barnstead Thermolyne employee orientation project), we wrote complete author-ready narratives for each lesson. This gave the client something to relate to for approval of the program's content.

Lesson 1: History and Values

Lesson 2: Organization

Lesson 3: Manufacturing Process

Lesson 4:

Lesson 5:

STEP 6 GET CLIENT APPROVAL OF THE SCRIPT

The client carefully reviews the author-ready narrative or the program's content which is presented in the script. You will also present:

A. An information map that describes the various interactive functions of the program.

B. Storyboards illustrating video or animation.

C. A "disposable" prototype, including some graphic elements that will be kept for the final program if the client approves.

This is a crucial review and approval period, and you must obtain the client's sign-off, including any revisions. If major changes are recommended, a revision agreement may have to be drawn up.

STEP 7 FINISH THE DESIGN DOCUMENT

Final revisions and finishing touches are made, and the design document is finalized. This is a critical goal, and you are now ready for production. Adjustments or revisions during these first seven steps are always easier and less costly to make than after production starts. To maintain budget and to stay on schedule, it's important to "freeze the design."

STEP 8 BEGIN PRODUCTION

Video production begins, and graphic design, sound design and computer programming get underway. Design documents, which contain the script, storyboards and all pertinent paper on the project, are distributed to the production staff and talent. The project manager coordinates the production schedule. The production assistant distributes and collects time sheets.

Step-by-Step Development of a CD-ROM Project

STEP 9 DESIGN GRAPHICS AND TEMPLATES

Graphics are among the most time-consuming assets to develop. For our employee orientation program, there were three production people assembling the lesson elements, all of them following a common template. Fonts, as well as all of the graphics produced for this program, are libraried on the studio's network file server. They are also archived on CD-ROMs. A layout grid, like the one shown here, will provide a consistent map for all of the program's on-screen components (such as navigational buttons).

STEP 10 DEVELOP THE USER INTERFACE

This is the program's "home page" or main navigational screen. For our Barnstead Thermolyne project, buttons to transport the user to each of the lesson elements were placed in a yellow box on the left-hand side of the screen, with titles describing the contents next to each lesson number. To mark the user's progress, a water drop appears on the button as each lesson is completed.

Randy Hoff

STEP 11 SHOOT THE VIDEO

An important feature of the employee orientation program was video clips of employees telling the company's story. The video was shot in a single day on a carefully coordinated schedule. The clips were shot "documentary style" with people responding to questions spontaneously.

STEP 12 COMBINE VIDEO WITH GRAPHICS

Completed video, audio clips and graphics are optimized or compressed to meet the performance characteristics of the client's target platform specs. In our case, the program's graphics were done in Adobe Photoshop, videos in Premiere and audio in Macromedia SoundEdit 16. The program's components were assembled in Authorware.

Barnstead Thermolyne | Employee Orientation

Diversification and expansion of the product line was a continuous process. However, regardless of how large Barnstead Thermolyne became, they never compromised their original company culture which encouraged innovation, productivity, and quality.

In 1988, the marketing department of the Barnstead Company was moved to Dubuque.

Randy Hoff

NOTEPAD
NEXT
GO BACK

Barnstead Thermolyne in Dubuque

1 2 3 4 5 6 7 Page 3 of 6

Flashcards Glossary Options Quit

STEP 13 DO ALPHA AND BETA TESTING

Alpha testing occurs as new components are completed and before they are integrated into the program's whole. Alpha testing strictly tests for functionality and compatibility. Beta tests occur when the product is near its completed state. Beta tests are designed to evaluate user response to the functionality of the product and to discover program bugs.

Program is too slow on my system... Videos are halting... I thought this was a button, but it wasn't!

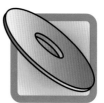

STEP 14 HAVE MASTERING, PACKAGING AND LABELING DONE

Once you've produced a significant number of successful one-off versions of the program, using a compact disc recorder, take one of these to your disk manufacturer. Also take along any files required for preparing screenprint materials for labeling. Any external packaging is also manufactured at this time. ■

CHAPTER 9

Information Design on the Web

There is no doubt that the Internet is the most important innovation in the evolution of the personal computer. Imagine: software that is independent of disk, drive or physical medium of any kind. You interact with multimedia that comes to you from a vast network comprised of computer file servers around the world. The promise of what the computer can do to make our lives better has finally been realized.

THE PERSONAL COMPUTER AND THE NET ARE ONE

If that heading seems a little too Zen, consider the facts. The Internet has caused an explosive growth in the amount of personal computer use, and growth in the number of people using the Net has been exponential. The Internet is taking interactive multimedia to the next step—freeing it from the confines and logistics of distributing material on a CD-ROM.

Right now, there is a performance gap between disk-based multimedia and what you can accomplish online, but that gap is closing. As performance on the Internet continues to improve, so will the opportunities for richer multimedia. But right now and for the foreseeable future, you must be realistic about the complexity of your product and the technical sophistication of your audience.

MORE POWER THAN WE KNOW WHAT TO DO WITH

With the explosive growth of the World Wide Web, it became painfully clear that many site designers had no clue about what the new medium really was. Pages were either passive billboards for company logos and trademarks, or over-designed digital versions of company brochures. Then there was the crowd who went nuts, trying to infuse their Internet sites with multimedia madness.

If you think the Web is just another platform for delivery of interactive multimedia, similar to what you can get on a CD-ROM, you might miss the greatest opportunity the Web provides. It's much more than a delivery system for multimedia (face it . . . television does a better job). What it represents is incredible power to: (1) communicate ideas and information that can be constantly updated, (2) break down geographic limitations like never before and (3) provoke

user involvement like no other media that has come before it.

THE TWO INTERNET LEVELS: TEXT AND GRAPHICS

Terms like Web, Net and Internet are often used interchangeably and mean the same thing to most people. But those who are more actively involved with the Internet tend to view it on two different levels, the text-based level and the more graphical World Wide Web. The distinction is somewhat simplistic, but it is important because a lot of Internet users don't even want to look at images and certainly don't want to wait for them to download.

Watch a Web power-user. They either cruise the text-only UseNet or newsgroups, or they shut off the display graphics option in their browser's Preferences file. These people just want the TEXT! They're in a hurry, and you must respect this user's time constraints.

The Mechanics of the Web

You can't view webpages without browser software. There are several different browsers out there, but most follow the basic format of the most popular browser, Netscape. Describing a Web browser as a means of viewing webpages is to oversimply; what the browser actually does is *assemble* page elements on your computer. (See the illustration on page 110.)

Depending on the preferences you have set in your browser software (such as typestyle or default background colors, for example) pages can appear differently on your computer screen than they were originally intended to look.

The fact that the user has so much control over his Web experience can be frustrating to designers who spend a lot of time designing the perfect page. Further complicating the problem is that different browsers have different features, and your site won't look the same on any two of them.

THE CHALLENGE OF DESIGNING A WEB PRESENCE

At a recent National Association of Broadcasters' multimedia conference, one of the presenters told the crowd, "If you are going to design for the Web, you must become accustomed to users deconstructing your designs." The term "deconstructing" is so appropriate.

Designers new to the Web soon discover that it is difficult to break out of the consistent interface enforced by the user's choice of a Web browser. So far, not everyone is running the same browser software, and a complex design that works in one browser environment may not look the same in another. So what if you designed your website and only checked it in a Netscape Web browser? You'll look at the same page in someone else's browser, and poof! All of your formatting is totally goofy! This is why it's best to keep things simple, and it's important to test your work in multiple browsers. This is also why, as a "newbie" Web designer, you must endeavor to adhere to the number one rule: Design for the lowest common denominator, at least for now.

How to Be Both Innovative and Practical

Design your site for two types of user. As the user enters your site for the first time, provide a "navigation panel" in your homepage that allows the user to select an information format. Tell your user up-front: "Our website provides you with two formats you can choose from to obtain information: (1) a graphic-rich, interactive multimedia environment and (2) a text-only environment that has much of the same information, and the same

search engine and downloadable file library. Press the appropriate button."

Your text-only website can exist on a single scrolling page or a series of shorter, non-scrolling pages, depending on the amount of text you're dealing with. Many readers don't care much for reading long articles of text in scrolling fields. Break the text into shorter pages with a Page Turn button at the bottom, and you will immediately create a more comfortable reading environment.

LEARNING HTML

The language used to program webpages is called HTML, which stands for Hypertext Markup Language. Technically, this is not a programming language, but more a typesetting code that has been adapted for this domain.

You can create webpages using one of several HTML editing programs: HTML Editor, HotDog and Hot Metal were early favorites (and still are) by being very basic and straightforward. With any of these, you create your page in a text window, highlight particular text elements and select HTML commands from pop-up menus, or you type in the code by hand.

Adobe PageMill, which first came out in 1995, is a real improvement over some of the earlier programs. This is a terrific program for designing webpages quickly. Basically, with PageMill, you can drag and drop graphics and text just like any other desktop publishing program. But for fine-tuning your pages, you may have to consult an HTML code specialist.

Grab the Source Document Code

One of the best ways to learn about HTML is by examining the source document code of a webpage you like. Your browser software allows

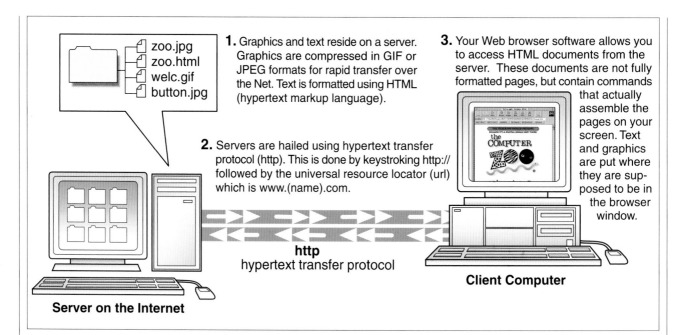

1. Graphics and text reside on a server. Graphics are compressed in GIF or JPEG formats for rapid transfer over the Net. Text is formatted using HTML (hypertext markup language).

zoo.jpg
zoo.html
welc.gif
button.jpg

2. Servers are hailed using hypertext transfer protocol (http). This is done by keystroking http:// followed by the universal resource locator (url) which is www.(name).com.

3. Your Web browser software allows you to access HTML documents from the server. These documents are not fully formatted pages, but contain commands that actually assemble the pages on your screen. Text and graphics are put where they are supposed to be in the browser window.

http
hypertext transfer protocol

Client Computer

Server on the Internet

How Browser Software Works
The browser isn't just a means of viewing webpages; instead, your browser actually interprets text files and assembles graphics and text to create the webpage right on your screen.

you to view webpages at the "source" document level, which shows the HTML tags in a document. Just study one or more of these documents. Then cut and paste the text into a word processing program, or better yet, open a source document in a webpage editing program, such as NaviPress or Netscape Gold. These programs have editing tools and HTML macros that somewhat automate the tagging process. Just begin fiddling with the code and pretty soon it starts to make some sense.

My colleague, Jon Ellis, taught himself HTML just by viewing source code, cutting and pasting, and experimenting. He takes my PageMill pages and opens them in Microsoft Word, a fairly ordinary word processing program. He toggles back and forth between the source code and Netscape where he previews the pages he's coding.

BREAK THE PARADIGM OF RIGID PAGE LAYOUT
Thankfully, Web browsers have become more forgiving and intuitive, and able to handle more complex page layouts in ways that are consistent with the designer's original concept. Also, traditional word processing, page layout and some graphics programs are including HTML plug-ins allowing for conversion of documents from print to Web display.

Adobe Acrobat is a program that converts printable PostScript files to formats that can be displayed on any computer without the need for the software that created the original document. Acrobat is a very efficient way to get printed pages on the Web fast.

But why should you settle for mere print-like pages? Sometimes there is value in doing print-type pages, but as I said before, the opportunities available on the Web go far beyond this.

Macromedia Authorware with Shockwave—An excellent strategy for bringing dazzling multimedia designs to the World Wide Web is to apply Authorware. This program is described elsewhere in this book

as a tool for designing computer-based training. However, it is also an extremely flexible multimedia authoring tool for anything from simple to sophisticated interactive applications. But how do you make an Authorware creation run on the Web? By running your finished application through Macromedia's Shockwave Afterburner component. This effectively compresses the application and enables it to be downloaded efficiently by a user with a Web browser (like Netscape's) which contains a Shockwave player plug-in (the entire Shockwave suite of software is easily downloadable free from Macromedia.com). What is neat about Shockwave is that it allows the user to begin seeing and using the file as it downloads, reducing downloading times. This technology is called data-streaming and it was pioneered by Macromedia for the Internet.

Designing a Truly Powerful Web Presence
So, if the Web is really about publishing dynamic information that changes and conforms to the user's information needs and personal preferences, how do you do it? The

answer in two words: relational databases.

Granted, these words are not exactly awe-inspiring to designers, but websites powered by relational databases are what Internet functionality is all about.

A relational database organizes data into structured lists, called tables. A table is simply a collection of horizontal rows and vertical columns; the spaces defined by these columns are referred to as fields or attributes. "Relational" means that these tables are linked or related to one another by creating programming links from the cells of one table to appropriate information residing in cells in another.

Such database structures make website information management easier. Otherwise the somewhat static pages must be completely redone when changes are required. If you build your site using database-supported tables that load information on demand, it's easier to change or update Web content without having to download completely new HTML coded pages.

You still design *pages* for the Internet, with cool graphics and neat little drop-shadowed buttons that appear as if they are hovering above the screen, but in a database-driven site, the content of the pages, including the graphics, resides in a database. This content then loads into pre-formatted tables and builds the pages. It takes some talented programmers to execute this kind of functionality.

Among the most celebrated websites that embrace this kind of functionality is HotWired (the online version of *Wired* magazine, at http://www.hotwired.com). Hot-Wired, in fact, was one of the first sites to break the static page mold and create dynamic, ever-changing website environments. Virtually every element of HotWired's site is

loaded into their pages by an HTML script called a "local executable." This means the user actually creates the pages on command, including choice of content.

The process can be compared to building just the skeleton of a house out of 2 x 4s. When you visit the house, the walls, wall coverings, pictures, carpeting and furniture all materialize instantly, room by room (page after page). If you leave the site and return later, the rooms change. Different pictures on the walls, different content on the pages.

WEBSITES THAT COLLECT INTELLIGENCE

What good is an informational website where information only goes out but nothing comes in? Not too long ago, Netscape revealed that buried in the code of its browser were "cookies." This innocent term was a word for program code that collected data on the sites the user was visiting and then, on demand, provided that information—called "threads"—to Netscape. This is valuable intelligence for prospective advertisers. I recall there were some shrill protestors of this strategy; who wants to find out you were an unwitting accomplice to a bunch of crass marketeers?

Regardless of the protests, user data is important information to anyone who is investing in a Web presence to sell, advertise and communicate. You *can* provide for automated collection, but the best information is always what the user willingly provides you.

By providing a well-designed user feedback or registration form, you can collect some excellent information.

Design Tips for User Data Forms
Forms can be provided at any point in your website—at the front door,

Reality Check

Leveraging the Net's Greatest Features

You must learn how to leverage the Internet's best features:

• A community of users exists on the Internet that really doesn't exist in the context of a CD-ROM. On the Net, several users can partake of an interactive experience at the same time. As these users interact with the content you provide, they can add to it, change it and even update it for you, so the program becomes unpredictable and the information dynamic.

• The Net empowers its users with the ability to access virtually infinite volumes of information, yet also find precisely what they are looking for with a minimum of effort.

• On the Net, a growing number of users prefer reeling information in rather than hunting through a maze of pages. Search engines are becoming more powerful, and there are those that can be programmed to absorb the proclivities of the user—i.e., intelligent agents that search and retrieve specific information not only requested by the user, but information assumed useful to the user. In other words, users will not surf themselves, but will "hire" an intelligent agent to surf for them. ■

back door or both. The most common way to capture user data is the "sign-in page." This can be something as simple as requiring users to click preference boxes, which launch specific pages while recording these preferences to a user database. For something a little

Great Tools on the Internet, For the Internet

Shockwave

Macromedia Shockwave is available at http://www.macromedia.com. Shockwave is an application that enables more efficient transfer and playback of Macromedia Director and Authorware multimedia files via the Web. The application is actually comprised of three components:

1. Afterburner: This is the post processor for Director and Authorware source files. Multimedia developers use it to prepare content for Internet distribution. Afterburner compresses the files and makes them ready for uploading to a Web server from which they can be accessed by Internet users.

2. Shockwave Player Plug-In: This component is for Web browsers. It allows Macromedia Director or Authorware files to be played seamlessly within the same window as the browser page. You can download an installer program from Macromedia and install this plug-in to your most recent version of Netscape.

3. Shockwave Player Helper Application: This plays Macromedia Director and Authorware files with any browser being used, but the programs appear in a separate window on the screen from the browser page.

To sum up, Shockwave provides a compression scheme that optimizes and compresses the Macromedia files to their smallest possible size, while still allowing acceptable play on a variety of platforms equipped with the Player Plug-In or Player Helper Application. Since Macromedia is the number one developer of multimedia software for both the Mac and PC, this product is a natural.

VRML

VRML stands for Virtual Reality Modeling Language. (Like HTML, VRML is an open standard, meaning it's freely distributed to developers.) This is a highly sophisticated derivative language based on HTML, which was developed for interactive gaming applications for the Web. It can be used to create environments where users interact with each other in a virtual three-dimensional space, including "chat rooms."

Java

Java, from Sun Microsystems, is available at http://www.javasoft.com. Pardon the pun, but Java is hot. This is a robust integrated Web programming environment for the creation of software applications that would be impossible to create using HTML.

Some industry observers have called Java "C-programming for the Web." Indeed, Java is a very powerful programming language and will factor heavily in the coming generations of modular software, which are

called applets; these are bits of programming that can be downloaded from the Internet for whatever purpose, and automatically discarded when you're through with them. The development of applets is truly revolutionary thinking. It means software will no longer be confined to being distributed on disk. Unfortunately for non-programmers, Java is a command line programming language, meaning that this is another language that will be difficult to master without the help of a programmer.

RealAudio

RealAudio, available at http://www.realaudio.com, was among the first to create a commercially viable solution for Web sound.

I can't understand why more Web designers don't use sound in their websites. I love radio, because well-produced audio can create wonderful illusions for the listener. And there are a number of ways to incorporate sound effects, music and other audio files into your websites.

Like other plug-ins that add functionality to your Web browser, you can visit this site and download the necessary installer program. Once you install the software and register at the RealAudio site, you can also gain access to other audio-oriented sites (and RealAudio keeps updating their list!). ∎

more sophisticated, you can ask more lengthy "essay" questions.

Here are some design tips for user data forms with the most important objective in mind: Be courteous to the user, and don't make them uncomfortable with personal questions or tediously long questionnaires.

1. Make registration an option—

not a requirement—for gaining access to your site.

2. Keep registration forms short and simple. If the website were your home, and this were a guest, would you ask this person for their income range?

3. Provide an incentive—maybe exclusive access to specific areas of a site or special information—if the

user will fill out a more lengthy form.

4. Tell the user upfront why you desire this information. It's a courtesy few sites extend.

5. If you intend to share the data with anyone outside the site sponsor, ask the user's permission, especially if it's for marketing purposes. Once again, a courtesy.

HOW LINKING CREATES A COMMUNITY

The individual pieces of a particular website may converge from several different servers. Likewise, hyperlinks, or pointers, can provide dynamic links to other webpages—also on different servers—which can load quickly and seamlessly with the touch of a button. So even though two pages may exist on different computers several thousand miles apart, the user may not immediately be aware of this.

Earlier in this chapter, I used the metaphor of a house under construction to describe how a dynamic website works. Now, let's look at that house in relationship to other houses next door and across the street. Linking the content of your pages to other relevant pages embodies the spirit of what the Web is all about. A key objective of any webmaster should be to create a neighborhood (or a "community") out of a useful, well-connected set of hyperlinks.

A good example of this can be found on any of several agricultural websites on the Internet. Many feature hyperlinks to subjects farmers care about, like weather, moisture tables, commodity prices and legislative issues. Press the Weather button in one agricultural site, and immediately go to a national weather satellite map. The weather site is located on another server in another city, but the satellite information is updated continually. It's a perfect link.

Likewise, if there is other information on the Net that would complement your page, you should establish a link with that page. In fact, you should collaborate with several other appropriate websites and ask them to point to your page. Strategic alliances are all part of building communities on the Web, and that adds value to your site.

WEB CULTURE AND THE "WEB LOOK"

Developers and users have grown accustomed to the Web's look and feel to the point that virtually all multimedia, even that which is delivered on CD-ROM, now looks "Web-like" in some ways.

For example, developers and designers have keyed into a comfort zone of hypertext links, on-screen buttons and "floating" graphics with drop shadows that call to the user, "Press this and something neat will happen."

As an information designer, you must learn to work with some of the conventions that are already in place, or risk losing potential visitors to your site. For example, you probably *don't* want to give too much text information in a single page; this requires the user to scroll through seemingly endless gray text. Instead, you may want to chunk your information into shorter pages requiring no scrolling whatsoever. This gives more of a "page turning" feel and is definitely more user-friendly.

Using Frames

A convention popularized by Netscape is the use of page "frames," which can best be described as a way to put pages inside of pages. Certain unchanging aspects of your pages, like the banner and navigational buttons, can remain in place while information inside the frames changes.

Applying frames to a webpage site appears to reduce the number of separate pages you will have to create. What frames really do is reduce the amount of time the computer screen has to completely refresh as a user moves through a site. This design strategy works particularly well when applied to sites with large amounts of text information.

STATE OF THE ART

The Internet is basically a traditional packet-based network. Information is downloaded by the user and is displayed in the browser.

However, some program developers figured if the data could be compressed enough, some of the information could be displayed on the user's computer screen even while the rest of the data was still downloading. This data-streaming technology is continuously improving while, at the same time, Internet service providers are trying to supply a larger capacity data pipeline to more people.

The larger the data pipe, the faster and better the Web can perform. With higher capacity bandwidth, you can do some serious animation, video conferencing, high-quality audio transfer and richer interactivity. Until that time comes, there are some cool things you can do right now with some very useful tools, including Macromedia Shockwave, VRML, Sun Microsystems' Java and RealAudio, all of which are free for you to download from the websites that developed and sponsor the technology. (For more about these programs, see the sidebar "Great Tools on the Internet, For the Internet," on page 112.)

The emphasis is on proper asset development and management

STEP 1 HAVE A PLAN

Information mapping is the first step in any multimedia enterprise. The Index Page is the first thing visitors to your site will see—a launching point, but also a comfort zone. Plan your major pages and provide logical pathways between them. This organizational chart shows major pages and routes for a site we created for the Dubuque Telegraph Herald called "The Computer Zoo." Each colored button corresponds to its destination page.

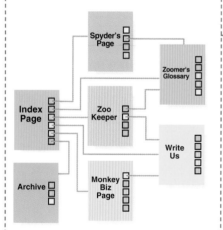

How do computers do 3D animation?

Welcome to the Zoo

STEP 2 DEVELOP THE LOOK

Asset production includes both graphics and text elements that will comprise the page. As you create your site's look, you select a color palette, and a graphic design style. Whenever possible, produce your graphic elements in the exact size you will need them in the destination file. The goal here is to reduce the amount of work your user's browser has to go through to display your graphics.

Tool Box

Software
- Adobe Photo-shop for graphic production
- Adobe PageMill for webpage design and layout
- Microsoft Word for HTML tags (any word processor will work)
- Netscape Navigator to view your final product

STEP 3 OPTIMIZE YOUR GRAPHICS

You must limit the number of colors your graphics need to display in order to make downloading faster for the user. For our "Computer Zoo" graphics we used an interlaced GIF file. (These graphics materialize gradually in the user's browser window, so the user is less likely to see a blank space on the screen while the graphic is still downloading.) The objective here is to reduce the amount of color information (bits per pixel) and maintain quality.

STEP 4 DO GRAPHIC FILE FORMATTING

For the "Computer Zoo" project, we used a special plug-in for Photoshop called BoxTop, shareware we downloaded from the Internet. This plug-in allows us to save graphics as interlaced GIF files. The illustration shown here is our banner graphic on the Index Page, so we want it to materialize as quickly as possible. Since we are going to work with a simple white background on our webpages, we can click on "None" in the small window. We will not need to make the background of these graphics invisible, even though it's an option.

STEP 5
ORGANIZE YOUR ASSETS

You'll want to have a plan to manage the mounting number of files, both graphic and text, as you create your webpage. Remember, even though your operating system may support long file names, keep all file names to no more than eight characters and always include a three-letter extension. Why? Because the server won't recognize longer file names, nor files without a file extension.

STEP 6
BEGIN PAGE ASSEMBLY

This is an Adobe PageMill page assembly window. (PageMill was among the first to feature drag-and-drop page assembly.) From open directories on the desktop, just drag the file icon to the page, and the graphic pops into place. Of course, we are not just throwing this page together without some logic and planning. The small pop-up menu is the program's "attributes inspector," which sets the page's background color or tiles in a GIF file, creating wallpaper. For legibility on a wide variety of displays, I prefer white or lightly toned backgrounds.

Step-by-Step Webpage Planning and Execution

STEP 7 CREATE SOME REALLY COOL NAVIGATION BUTTONS

Obviously, we were blessed with a fun theme for this website, but even so, there's a lot you can do in this area. For this site, I enlisted the talents of media designer Eric Faramus to create icons to mark the pages. These particular icons also make great buttons for the index page.

STEP 9 CREATE REDUNDANT BUTTONS

For those in your audience who view webpages for text content only, or if some network or user's system glitch only allows the text to download, the user will still have some form of navigation. This blue text serves as hypertext links to the same locations the buttons will take you.

STEP 8 MAKE A NAVIGATION PANEL AND HOT LINKS

I went back into Photoshop and arranged the individual buttons into a single graphic. This created a control panel on which we could designate hot spots, or hyperlink areas. In PageMill, you are provided with simple tools that allow you to designate several hot spots on a single graphic. You then select the hot spot and drag the page icon from a connecting file to that hot spot. The program automatically assigns the destination page's address to that hot spot.

Give Your Button to Other Sites

Other sites in your network neighborhood might want to feature a hypertext link to your site. So give them a graphic to download that points the way to *your* site.

STEP 10 ORGANIZE YOUR WEBSITE DIRECTORY

Macintoshes, or PCs operating Windows, are great for website management for the reason illustrated here. This is a Mac window with the accumulating files that comprise our site. With the Macintosh, I can drag my "picons" around the screen, arranging them in logical order. This is helpful when you want to take inventory, making sure all of your graphics and text documents are at the same file level (or for you PC people, in the same directory or file folder). Checking that all of your files are where they need to be reduces the risk of leaving a key file behind when you upload your files to the website.

STEP 11 TEST THE PAGES AND INTERACTION

You can only guess which brands of Web browser will be accessing your site. Here we've designed an extremely simple and consistent page layout from page to page, which we tested by downloading into whatever browsers we had on hand . . . you may want to try America Online, Microsoft, Netscape and maybe an old copy of Mosaic. This testing is crucial in confirming that all of your interactions, hyperlinks and hypermaps are working properly. Don't be surprised if your buttons don't work but your hypertext hotlinks do. In addition to providing navigation for "text only" users, hypertext links are useful if your buttons won't work in some browsers.

STEP 12 CUSTOMIZE THE HTML TAGS

As you become more comfortable with HTML, you can begin looking at the source code for your pages by merely opening your HTML documents in a text editor or word processing program. As you become more proficient, you can splice in custom tags and scripts to do things like play audio clips, animations, etc. ■

CHAPTER 10

Preparing Graphics for Multimedia

IN THIS CHAPTER, YOU WILL LEARN:

- The difference between preparing graphics for multimedia and preparing graphics for desktop publishing
- The most important software for multimedia graphics production
- The best strategies for gathering images on a budget
- Step-by-step: How to capture, manipulate and format a graphic element for multimedia and online applications
- How to maintain image quality at low resolution
- Features of the main graphic file formats

Now that the computer has become the principal tool of graphic designers (it wasn't too long ago when those tools were an X-Acto knife and an electric waxer), computer graphics have naturally gotten better. They look more natural, less like they were rendered by a machine. So it's ironic, really, that with the growing popularity of multimedia and the Internet, computer graphics have regressed about ten years.

GRAPHIC PRODUCTION FOR MULTIMEDIA AND FOR DESKTOP PUBLISHING

What I mean by "regressed" is that just when we could afford enough V-RAM and computer power to render images at a high enough resolution for acceptable desktop color publishing, we've gone back to designing graphics with less than eight-bit color depth. Suddenly, we're thrilled when we can take a really nice photograph and dither it down to 15 kilobytes so it can materialize more quickly on our webpage.

I'm not all that unhappy about this phenomenon. Right as I faced the prospect of buying a more powerful home computer, I found myself doing more Web and multimedia graphic design at a maximum 72 dpi; suddenly my old 44 megahertz Macintosh and 19-inch monitor were overkill for graphics that never exceed 640 x 480 pixels.

I'm referring only to doing graphic production—not to multimedia authoring—on this particular computer. Animation, QuickTime video editing and programming must be passed off to our fleet of higher-powered studio computers. For straight graphic work, though, my Mac suddenly has an extended lease on life.

THE MOST IMPORTANT SOFTWARE FOR GRAPHICS PRODUCTION

If there was a Nobel Prize for software publishers who have done the most to further the productivity and growth of the graphic design trade, the award would have to go to Adobe Systems.

Adobe's Photoshop is clearly the most essential and indispensable software on a designer's hard drive. I doubt if anyone in our trade would say they could live without it. For designers, Photoshop is like oxygen. It's got all the essential tools, plus additional capabilities you may

Image Gathering Strategies on a Budget

Multimedia production has an insatiable appetite for photos, illustrations and graphics. Where will all these images come from? There are several sources.

1. Create your visuals from scratch. Storyboard the concept, assign a photographer and pay for expenses, which include film, processing, digitizing (scanning) and, most costly of all, reproduction rights, modeling fees and releases.

2. Buy stock images. This is typically less costly than shooting your own photos, but the cost depends on the stock agency, the type of photo and how you are going to use it. Typically, stock photo pricing is based on the estimated size of the intended audience. Ask stock agencies for their price schedule for multimedia usage.

You can also use stock photos from a CD-ROM clip collection: the "2,000 photos for one low price" collections—these are getting exceedingly popular (maybe that's why we see some of the same images from product to product). However, it's advisable to examine the licensing agreement for hidden costs. If your product goes into wide distribution, you may owe more money to the licenser for a particular image.

3. Use a video camera or a digital still camera and capture images directly into your computer. This is truly image gathering on a shoestring budget, but you may be surprised: In many cases, this can be the best method of image gathering as well as the least expensive.

Still images, combined with a good quality sound track, can often have more storytelling impact than full-blown video or film. Such a presentation is often more stimulating to the imagination. Furthermore, the system overhead required to display still images and play audio is less than what you need for playing video.

There are a number of inexpensive ways to capture video into a digital file. Any computer equipped with a video capture card (or any AV-capable multimedia computer) can capture video sequences or video frames directly from a camera. My favorite device is the Minolta Snappy, an accessory attachment I bought for less than $200. It attaches to my Toshiba through the serial port and allows me to attach a video cable from my 8-mm Sony Handicam. Software on the computer allows me to snap individual frames of video from the camera to image files for inclusion in my multimedia program.

My original strategy was to use the device for prototyping and rapid image gathering during the pre-production creative development phase. But I soon discovered the image quality was fantastic; an added bonus was the high-quality sound track I was gathering while shooting pictures. Sometimes sounds I've managed to record by accident find their way into my programs.

On one occasion, my studio was producing a simulation for a computer-based training project. Video was not an option on this single disk program. We decided to use still frames of the actors to dramatize the events: We shot intimate close-ups using dramatic angles, and we ended up with great photographic choices. Because of the excellent light reception inherent in video cameras, we shot everything in available light. Because we didn't shoot film and did not have to scan traditional photographs, we saved a small fortune on processing costs and untold time. Nor did we have royalty fees to pay.

To add even more artistic drama to the photographs, we extracted the color and toned the images in monochromatic hues. To tell the truth, the quality of the images at 72 dpi was indistinguishable from higher quality images shot on film. ∎

never use or even figure out. That's what is so cool about Photoshop—no two people use the program in exactly the same way. It's like no two artists holding a paintbrush the same way.

Only Fractal Design's Painter approaches Photoshop in popularity, power and flexibility. Painter even exceeds Photoshop's abilities in some ways, but why quibble? Who can resist using Painter's image hose to squirt flowers, coins or clovers all over the screen?

What Painter does best is allow the digital artist to create images with an infinite variety of surface textures and lighting effects. In multimedia, where the design objective is to create a natural and almost tactile feel to one's graphic look, Painter has awesome power. For example, you can take photographic images that otherwise would be flat and sterile and turn them into textural renderings that appear to have been painted by hand. With lighting effects you can manipulate the contrast and drama of a composition, thereby enhancing depth and dimension.

HOW TO MANIPULATE RESOLUTION

Preparing graphics for multimedia is not the same as preparing graphics for desktop publishing. In the multimedia world, high resolution data is just a waste of bits-per-pixel.

ProFile

Ellen Pack

Founder of Women's Wire Website

Back row: Lourdes Livingston, Ellen Pack, Laurie Kretchmar. Front row: Sarah Stillpass, Katharine Mieszkowski, Paige Manzo, John Hoag and Margo Carn

"I would describe myself more in the producer role rather than as an artist," says Ellen Pack, creator of the cutting-edge "Women's Wire" site on the World Wide Web. Ellen founded Women's Wire and is vice-president in charge of product development. Prior to this, she was the CEO at a start-up software company. Her formal education includes an M.B.A. from Columbia University. She says she's always been interested in developing products and services that people like to use.

Women's Wire, located in San Mateo, California, has one graphic designer, one HTML designer, three editors and one Web director (programmer) working directly on site development. Staff members have varied backgrounds, including graphic design for newspaper, magazine editing for major national magazines, website development for a radio station and programming for the Internet. Women's Wire has a total staff of seventeen,

including a CEO, CFO, director of marketing, director of business development, producer of new products, online community manager and administrators.

WW's audience is women on the Internet. "We also have . . . clients who pay for advertising," explains Ellen, "which allows us to offer our publication for free on the Web."

Marketing WW involves strategic links with other websites. "We also do PR and speaking engagements," says Ellen. "Word-of-mouth and links lead a lot of people to our site." ★

the WEB

Women's Wire: Women's Resources on the Web

Women's Wire

We've often heard demographers characterize the Internet as a high-tech hangout for boys, but one look at Women's Wire and you'll know better. The developers of this site wanted to build a hip online magazine through which one can easily navigate. Not only did they succeed in their goal, but they also created a technical triumph, combining Shockwave animation and Java programming. From the opening screen, this site kicks visually.

Women's Wire has a very clean, professional and yet hip look and feel. Navigation employs numbered departments, and a bar at the bottom of every page reduces the necessity for backscrolling to look for navigation buttons. The Women's Wire identity is non-intrusively placed on each page. The color scheme is a mix of primary colors and black and white images, which provides a graphic edginess.

Women's Wire is aimed at women ages twenty to forty, college-educated, professionals or aspiring professionals. All editorial material is created specifically for the site. The WW team of designers, editors and technologists are all involved in the creative process from the very early stages of all features—it's this synergy among departments that really makes great Web content.

It took five people (all working about half-time on this project) and one contract graphic designer three months to go from conception of the site to its launch. WW used Lisa Marie Nielsen Design of San Francisco for design concepts and original design work.

"We try to include sound files whenever they are relevant to the stories we are doing," explains Ellen. "For example, recording samples in a profile of an artist, a jingle from an advertiser. Sounds can be played using Netscape 2.0 for Windows or Sound Machine for the Macintosh." Video clips have also been featured, and are all created and stored using QuickTime. Women's Wire can be found at http://www.women.com. ★

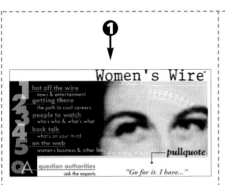

1
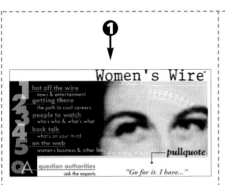

1 Elements on this opening
screen change frequently, an
attractive feature for repeat visitors.

2 An example of advertising
and feature content found on
Women's Wire. Though Women's
Wire contains some advanced
programming, it's clearly the
quality of the content that drives
the total quality level of the site.
And that's what really builds a
constituency.

3 The animations on these
opening screens are fairly
simple, but still attention-getting.

Hardware

The site runs on a
Sun SPARC 20
utilizing Solaris 2.4
and Netscape
Communications
Server. Creative
development on a
variety of Macintosh computers and
Pentium PCs running Windows '95. A
Wacom pressure sensitive tablet for
graphics.

Software

A variety of text editors for HTML
including Microsoft Word. For graph-
ics: Adobe Photoshop and Illustrator,
Fractal Design Painter. C programming
development software, PERL for CGI
(for server pushes, forms handling,
special effects), Macromedia Director
and Shockwave for Java and Javascript.

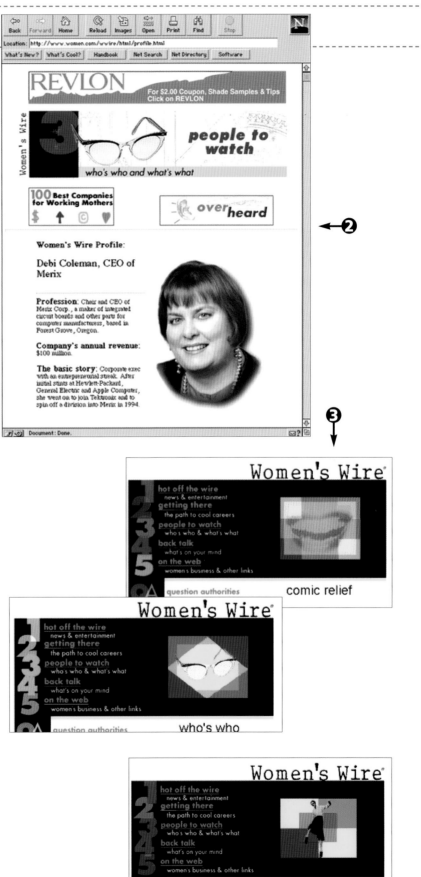

Mary Pisarkiewicz and Steve Mazur

Managing Partners of Pisarkiewicz & Company, Inc.

PHOTO: MICHAEL KANAKIS

Mary Pisarkiewicz founded Pisarkiewicz & Co., Inc. seventeen years ago, right after graduating at the top of her class from Parsons School of Design. As creative director of the company, she has worked across many industries and in just about every communication medium. Mary has also been a lecturer at Parsons School of Design and is currently co-chair of the Joint Ethics Committee, a nationwide arbiter of issues for the design and advertising industries.

Steven Mazur, who graduated from the University of Maryland in marketing and economics, is now one of the pioneers in the multimedia industry. In 1987 Steven founded KSM Interactive, where he created the P.R.I.D.E. Program for Responsible Alcoholic Beverage Service, an award-winning interactive video program developed for the hospitality industry. Now with Pisarkiewicz & Co., Steven produces all multimedia projects and

helps ensure that their strategic and innovative design work meets clients' objectives.

With offices in the Flat Iron District of New York City, Pisarkiewicz & Company, Inc. consists of a creative director, four designers, a strategic marketing and multimedia specialist and four support people. "We set clear communication goals in our multimedia projects," explains Mary. "Among our primary goals for our client is to evoke a response from the customer . . . to buy, to register, to inquire." Clients include American Express, Colgate-Palmolive, Katz Media, Kraft Foods, Schering Plough and Warner Music Group.

Their website is located at http://www.designpm.com. ★

CD-ROM

Pisarkiewicz Portfolio: A Study in Elegant Simplicity

Pisarkiewicz & Co., Inc.

Marketing and selling in the technology game is often more complex than selling relatively lower-budgeted print pieces to a customer. Often, depending on how large the difference is between a client's needs and desires, there is a critical education component to the process, usually on the front end. ("Yes, sir, that would be cool to do . . . but this is what the technology, your budget and our talent are currently capable of. . . .")

A good strategy is to combine the education process with the introduction of the design group's portfolio, as Pisarkiewicz & Company did with their disk-based self-promotional piece. This is a delightful piece of work—simple and elegant in its design and in synchronization with all of Pisarkiewicz's other communication and packaging pieces, many of which are featured on this digital portfolio.

Mary explains, "We use the program to actually get the client thinking by posing critical questions that make [them] evaluate their current communications design situation. Then we show them how they would benefit in working with Pisarkiewicz & Company, by showcasing our work, giving an understanding of our thinking and a feeling of who we are as a company."

The project was designed from the ground up for Macs and PCs, with an intuitive point-and-click interface enabling the viewer to peruse a portfolio that shows problems and solutions. The look and feel of the piece is also consistent with the company's Internet site.

The entire portfolio has been optimized and compressed into a self-extracting installation program that comprises 4.2 megabytes of compressed files divided across two floppy disks. Though it can be delivered on a CD-ROM, it is often preferred on the floppies, which enable the program to run on a much wider array of clients' computers. The client simply installs disk one, and runs an automatic assembler program where it installs Pisarkiewicz's program on the user's hard drive. ★

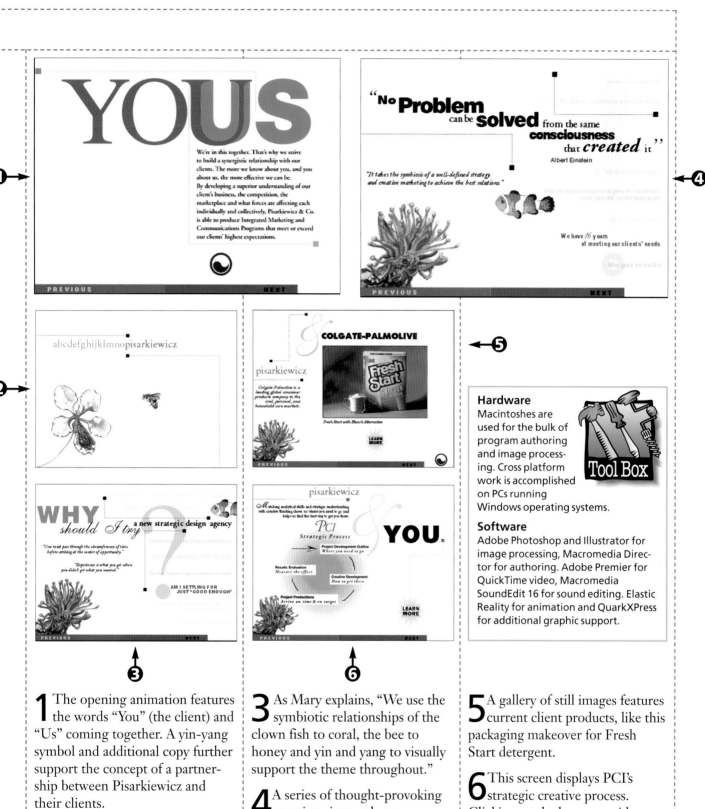

Hardware
Macintoshes are used for the bulk of program authoring and image processing. Cross platform work is accomplished on PCs running Windows operating systems.

Software
Adobe Photoshop and Illustrator for image processing, Macromedia Director for authoring. Adobe Premier for QuickTime video, Macromedia SoundEdit 16 for sound editing. Elastic Reality for animation and QuarkXPress for additional graphic support.

1 The opening animation features the words "You" (the client) and "Us" coming together. A yin-yang symbol and additional copy further support the concept of a partnership between Pisarkiewicz and their clients.

2 In this delightful bit of animation, a bee flies across the screen to meet the flower as the letters spelling the company name materialize at the top.

3 As Mary explains, "We use the symbiotic relationships of the clown fish to coral, the bee to honey and yin and yang to visually support the theme throughout."

4 A series of thought-provoking questions is posed, many followed by an encouraging response that expounds on the benefits of a working relationship with Pisarkiewicz & Company.

5 A gallery of still images features current client products, like this packaging makeover for Fresh Start detergent.

6 This screen displays PCI's strategic creative process. Clicking on the boxes provides more information on each topic.

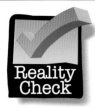

Optimum Resolutions and File Formats: A Step-by-Step Tutorial

Optimum scanning dpi, of course, depends on the size and quality of your image. Let's go step by step through scanning and optimizing a small image, say 1½" x 2¼", and enlarging it to 320 x 240 pixels (roughly a 200 percent enlargement).

1. Set your scan rate for at least 300 dpi, specifying an RGB color palette (save as a PICT or Adobe Photoshop file).

2. Now scale the image up in Photoshop using the Image Size command in the Image Menu. This halves the resolution of your image to 150 dpi, still ideal for maintaining a sharp image.

3. I recommend doing all image manipulation, including special effects, at full-color RGB and at double the resolution of your target dpi (which is always 72 for multimedia and the Web). You scan at 150 dpi. This way, the image will stay sharp and less pixelated through the manipulation process. So at this point, do whatever you want with the image—run it through filters, change the colors, go nuts.

4. When you are finished manipulating, change the file size to 72 dpi. Note that the image will be 225 kilobytes in size. Save the image as a native Photoshop file so we can experiment with it later in its original state.

5. It's time to reduce the image's color depth and choose a file format compatible with your multimedia application (for multimedia on most PCs, that means 256 colors at the most). Go to the Mode Menu and choose Index Color. You have a lot of options here. You can choose a color depth from three bits per pixel on up to eight bits per pixel (256 colors). Experiment with these and see what happens to your graphic, but ultimately you will select 256 colors, especially if it's a photo with continuous tones. I've found choosing "System" in the Palette Box is the safest for all images destined to run on any multimedia-capable computer. On today's newer PCs (and Macs) it's not always necessary to reduce graphic file sizes that radically, but it's still advisable—especially when you are planning to animate the graphics.

Remember, choosing Index Color locks in just the palette colors used by the image. If you were to go back and manipulate the file, it would crumble into pixels (try it). You can re-manipulate the image, but you'll have to change it back to full-color RGB in the Mode Menu. Doing so gives you the color depth necessary to manipulate images in Photoshop and attain anti-aliasing.

6. After manipulation, select Index Colors again for the image. Save the file as a PICT file with 256 colors. Note the size: less than 70 kilobytes.

7. Reopen your original 225 kilobyte Photoshop file. Let's explore another option with graphics destined for the Web. You can leave your image as a full-color RGB and save it in JPEG format (the most popular file format for graphics on the Internet). Note the file size. What was once 225 kilobytes now occupies just 3.24 kilobytes on your hard drive as a JPEG. This is because JPEG is a true image-compression scheme, compatible with Web browsers, which can download and uncompress the file for your display—the quality of the image will be intact. The Web loves JPEG files, which can be downloaded fast. ■

The Internet particularly needs graphics that are lean and mean, with limited palettes and small file sizes. If your graphics on the Web download too slowly, you will only make your audience impatient. In CD-ROM development, graphics have to be similarly light and lively so there's room for synchronized sound files, animation and all the other data that has to make it through the wire.

Resolution and Color Depth
For a lot of artists, especially those new to computer graphics, resolu-

tion is still something of a mystery. Seriously, do you really know what the optimum dpi scan resolution should be for a 3" x 5" color landscape photograph that is going to be reduced to 2½ inches wide in your target publication and commercially printed at 133 lines-per-inch?

The commercial print rule of thumb is: Scan your photos at two times the lines-per-inch (lpi) of your target printer technology. This means scanning the photo at 266 dpi, right? Wait! The picture will be reduced by 50 percent in the final layout. So you could scan at, say,

150 dpi, and the reduction of the photo by half would double the resolution of the final image to 300 dpi. (Note that this is actually *better* than the 266 dpi required by our rule of thumb. In fact, the correct answer is any number between 133 and 150 dpi.) Knowing this, you can scan at 150 dpi and save on file size, plus still have more than enough resolution for a quality result.

For multimedia, things are a little different. Color graphics for multimedia production are always 72 dpi in their *final* form. However, just as it is with print production,

that doesn't mean you have to scan or manipulate images at 72 dpi. Depending on the image, it's best to scan and edit at a higher resolution, at least 150 dpi, even for multimedia images. The higher the resolution, the better your images will hold up to manipulation—like scaling, stretching, bending, shrinking and whatever else you plan to do to them in Photoshop.

GRAPHIC FILE FORMATS

The following are brief explanations of some of the most common graphic file formats.

PICT (Short for "picture"): File formats for CD-ROM multimedia animation or digital video are always PICT files. (Other file formats are for other applications—EPS and TIFF are always for printing and publishing.)

GIF (Graphic Interchange Format): This is a popular graphic file format for the World Wide Web. GIF files can be interlaced like a video frame (called an interlaced GIF) that materializes on the screen in stages as it continues to download.

A GIF image's color palette must be indexed (limited to a specific color for each pixel). These palettes don't allow the pixels to alias or blend at the color edges, but this isn't important unless you're going to re-edit the image in Photoshop—then you must convert it to RGB. Regardless, GIF's limited color palette scheme further lowers the image's color overhead and provides you with a smaller file size.

JPEG: This Joint Photographic Expert Group standard file format can be used to format Web graphics. It allows you to display an RGB image that has been compressed for more rapid transportation through the wire. JPEG has become a popular method of compressing graphics intended for the Web. There are plug-ins in Adobe Photoshop (Pro-JPEG) that allow you to adjust the compression ratio and file size, but at some loss of image quality. Depending on the graphic, some compress better than others.

Remember: Your goal in preparing graphic images for multimedia is to always reduce the color your images need to display properly, so that the images can be animated smoothly in your multimedia authoring environment, or downloaded quickly on your webpage.

DEBABELIZER

What if you're faced with the challenge of converting a whole pile of graphics from a full-color Macintosh platform to a PC multimedia project designed to support a 256-color (or less) palette? Image conversion and optimization on a large scale can be extremely tedious—opening each graphic, one at a time, and resetting the color palette to 256, then saving the graphic in the appropriate format.

There's a great software program called DeBabelizer that can do this laborious chore for you. Its best feature is that it can batch process—all you have to do to set up the conversion process is select the files you want to convert, choose the graphics file format to which you want to convert them and hit the execute button.

DeBabelizer supports conversions among more graphic file formats than you knew existed. Along with Photoshop, DeBabelizer is one of the most productive programs you can have in your studio.

3-D IMAGING AND ANIMATION

Three-dimensional graphics and rendering programs are an important part of multimedia production, but instruction on how to use them is an art form that requires its own set of books. It is an entirely unique craft that didn't really exist before computers were programmed for the express purpose of creating graphics.

Artists who specialize in working with 3-D imaging programs are special people. Most designers who are in this trade are also animators, and know how to render not only environments in virtual space but also conceptualize figures in that space.

If you are green as grass when it comes to 3-D animation, a great introductory program is Specular LogoMotion. It's surprisingly robust for such an inexpensive program, allowing you to extrude 2-D graphic files, such as a logo, render a surface over the wire-frame, light the creation you've made with several adjustable light sources and animate the object into a Quick-Time movie file.

WHERE WE ARE HEADED

Regardless of how powerful computers become, how much capacity will be available on CD-ROMs or how fast the Internet will become, graphics created for these multimedia platforms will have to be produced in a manner that optimizes their file sizes. Not only do your graphics have to make it through the wire, but they are competing for data space with the program's other assets, like animation, music and sound effects. The most useful skill you can develop, besides drawing ability, is how to leverage resolution and color depth to create the highest quality graphics possible for your target platform.

One of the best examples of how a team of artists managed limited color palettes for maximum image quality is found in one of my favorite SuperNintendo games. Take the opportunity to study the screens of "Donkey Kong

Country," especially the underwater swimming sequences. I'm a scuba diver, and this game captures the reef environment very accurately.

Of course, computer game environments like SuperNintendo use multiple customized (but limited) color palettes. You are actually viewing foreground and background layers, each with its own complete system color palette. The illusion of depth and dimension is so splendid in "Donkey Kong Country" that it's hard to describe in words. But regardless of how complex this image appears on the screen, the palettes are limited to as few colors as possible. The game needs every bit of data space it can claim to convey animation, rich music and sound tracks, and interactive functionality.

CHAPTER 11

Beta Testing, Mastering and Duplicating

Alpha testing is primarily concerned with the basic look of the program in its earliest developmental stage. But functionality testing, although it may have its earliest beginnings at the alpha stage, continues throughout the production process. The rounds of testing that follow the alpha test are the most crucial, and are known as beta testing.

Beta testing typically takes place in stages. As bugs are discovered and corrected, subsequent repaired versions can be released for reevaluation. Beta test versions can be identified by a simple numeric code (V1.0a for "version 1.0, first edition," V1.0b for "version 1.0, second edition," etc.).

BETA TESTS MUST BE CONTROLLED EVENTS

Beta tests must be highly controlled events with a designated quantity of qualified users. Your user group can be divided into two basic types of user:

1. The Power User: This tester can be counted upon to put your application through its paces and provide you with constructive feedback on the program's functionality and problems. The expert user will typi-cally make recommendations for improvements.

2. The New User: New users will tend to give you a more accurate evaluation of the current level of performance, comfort levels at various points in the program, and will likely uncover unique bugs.

The first group of beta testers need not be supervised. The neophytes, however, should be supervised closely. Your best beta testers are formed into manageable focus groups who can be closely observed actually using the product.

If you can arrange it, put the users in a room alone with two video cameras, one trained on their faces while they perform functions, and the other trained on the screen. You will probably learn more about your program from observing your user's face than anything else. You'll observe things like impatience at your program's poor performance or delays, frustration at clicking upon graphics the user thought were buttons and a desire to skip dull material.

BETA TESTER'S RULE: DOCUMENTATION

Having participated in several beta tests, I've had to fill out my share of

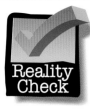

Know Your Target Platform

If you plan on distributing your multimedia projects to other computer users, you have to realize that all computers are not created equal. No two Macs or PCs are equal in performance—no two Quadras, Power PCs, 486s, 486 DXs or Pentiums. This is because virtually all personal computers have been customized by their owners. Memory, disk speed, capacity and speed of RAM, and processor speed all contribute to enhance or degrade the performance of software.

You'll notice that packaging on CD-ROMs specifies minimum computer configuration requirements. These descriptions go beyond the basic Mac/Windows/DOS labeling to include RAM capacity. "This CD-ROM requires a 486 with a minimum of 8 megabytes of RAM." Believe me, you'll be a step ahead of your competition if your labeling is accurate, because (whether intentionally or unintentionally), this type of labeling *isn't* always correct.

No story better illustrates this point than the one about a Hollywood studio whose newly formed interactive subsidiary issued a major CD-ROM production just in time for Christmas; the product featured the characters of a popular animated film. The CD-ROM box had labeling announcing that the program would run on a 386-class PC compatible computer. This turned out not to be the case. Advanced users with 486 and 486-DX4 machines may have had some luck with it, but the company's customer support lines were flooded with angry calls from parents of very disappointed children. A lot of disks were returned to retailers after Christmas.

The lesson? Know your audience and the computers they are likely to have, and don't overproduce your product for the target platform. And always advertise your product with an accurate decription of what type and level computer is needed to run it. ■

evaluation forms. It's the price one pays for the honor of being a beta tester.

More Than Just a Bug Hunt

Evaluations have to be more than just bug hunts. Don't worry, you'll hear about the defects. But what you especially want from your experts are their overall impressions of your software. The real test is how you leverage this information to improve your software.

Here are six of the best questions you can ask. Don't be fooled by their simplicity or seeming innocence. They are designed to provoke just the responses you'll need.

1. Describe your computer platform:

Brand _____,

Model _____,

CPU_____,

Megahertz (processor speed)

_____,

RAM _____.

2. What do you think about the user interface? Rate the design for look and feel: 10 being "best," 1 being "needs help."
3. What exactly would you change about the interface?
4. About the program's content: What areas of this interactive environment interested you the most? The least?
5. Rate the program's overall performance: 10 is "zippy," 5 is "average performance," 1 is "needs speed."
6. What's missing? Is there content you feel should have been included? What?

These are probing questions that will deliver news you can use. Question 1 is crucial information that will help reveal platform-specific problems.

TEST ON YOUR TARGET PLATFORM

Certainly, you can develop your project on a more powerful workstation, but as early as possible in the development cycle, you will need to optimize your project's performance. The best way to do this is to play your project on your users' target platform.

If it's designed to play on a general class of computers—like Macintoshes or PC 486s—tweaking will be required to enable the application to perform on the minimally configured, or lowest common denominator system in that class. Software marketing companies continually monitor the installed base in their effort to match their software's performance to the largest group of users possible.

Test Extensively

If your application's minimum target platform is a PC 486 DX2 running at least a double-speed CD-ROM, then you should extensively test your product on that platform. However, don't be surprised if you discover two "identical" computers that don't perform exactly the same way.

Often two similarly equipped and configured PCs may contain slightly different versions of critical

utility software. This is particularly true in the realm of hardware drivers. Case in point: I installed a catalog software demo on some Pentium-based notebook computers with built-in CD-ROM drives. One notebook was a Panasonic and the other a Toshiba. After we launched the program, we noticed the performance of the video clips was distinctly different. One performed well (the Toshiba) while the other performed haltingly and was out of sync. The machines had similar double-speed CD-ROM drives and were both equipped with 16 megabytes of random-access memory. Both machines were running Windows 95 and the latest version of QuickTime for Windows. What was the problem?

It took us several hours of testing, and reinstalling key software components on the Panasonic. No matter what we tried, our program ran poorly. We did discover that our program ran acceptably on a Panasonic notebook equipped with Windows 3.1.1. Could it be Windows 95? Finally, we called Panasonic Technical Support.

"Yes, we realize we have a problem," said the tech representative. "It's our CD-ROM hardware driver. It's not completely compatible with Windows 95." We were stunned. We would never have thought of the hardware driver. Until the new driver would be available, we had to run the program on Windows 3.1 on that model.

There are a lot of problems of this sort you'll deal with during the beta testing stage. Because personal computers are precisely that, *personal*, they become configured to the specific needs and applications of their owners. Hence, you never know when you add some new ingredient to the mix if you're about to launch a chain reaction (I call it an allergic reaction).

USING YOUR CD-RECORDER

Copying files on a CD-ROM recorder (CDR) is not as simple as copying files onto your computer's hard drive. You need a CD recording program that requires you to go through a specific list of steps and preparations so your disk is sure to work like it's supposed to when it's finished. You will need at least a 750 megabyte hard drive with about that much free space. This gives you the necessary amount of file cache to allow data to flow uninterrupted from your hard drive to the CD-ROM during the recording process. Incidentally, you can also attach a CD-ROM player to a recorder and record from disk to disk for easy duplication.

Let's say you want to record digital photographic files to a CDR using a Kodak CD Writer drive and accompanying software. You can record a few files now and more later until the disk is full without a problem, but if you are recording a complete multimedia project, it's a good idea to record the whole program to CDR in one uninterrupted session, to ensure your disk will run properly.

If you're copying a huge program that may require using two or more CDRs, your recording software will account for that, and will set up your pre-record routine to accommodate multi-disk recording.

Corel CD Creator

Every CDR comes with utility software to set up and execute your recording sessions in a way that will minimize errors. One of the best third-party software programs currently on the market is Corel CD Creator (less than $100). Its "Disc Wizard" interface easily allows you to organize your files using Windows' drag and drop feature. Also, you can record data and audio to the same disc, which allows users to

play your CD on their multimedia computer or pop it into their audio-only CD player to play just music. The icing on the cake is a CD jewel case insert design template that's included with the program.

CD-ROM SERVICE BUREAUS AND POTENTIAL PROBLEMS

All beta tests at our studio are recorded on CD-ROM "one-offs," or recordable compact disks that perform identically to disks that have been glass mastered. The value of having a recordable CD-ROM drive is discussed in the hardware chapter, but these are not inexpensive devices.

In consulting with several CD-ROM recording service bureaus, I discovered some interesting statistics. On average, I was told, it takes three recordings to get a disk that is reasonably functional. There are a variety of problems encountered, but most are avoidable through careful planning.

CD-ROM Drives Don't Perform Like Dedicated Hard Drives

Most multimedia producers new to the process of producing their work on CD-ROM don't fully understand that a CD-ROM is not really a high-performance hard drive. Consequently, animation, video and sound clips have to be compressed sufficiently to run at a speed matching the data-throughput capabilities of, say, a double-speed CD-ROM (not many are running single-speed CD-ROM drives anymore). Whereas a hard drive and a fast processor could support Quick-Time video in a 320 x 240 pixel window at a frame rate of 15 frames per second with audio at 22 kilohertz, the same clip playing on a CD-ROM would more than likely choke.

It's back to the studio for the time-consuming re-compression of

Checklist: Controlling the CD-ROM Recording Process

- Are all graphics files on board your transport disks?
- Are the file names proper and do they correspond with those needed by the program?
- Are all movie files on board your transport disks?
- Have all movies and animations been compressed and sized properly for CD-ROM data rate?
- Are all sound files on board?
- Are all of the designated font files necessary for the program ready to install from the transport disk?
- Are utility programs on board: QuickTime? Adobe Acrobat Reader?
- Is your installer software application on board? (This is software the end-user will need to install necessary files to their hard drive.) ∎

the original video file to a frame-rate that will play. The video window will likely have to be reduced in dimension, colors dithered down to 256 and frame rate reduced to 10 FPS.

Bad File Names

Another significant problem encountered by the service bureaus is improperly labeled graphic and video source files—especially among programs designed to work on a cross-platform (Mac/Windows) disk. Files should contain no more than eight characters (all lowercase), or they won't be properly located by the disk's directory. It's basic, but a common problem.

Too Much of the CD-ROM Must Be Installed to the User's Hard Drive

Depending on how you've designed your software, and how many high-capacity assets your program depends upon (like video and sound files), some of your program's functional files may run better if they are installed on the user's hard drive.

However, don't succumb to the temptation to install large portions of your program's software files onto the user's valuable disk real estate. It's just bad form to require your users to have enough disk space to literally drag your CD-ROM's contents to their hard drives, even if the program plays better when most of it is transferred. If you find yourself facing this temptation, go back to your programmer and fix the file sizes and optimize performance.

Missing Files

Somehow, in the transfer of a program's assets to transportable media, like a SyQuest Drive, files get misplaced or forgotten. Nothing is more frustrating than firing up the program from the CD and discovering a missing graphic or movie that was supposed to play. Make the extra effort to maintain an accurate inventory of your program's assets.

Miscellaneous Problems

CD-ROM service bureaus tell multimedia producers that many of the problems of faulty disks can be avoided if they have completely bug-checked their program and thoroughly tested it on various platforms before burning a CD-ROM. According to several bureaus I consulted, most people don't do a good job of this, and to compound the problem, most want overnight or rush service, doubling the rate. You better have deep pockets if this is

going to be your CD mastering strategy.

MASTERING AND REPRODUCTION

After beta testing and bug fixing, it will eventually be time to take your program to the next step. Companies who create the glass master, which is used to replicate thousands of CD-ROMs, require only one thing: a reliable one-off from a CD-recorder. CD-ROM manufacturing companies want to make sure you've done all of the necessary pre-mastering testing before they commit your files to this expensive process.

The beauty of CD-ROM manufacturing is in the reliability of the final product. Because this environment deals in extremely precise digital information pressed to a thin metal disk sandwiched between durable clear plastic, the manufacturing defect rate is extremely small—fewer than one in a thousand disks may contain some tiny defect, usually caused by contamination, such as a speck of dust.

DISK LABELING

As a CD-ROM disk revolves at a fairly high speed in a CD-ROM reader or player, a laser beam of light encodes the data from the disk's surface. If you stick a paper label on the top surface of the disk (the safe side), I've often been told you stand a good chance of causing the disk to spin out of balance. Plus, any adhesive or paper speck from the label could, in time, contaminate the play surface of the disk—or worse, damage your drive. Whether or not this will actually happen, it's not a risk worth taking.

There aren't many ways to creatively label a CD-ROM yourself. Sure, you can always use a felt-tip marker. And there is such a thing as a one-off laser disk printer (Rimage

makes one), which puts nice, smooth, one-color graphics on the one-off. Some CD-ROM service bureaus are using them for short runs, too.

SCREEN PRINTING

CD-ROMs are commonly labeled through a special screen printing process, done by the manufacturer. The inks are specially formulated so they don't eat into the plastic surface. They cure at a lower temperature than traditional screen printing inks.

Screen printing CD-ROM disks sounds simple, but it isn't. There are not that many companies that only specialize in printing on disks. I tried to get some blank disks for our CD-ROM recorder pre-printed, and I had a heck of a time finding someone who could do a low quantity (250) for a reasonable price. I did find one, however.

Form Graphics of Winona, Minnesota, specializes in printing on CD-ROMs, including blank recordable disks. I send them a Macromedia FreeHand or Adobe Illustrator file, and a case of disks, and they go to town. Based on a quantity of 250, four-color printing costs about $2.20 per disk. Form Graphics is at 978 Fourth St., Winona, MN 55987, (800) 657-6966.

PACKAGING

The style and quality of your packaging is limited only by your imagination. You can always print labels that fit into plastic jewel boxes—it's rather pedestrian, but it works. You can also go as cheap as cardboard sleeves, or you could insert the disk in one of those book-sized shelf-boxes with molded plastic disk holders, which makes a nice presentation.

TURNKEY SERVICE PROVIDERS

One of the best experiences I've had in this arena was working with a New Jersey CD-ROM recording company, a regular one-stop shop for CD mastering, labeling and packaging. The company is called DiscMakers. I found their ad in the back of one of those multimedia magazines. DiscMakers is at 7905 North Route 130, Pennsauken, NJ 08110, (800) 468-9353.

This company will not only master and replicate your CD-ROM, they can also design your labeling and packaging. The full-color design service is advertised as "free" (OK, it's actually folded into the package price), but the value-added turnkey services provided by this company are just what a lot of producers need.

Ali Sant

Media Designer for the Exploratorium, San Francisco

Alison Sant, media artist and multimedia developer for the Exploratorium, San Francisco, comes to multimedia by way of photography. Her B.F.A. from New York University, TISCH School of the Arts, is in photography, and her coursework combined photography and interactive telecommunications.

Ali's career actually began while still in school; she worked as a researcher for Magnum Photos, taught photography and was a printer for New York photographer, Larry Clark. After college, Ali moved to San Francisco where she became an assistant producer for an interactive production company. She soon joined the staff of the celebrated science museum, the Exploratorium. There, Ali produced CD-ROM projects and multimedia exhibits.

Ali has produced some interesting projects throughout her career, including "American Visions," a CD-ROM project on twentieth century artists; "Vinny McShane," an ongoing photographic documentary spanning eight years of one man's life as he moves from drug addiction through rehabilitation; and "Intersection," an installation at the Exploratorium that appears to merge visitors from two different locations within the museum and places them on the streets of San Francisco using blue screen tech-

Ali Sant

nology. (Blue screen, or chromakey, has been a staple of video and film production for years and has naturally found its way into multimedia production. It's a useful technique that mattes figures against any backdrop you choose.)

Ali also worked with a small production team on "Nagasaki Journey," a website featuring the photographs of Japanese photographer, Yosuke Yamahata. "I became involved in a lengthy discussion with our director of media, Susan Schwartenberg, and Rupert Jenkins (editor of the book, *Nagasaki Journey*)," explains Ali. "Rupert was involved in the development of an exhibit of the Yamahata photographs. We discussed the possible uses of [this] photography on the Web."

In observance of the fiftieth anniversary of the bombings of Hiroshima and Nagasaki, exhibitions were to open simultaneously in New York, San Francisco and Nagasaki. The website was a way to extend the exhibit to a larger audience. A user forum was included for reflection and discussion.

"We wanted to create a design that would be visually interesting and accessible," explains Ali. "We also wanted to create something . . . appropriate to the weight of this material, that would initiate an atmosphere where people would be engaged and reflective. I discovered that it was interesting to begin thinking of the Web in this way," adds Ali. "Its potential lies in the creation of atmospheres or environments instead of pages. This way, people aren't just looking at a collection of information but a context within which to examine things." ★

Nagasaki Journey: Letting the Images Speak

Ali Sant

August 10, 1945, the day after the bombing of Nagasaki, Yosuke Yamahata began photographing the devastation. His companions on the journey were a painter, Eiji Yamada, and a writer, Jun Higashi. More than fifty years later, the renowned Exploratorium museum of San Francisco, California, mounted a showing of the Yamahata photographs, one of the most dramatic collections of images depicting nuclear devastation ever seen.

The Exploratorium creative team handled the images with respect and reverence. The site's black background sets off the richly detailed black-and-white images very effectively. Interaction is simple—viewers have the impression they are turning the pages of a rare book rather than visiting a website.

For some it may be difficult to view this site. For others, it may be too politically provacative. Still, the site's creators knew that these images and words must never be forgotten nor relegated to the exclusivity of a gallery or museum.

The creative team who worked on this project included director of media Susan Schwartenberg, Ali Sant, Rupert Jenkins, Marina McDougall, Michael Pearce and Jim Spadaccini. ★

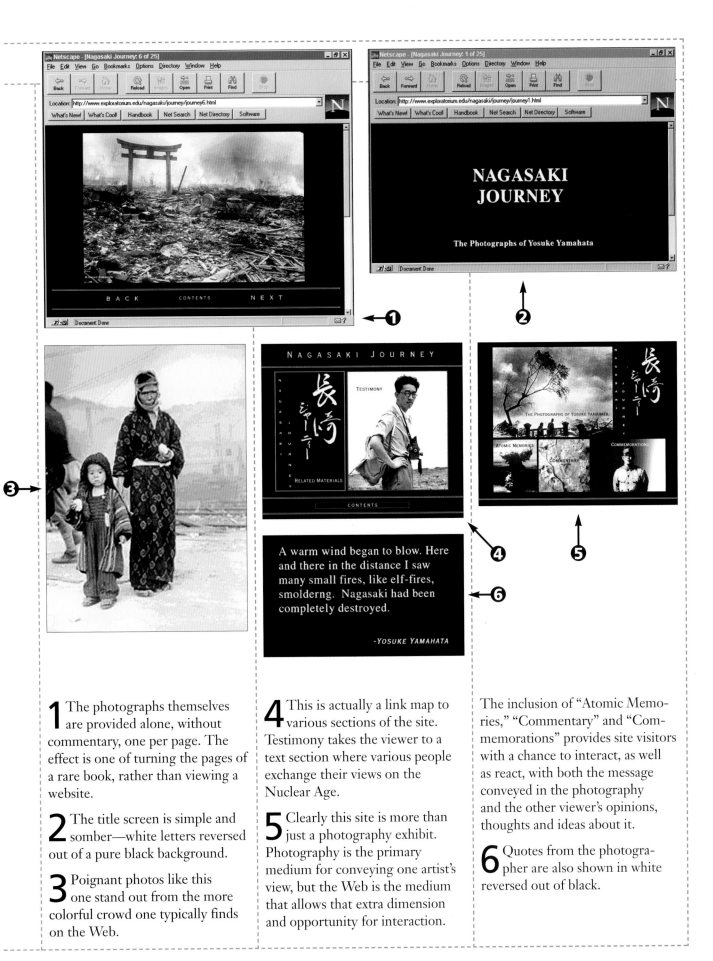

1 The photographs themselves are provided alone, without commentary, one per page. The effect is one of turning the pages of a rare book, rather than viewing a website.

2 The title screen is simple and somber—white letters reversed out of a pure black background.

3 Poignant photos like this one stand out from the more colorful crowd one typically finds on the Web.

4 This is actually a link map to various sections of the site. Testimony takes the viewer to a text section where various people exchange their views on the Nuclear Age.

5 Clearly this site is more than just a photography exhibit. Photography is the primary medium for conveying one artist's view, but the Web is the medium that allows that extra dimension and opportunity for interaction.

The inclusion of "Atomic Memories," "Commentary" and "Commemorations" provides site visitors with a chance to interact, as well as react, with both the message conveyed in the photography and the other viewer's opinions, thoughts and ideas about it.

6 Quotes from the photographer are also shown in white reversed out of black.

Paul Sidlo

ReZ.n8 Productions

Paul Sidlo, whose professional background is in broadcast production design, is currently president of ReZ.n8 Productions, a Hollywood, California, design studio that comes to multimedia from the video and film industry service sector. Paul's résumé prior to coming to ReZ.n8 is impressive, and includes producing and directing trailers and titles for Disney, Interscope, Savoy Pictures and Caravan Pictures; as well as broadcast design and packaging for CNN, Warner Bros., CBS Sports and News, Fox Home Entertainment, The National Football League and the Winter Olympics.

ReZ.n8 specializes in computer animation and special effects work. Among its clients are Dream Quest (Industrial Light and Magic's commercial division), Lucas Films and Disney Imagineering.

Paul has won numerous awards since he graduated from Ohio State University with a B.A. in Communications. He's been a producer, director and designer for nearly twenty years. As president of ReZ.n8, he has developed some of the world's finest computer animation. An acknowledged pioneer in the field of computer graphics, he's in demand world-wide at conferences, where he speaks about computer animation and his other areas of expertise. ★

ReZ.n8 Productions

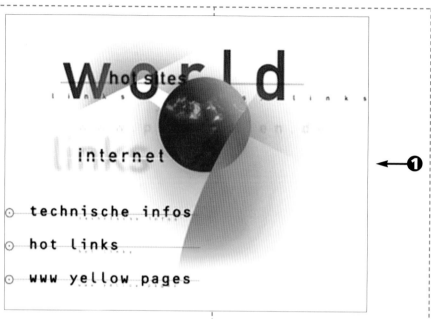

◀— ❶

Pro Sieben: German TV Station Uses the Web to Promote Its Schedule

ReZ.n8 Productions

Pro Sieben, one of Germany's largest television stations, joined many other broadcast companies around the world when it decided to put up an informative website promoting its programming schedule. Young families are the target audience of this station's site, so ReZ.n8's goal was to project a clean, yet somewhat abstract, illustrative style with the use of experimental typography.

The content of the site includes information on Pro Sieben's movies, news, talk shows and other programming information. The website was designed to include all of these areas, along with community news.

ReZ.n8's Web designers rely on some useful design conventions in their construction of this site; for example, a navigation bar on the bottom of each page makes navigation easy, even for a first-time user. The site is organized in a simple, user-friendly way; its hierarchical structure makes for simpler and faster navigation. The site uses a customized search engine, so a user can retrieve data just by typing in a word or a series of words, called a query.

Of course, the entire site is in German, which required a significant amount of translation time for the designers, programmers and everyone else involved in the project. "Fortunately," says Paul, "two of ReZ.n8's staff members speak fluent German."

The designers for this project included Paul Sidlo (creative director), Eleanor Glock and Sherry Gordon. ★

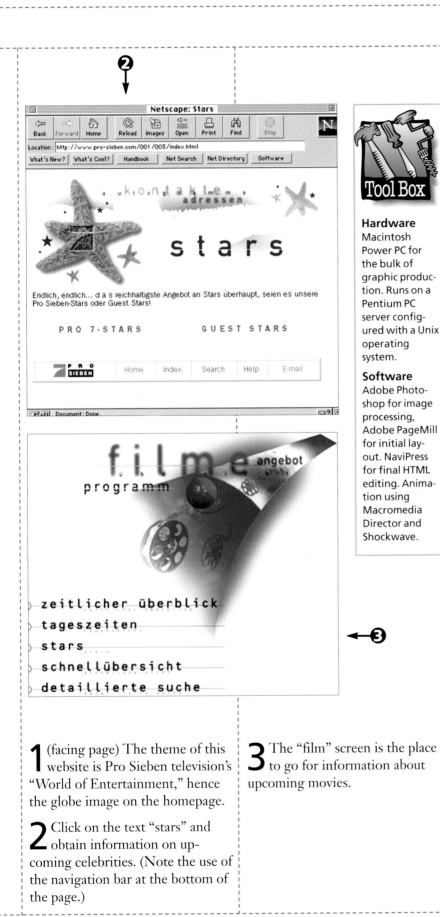

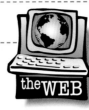

FOX Sports Website
ReZ.n8 Productions

If you're a sports fan, there are several sites on the Web containing everything from scoreboards and point spreads to sports news, opinion and trivia. There are even sites featuring "chats," or online interviews, with star athletes. But in terms of all-around usefulness, few exceed FOX Sports' website, designed by Hollywood's ReZ.n8 Productions. From a sports fan's point of view, this is a terrific site, since it delivers the goods quickly, thanks to great programming—you can get important information immediately, such as what the score is, and what time the game begins.

You don't have to spend a lot of time in this site to begin tapping the wealth of information available. As just one example, the NHL Hockey area has detailed information and photographs on the new "FOX-TRAX" puck technology, a new video tracking method designed to enhance the viewer's experience by resolving the age-old problem in TV hockey: the inability of the viewer to see the fast-moving puck. This type of in-depth information is typical of what's available in other parts of the site, such as football, baseball and basketball.

In addition to lots of features and great functionality, the entire site just looks great. It has the look, feel and sense of immediacy of a giant arena scoreboard. ★

Tool Box

Hardware
Macintosh Power PC for the bulk of graphic production. Runs on a Pentium PC server configured with a Unix operating system.

Software
Adobe Photoshop for image processing, Adobe PageMill for initial layout. NaviPress for final HTML editing. Animation using Macromedia Director and Shockwave.

1 (facing page) The theme of this website is Pro Sieben television's "World of Entertainment," hence the globe image on the homepage.

2 Click on the text "stars" and obtain information on upcoming celebrities. (Note the use of the navigation bar at the bottom of the page.)

3 The "film" screen is the place to go for information about upcoming movies.

ReZ.n8 Productions

➊

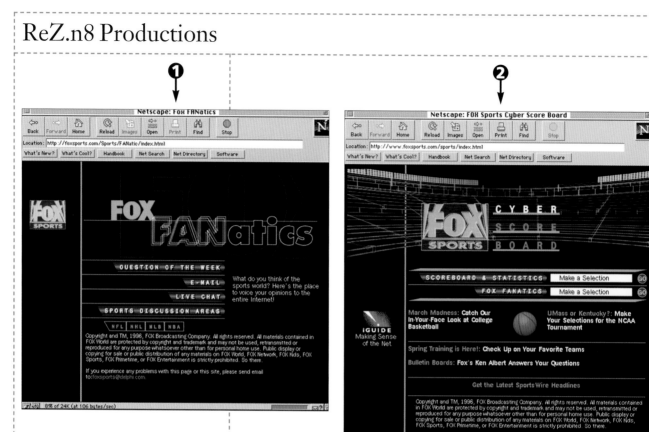

➋

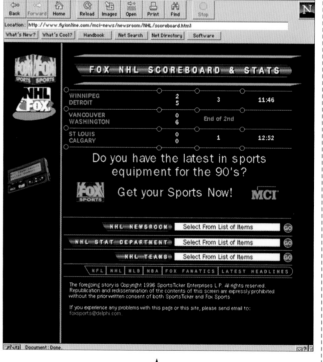

FOX Sports Website

1 Constant animation is provided with a spinning FOX Sports logo in the corner of the screen. Also note the use of frames. A variety of hyperlinks can be displayed along the left margin of the screen, adding additional navigational opportunities.

2 This site makes heavy use of pop-up menu buttons, which allow the user to quickly navigate to the score and schedule board of choice: hockey, football, baseball and basketball.

3 Navigation buttons are located in a consistent spot from scoreboard to scoreboard, so the user is never more than a click away from another sport featured in the site. This is an excellent example of non-linear branching. The user doesn't have to revisit the home page to figure out where else to go.

Tool Box

Hardware
Macintosh Power PC for the bulk of graphic production. Runs on a Pentium PC server configured with a Unix operating system.

Software
Adobe Photoshop for image processing, Adobe PageMill for initial layout. NaviPress for final HTML editing. Animation using Macromedia Director and Shockwave.

➌

Glossary

AIFF (Audio Interchange File Format)—A 44 kilohertz (kH) audio file format playable in a wide variety of software applications on both the Mac and PC. Designated on the PC by file extension .AIFF, .AIF or .IFF.

Aliasing—The pixelation of an image on a computer screen. Aliasing is the byproduct of resolution enforced by an image's scan ratio to the image's final screen size. For example, if you scanned an image of a postage stamp 1:1 at 72 dots-per-inch and then decided to enlarge the image to fill your screen, radical aliasing would result. Aliasing is also known as pixelation or "the jaggies."

Anti-aliasing—Pixel manipulation to minimize aliasing. In bitmap editing programs like Adobe Photoshop, anti-aliasing can be performed automatically. The image's pixelmap is analyzed and interpolation (or blurring) takes place between contrasting pixels, thereby softening the severe stairstepping. In multimedia production, anti-aliasing is utilized to smooth the edges of typographic elements, and floating or animated images to make them more pleasing to the eye.

AVI (Audio Video Interleaved)—File format for video with sound files developed by Microsoft to play in Windows applications. In Windows, these video files are stored with the .AVI extension to enable your computer's multimedia software to find and play on demand.

BMP (Bitmap)—A graphic file format developed to save bitmapped images for display in Windows applications. Designated by a file extension of .BMP.

Cinepak—Trademark name for a highly efficient video compression scheme originally developed by SuperMac Technologies (now Radius). It's most often used to compress videos for CD-ROM playback. It can handle up to 24-bit color depth video, but it allows you to compress files down to 8-bit color and does a good job of dithering the colors to deliver acceptable quality.

Codec—Acronym for video compression/decompression. Video files represent an enormous amount of image data, which must be compressed to enable storage, and then decompressed to enable smooth play on a variety of computer platforms. Several software algorithms (or codec schemes) have been devised by technology companies and industry engineering groups to process video data; these include QuickTime, JPEG, MPEG, Truemotion, AVI, Indeo and Cinepak.

DIB (Device Independent Bitmap)—A Windows image format for bitmap files that allows transportation of the image to a wide variety of devices, such as game platforms, other computer platforms and other bitmap or image editing applications.

Dithering—Pixel interpolation that takes place when images are translated from a larger color palette to a smaller one. The main purpose of dithering is to reduce the size of the graphics file, while still providing for relatively smooth color rendition. Multimedia requires graphics files to be as small in size as possible, and dithering graphics and videos is one of the best strategies for achieving this. Many graphic programs, for example, edit images in 24-bit color depths for the target desktop publishing user. The multimedia producer doesn't necessarily need 24-bit color depth, preferring smooth movement to smooth color rendition. So, 24-bit files are re-rendered to 8-bit color depths (256 colors), significantly reducing file sizes. In order for the image to display relatively smooth color transitions with this more limited color palette, dithering, or pixel interpolation, takes place.

Dithering Down—See *Dithering*.

DVD (Digital Versatile Disk)—Compact disk standard established by industry leaders to increase the capacity of the disks. The new format holds 4.7 gigabytes per layer compared to 680 megabytes for a CD. DVDs offer a dual-layer, single-side option, for even higher capacity: 8.5 gigabytes on a single side.

EPS (Encapsulated Postscript File)—A desktop publishing file containing high resolution printing information, color separation data and a low-resolution placement component to be used for positioning in a page layout program. You must convert EPS images into PICT files for use in multimedia applications.

FPS (Frames Per Second)—The number of frames played per second; the measurement of video speed required to provide the illusion of motion. When an analog video signal is captured by a computer, it is converted to frame-based animation, or a series of bitmapped images that fly by your eye, almost identical to the way motion picture film reproduces motion. The quality of this illusion is maintained by the quality of the individual images and the number of frames viewed per second. Thirty frames per second, or full-motion, provides fluid, seamless motion, but 30 FPS is possible on only a few very powerful computers. On multimedia CD-ROMs, for example, video can play at 10 frames per second and still be acceptable. Animation (as in cartoons) can run acceptably at 10 to 15 frames per second.

FTP (File Transfer Protocol)—Internet terminology; a method of downloading or uploading files from one networked computer to another.

GIF (Graphic Interchange Format)—A file compression format developed for graphics exchanged on CompuServe, America OnLine and the Internet. GIFs can be opened on any platform provided you have a GIF reader utility that allows you to convert the file into a file format viewable on your computer.

Gopher—One of the more famous Internet text file search utilities.

Graphic Conversion—A necessary part of your production process if you're making a cross-platform product or repurposing graphics from one platform (such as

the Mac) to another (such as the PC). This usually means taking the high-resolution, 24-bit graphics containing millions of colors and converting them to 256 colors, then saving them in different compatible graphic file formats using bitmap editing programs. Adobe Photoshop is one option; Debabelizer can be used for batch converting lots of graphics files.

Homepage—A highly graphical billboard on the Internet, which may or may not be connected to additional pages of related information. When used in a multiple-page offering, the homepage may be compared to the title page of a book. Homepages are viewable by the user with an application called a Web browser. A homepage may contain buttons or hypertext elements that allow the user to view or download files or that transport the user to other locations on the homepage's resident file server.

HTML (Hyper Text Markup Language)—The Unix-inspired machine language used to design homepages on the Web.

Hybrid CD-ROM—(1) A CD-ROM formatted to play on Mac, Windows and DOS machines, or (2) a CD-ROM disk that has links to online services, such as the Internet or World Wide Web. For example, a company may issue a video-rich catalog of their product line on CD-ROM, with the current price list and new product information available online. The CD-ROM would contain the necessary communication software to allow the user, at the click of a button, to access the remote online files from a computer with a modem.

Hyperlinks—Areas on a webpage where the user can point and click to navigate to new areas of interest or reference.

Indeo—High-quality video codec scheme devised by Intel to play video on personal computers equipped with Intel processors.

Java—A programming language developed for the Internet by Sun Microsystems. It has been instrumental in moving software toward a more modular "applet" environment, in which key, useful bits of software code are delivered via networks, then combined by the user to form entirely new and custom-tailored applications.

JPEG (Joint Photography Expert Group) and Motion JPEG (Motion Joint Photography Expert Group)—Two variations of a codec scheme. JPEG was originally devised as a means to store still images, and it was soon adapted to compress and decompress frame-based video (Motion JPEG). This innovation enabled non-linear editing of extremely high-quality video on a computer (see *MPEG*).

Metafile—A multi-platform graphic file that contains both vector (line-based) and raster (bitmapped) image data. Also see *WMF*.

Microsoft Video—see *Video for Windows*.

MIDI (Musical Instrument Digital Interface)—A digital file format that facilitates the capture of sound generated by musical instruments. MIDI sounds are captured and managed with a MIDI sound card installed in the computer. MIDI hardware enables musicians to digitally map musical sounds to specialized computer software, where they can be edited using a graphic interface. The files can also be charted onto musical score sheets and printed. The true usefulness of MIDI, however, is in its ability to create music and sound files in formats compatible with a wide range of sound reproduction computer hardware. MIDI files are designated on the PC by file extension .MID or .MFF (for MIDI File Format).

Mosaic—The first World Wide Web browser, developed by the University of Illinois Super Computer group for navigation on the Internet. This browser was originally distributed free to anyone on the Internet, and became incredibly popular because it provided the graphical interface that moved the Internet from a command line text-based medium to a bonafide multimedia experience. Mosaic's developers ventured into commercial enterprise and formed the now-famous Netscape.

Motion JPEG—See *JPEG*.

MPEG and MPEG II (Motion Picture Expert Group)—The current quality standards for digital video compression schemes. MPEG is the consumer-grade standard for video (320 x 240 pixels) and is designed to play on CD-ROM, for example. MPEG II (640 x 480 pixels) is the broadcast video standard characterized by even more powerful compression and smaller file sizes, enabling video to be more easily transmitted via satellite or through fiber optic cable.

In comparing MPEG to JPEG or QuickTime, JPEG compresses video one complete bitmap frame after another, in what is referred to as spatial compression. MPEG uses a temporal compression scheme in which only differences in frames of video are compressed. Subsequently, MPEG can compress a video segment to a much smaller file size (200:1), while still maintaining high quality. Currently, hardware add-ons are required to compress and decompress MPEG files. But as computers become more powerful, MPEG will be accomplished entirely in software, as QuickTime is on today's computers.

Netscape—A commercial Web browser.

Non-Linear Editing—Computer-based editing of video performed in a non-linear environment: A much more flexible method of editing than traditional linear or A/B roll editing. In non-linear editing, a time line of the video program is represented on the computer screen, and video clips or segments can be placed on the time line in any order desired.

NTSC (National Television Standard Connection)—One of two competing world video hardware standards (the other is PAL). NTSC is accepted in North

America and in several other parts of the world. PAL, by contrast, is accepted in western Europe and Australia.

Overlay—To place one graphics element on top of another, or otherwise combine different multimedia elements; when text titles, for example, are combined with video, they are "overlayed."

PAL (Phase Alteration Line)—One of two competing world video hardware standards (the other is NTSC). PAL is accepted in western Europe and Australia. Videotape from these regions may very likely be in PAL format, and may not play on your NTSC video playback equipment.

PICS—Animation compression file format most popular on the Macintosh platform.

PICT (Picture)—The most common graphic file format for still images in multimedia; PICTs are bitmap images.

Pointer—In the lexicon of the Internet, these are user-activated commands, usually in the form of on-screen buttons or hypertext, which when clicked upon transport the user to another location or homepage.

PPP (Point to Point Protocol)—Internet terminology. A dial-up access method provided by Internet access providers. A lower capacity, smaller bandwidth and lower speed connection than a SLIP. Also see *SLIP*.

QuickTime—Apple's trademark video codec technology. A cross-platform software utility that enables frame-based animation, video and audio files to play. PC equivalents include Video for Windows (Microsoft) and Indeo (Intel).

Run-Time Application—A project that runs on a user's computer without the software program that was required to create it. Authoring programs—such as Macromind Director, Macromedia Authorware, Apple HyperCard and SuperCard—all have the ability to create run-time applications.

SLIP (Serial Line Internet Protocol)—Internet terminology. A dial-up access method provided by Internet access providers. A higher capacity, larger bandwidth and higher speed connection than a PPP. Also see *PPP*.

TGA (Targa)—A high-resolution, 24-bit image format developed by Targa/True-Vision. This format is widely supported by video editing programs, bitmap editors (like Adobe Photoshop and Fractal Design Painter) and other high-end video capture boards.

TIFF (Tag Image File Format)—A desktop publishing file format for the management of high-resolution bitmap files in a page layout program. In multimedia, TIFFs are inappropriate since high-resolution is not a priority. You will more likely convert your TIFFs into PICT files.

Truemotion and Truemotion-S—A software-only video compression algorithm developed by Horizons Technology (of San Diego, California), which features high-quality intraframe video compression with extensive control parameters. You can use this software in conjunction with your QuickTime video editing software. (Truemotion-S is the latest version of Truemotion.)

Tweak—To simplify your program's functions, optimizing the programming code or machine language to improve performance.

URL (Universal Resource Locator)—An address on the Internet. Website addresses begin with http://, and usually include www (World Wide Web). A typical example of a URL is the address for HotWired (the online version of *Wired* magazine): http://www.hotwired.com.

Usenet—The network of servers that comprise the Internet's newsgroups. Each newsgroup is maintained by people of similar interests, vocations and avocations. Valuable to those of us involved in multimedia, newsgroups are an excellent resource for consultation with fellow

professionals on everything from technical issues to problem-solving.

Veronica—The Internet search engine, or protocol, for such search applications as Gopher, WAIS (Wide Area Information Search), Archie, Yahoo, Web Crawler, etc.

Video Compression—See *Codec*.

Video for Windows (also known as Microsoft Video)—Microsoft's competitive entry in the video software utility arena. It delivers acceptable results playing video files on limited hardware platforms running Windows. Also see *AVI*.

VOC—A sound file format compatible with some SoundBlaster cards; used mostly in DOS applications. (VOC files may not play in a Windows environment.) Designated on the PC by the file extension .VOC.

VRML (Virtual Reality Modelling Language)—An open standard derivative of HTML used in the creation of virtual environments that can run over a network, and the Internet specifically. Network gaming and role playing environments can be facilitated using VRML.

WAV—Primarily a Windows sound file format, but also compatible with some DOS programs. Designated on the PC by the extension .WAV.

Wavetables—PC audio cards that recreate sound based on actual soundwave tables stored in the board's ROM chip.

WMF (Windows Metafile Format)—A graphic file format that supports both vector (line-based) and raster (bitmapped) images and displays them in Windows applications. Designated on the PC by file extension .WMF.

Yahoo—An Internet search engine; one of a growing list of website registries that enables users to locate particular sites of interest. Other search engines include Netsearch, Alta Vista, Magellan, Gopher and Web Crawler.

Bibliography

BOOKS

In this book, I've tried to cover more about strategic planning and less about the individual technical skills, like graphic design, video production and programming; the following titles go into much greater detail on some of these specialized topics. Hopefully, these additional resources will help you gain an understanding of how your interests and native skills can fit into the world of multimedia.

Apple Computer, Inc. Staff, *Multimedia Demystified?!*. Random House/New Media Series, 1995.

Dayton, Lennea and Jack Davis, *Photoshop WOW! Book*. Peachpit Press, 1994.

Feerer, Michael, *Premiere with a Passion*, 2nd ed., Peachpit Press, 1994.

Field, Syd, *Screenplay: The Foundations of Screenwriting*. Dell Publishing, 1984.

Frobisch, D., H. Lindner and T. Steffen, *Photoshop IQ: Imaging Effects for Mac & PC*. Silver Pixel Press, 1995.

Graphic Artists Guild Staff, *Graphic Artists Guild Handbook: Pricing & Ethical Guidelines*, 8th ed. Graphic Artists Guild, 1994.

Hofsinger, Erik, *MacWeek Guide to Desktop Video*. Ziff-Davis Press, 1993.

Kristoff & Satran Staff, *Interactivity by Design: Creating & Communicating with New Media*. Alpha Books, 1995.

Laurel, Brenda, *Art of Human-Computer Interface Design, The*. Addison-Wesley, 1990.

Laurel, Brenda, *Computers as Theater*. Addison-Wesley, 1993.

McClelland, Deke, *Mac Multimedia & CD-ROMs for Dummies*. IDG Books, 1995.

Rathbone, Andy, *Multimedia & CD-ROMs for Dummies*. IDG Books, 1994.

Rosen, David, *Making Money with Multimedia*. Addison-Wesley, 1994.

Serman, Chris, *CD-ROM Handbook*, 2nd ed. McGraw-Hill, 1993.

Smedinghoff, Thomas J., *The Software Publishers Association Legal Guide to Multimedia* (with disk and legal forms files). Addison-Wesley, 1994.

Stim, Richard, *Intellectual Property: Patents, Trademarks & Copyrights*. Lawyer's Cooperative, 1994.

Sullivan, Michael J., *Make Your Scanner a Great Design & Production Tool*. North Light Books, 1995.

Wodaski, Ron, *Multimedia Madness*, Deluxe Edition, Sams Publishing, 1993.

Wurman, Richard Saul, *Information Anxiety: What to Do When Information Doesn't Tell You What You Need to Know*. Bantam, 1990.

PERIODICALS

The following publications are produced primarily for multimedia artists, designers and producers:

Computer Artist: Digital Imaging, Illustration, Design, published monthly by Pennwell Publishing Co., P.O. Box 3188, Tulsa, OK 74101. Subscriptions: (918) 831-9405 or contact the editor, Tom McMillan, e-mail: tomm@pennwell.com.

Computer Pictures, Montage Publishing, White Plains, NY. Published monthly. Subscription: (914) 328-9157.

Desktop Video World, published monthly by IDG Communications Publishing, Peterborough, NH. Subscription: (603) 924-0100.

Electronic Media, published weekly by Crain Communications, Chicago, IL. Subscription: (800) 678-9595.

HOW magazine, F&W Publications, Inc., 1507 Dana Ave., Cincinnati, OH 45207. Published bimonthly. Subscription: (513) 531-2690.

Inside the Internet: Rocket Science for the Rest of Us, published monthly by the Cobb Group. Subscriptions: Customer Relations, 9420 Bunsen Parkway, Suite 300, Louisville, KY 40220. Call: (800) 223-8720.

Interactive Age: The Newspaper for Electronic Commerce, published bi-weekly by CMP Publications, Inc. Subscriptions: P.O. Box 1194, Skokie, IL 60076. Phone: (708) 647-6834. Internet: http://techweb.comp.com/ia.

Interactivity: Tools and Techniques for Interactive Media Developers, a monthly publication from Miller Freeman, Inc., 600 Hamilton St., San Francisco, CA 94107. Subscription information: (800) 467-7498. Internet: http://www.interactivty@mfi.com.

Internet World: The Magazine for Internet Users, a monthly publication from Meklermedia Corp., 20 Ketchum St., Westport, CT 06880. Information: Internet: http://www.info@mecklermedia.com. Subscribe via e-mail: isubs@kable.com.

Macromedia User Journal: For Multimedia Developers and Users of Macromedia Programs, published monthly by Hypermedia Communications, P.O. Box 10285, Des Moines, IA 50381-0285. Call (800) 772-5148.

Multimedia Producer: For Creators and Developers of Interactive Multimedia, published by Knowledge Industry Publications, Inc., 701 Westchester Ave., White Plains, NY 10604. Subscription inquiries via CompuServe: 72123.353@compuserve.com.

New Media, published by Hypermedia Communications Inc., 901 Mariner's Island Blvd., Suite 365, San Mateo, CA 94404. Subscriptions: Call JCI Customer Service at: (609) 786-4430.

Wired magazine, published by Wired USA, 520 Third St., Fourth Floor, San Francisco, CA 94107. Phone: (415) 222-6200. Internet: http://www.hotwired.com.

Credits

Pages 12-15: SilverTab Main Menu Screen, RedTab Main Menu Screen, "Fit Parade," Accessories Attract Loop, RedTab Detail Screen, Accessories Main Menu Screen, Additional Accessories Screen. © Levi Strauss & Co. Used by permission of R/Greenberg Associates Digital Studios Inc.

Pages 20-23: OM Records' Website Screens (various), "Spiritual High" Main Screen, slide show/"Free Tibet" page, Holistic Health section, including Ayurveda information, Plus Additional Screens. © 1995, 1996 OM Records. Used by permission.

Pages 24-25: "Samurai Baby," "Gold Face in the Clouds," and "Motion Elite." Designer: Jonathon Ellis. © Hardie Interactive.

Pages 32-35: 1995 IBM Annual Report. © IBM Corporation. Zyrtec Website. © Pfizer Inc. Used by permission.

Pages 48-49: ERTL Catalog Screens, MicroComputer Consultants' Safety Officer II Screen, Hardie Interactive Website Buttons, Dubuque Business Hall of Fame screens. Designer: Eric Faramus. © Hardie Interactive

Pages 50-51: Art Center Dayton Commemorative CD-ROM Screens. © 1•earth GRAPHICS. Used by permission.

Pages 54-56: Primal Rage Road Show Screen. © 1995 Time Warner Interactive; U.S. Robotics Website Screens. © 1996 U.S. Robotics. Used by permission of CKS Interactive.

Pages 68-73: "Digital Dexterity" CD-ROM Screens; AT&T Business Exchange Website Screens; Corestates Bank Website Screen; Odyssey Systems Website Screens; Lucas Bear OnLine Screens. © 1995-1996 Marcolina Design Inc. Used by permission.

Pages 73-78: Lollapalooza '94 Interactive Press Kit Screens. © 1994 Warner Bros. Records. Woodstock '94 Interactive Press Kit Screens. © 1994 A&M Records, PolyGram Diversified Ventures Inc., and Woodstock Ventures Inc. Used by permission of Media Logic Inc.

Pages 84-85: VizAbility CD-ROM Screens. © 1995 PWS Publishing Company. Used by permission of MetaDesign.

Pages 86-89: "Good Daughter, Bad Mother, Good Mother, Bad Daughter" CD-ROM Screens. © Susan Metros. "Investigating Lake Iluka" CD-ROM Screens. © Interactive Multimedia Pty Ltd. Used by permission of Susan Metros.

Page 103: Junnie's CatTracker Website Screens. Designer: Gary Olsen. © Hardie Interactive. Used by permission.

Pages 120-121: Women's Wire Website Screens. © Women's Wire. Used by permission.

Pages 122-123: Pisarkiewicz Digital Portfolio: Digital Self-Promotion Screens. © Pisarkiewicz & Co., Inc. Used by permission.

Pages 132-133: Nagasaki Journey Website Screens. © Exploratorium. Nagasaki Journey Website Screens 4, 6. © Exploratorium/Shogo Yamahata. Used by permission.

Pages 134-136: Pro Wieben Website. © 1996 Pro Sieben Television AG. FOX Sports Website. © 1996 IGuide. Used by permission.

Index

1•earth GRAPHICS,
50-51
3-D animation programs,
43
3-D Studio (Autodesk), 17,
43, 48
Access, direct vs. random,
90-91
Administrative assistant, 57
Adobe
 Acrobat, 110
 After Effects, 25, 35, 43,
 48, 51, 85
 Fetch, 64, 87
 Illustrator, 15, 19, 22, 42,
 55-56, 73, 75-76, 84,
 121, 123
 PageMill, 46, 103, 109,
 114-115, 135-136
 Photoshop, 22, 25, 33,
 35, 48, 51, 55-56, 70,
 73, 75-76, 87, 114, 121,
 123, 135-136
 Premier, 15-16, 25, 28,
 35, 48, 51, 55, 70, 85,
 87, 123
After Image (Cosa), 70
AIFF (Audio Interchange
 File Format) file, 31
Aldus
 Painter, 16
 Persuasion, 102
Allegiant SuperCard,
 44-45, 102
Alpha prototype, 10,
 66-67, 102
Alpha testing, 107
"American Visions," 132
America OnLine, 117
Animation
 3-D, 28, 125
 career in multimedia, 17,
 57
 "low tax," 12
 scanning for, 28
Annual report, electronic,
 34-35
Apple
 HyperCard, 44-45, 66,
 84, 102
 Media Tool, 87
 QuickTake Camera,
 30-31, 87
Applets, 112
Art Center Dayton Com-
 memorative CD-ROM,
 The, 50-51
Astound (Gold Disk), 44,
 66
Asymetrix ToolBook, 46,
 66, 102
AT&T Business Exchange
 website, 72-73
Attributes inspector, 115
Audience, 63
Audio
 digitizing board, 31

editing software for, 43
file formats for, 31
 optimized, 11
 sound card for, 31
Authoring programs, 44-
 46, 93
Author-ready narrative, 66,
 98
Autodesk 3D Studio, 35,
 43, 48
AVI (Audio-Video Inter-
 leaved) file, 28, 36, 40
Avid Media Composer, 21
Avid Media Suite Pro, 37,
 39

Backgrounds, 101
Backups, 38
Barnstead Thermolyne,
 104
Behl, Brian, 55
Beta testing, 107, 127-130
Bitmap frames, compres-
 sion of, 39
BMP format, 41
Boards
 sound, 31
 video capture, 36
Brainstorming
 creative, 61-62
 proposal, 59
Browsers, 109-110
Bruck, Randy, 55
Budget
 image gathering, 119
 multimedia, 58
Buttons
 circles with dots as, 23
 creating, 116
 designing, 96
 pop-up menu, 136
 redundant, 116
 roll-over, 21
 torn paper scans as, 48

Cameras, digital, 30-31,
 119
Captivator (Videologic), 36
Careers in multimedia, 7,
 16-17, 52-53, 57
Carter, Matthew, 12
Catalogs, 94
CD-recorder (CDR), 25,
 37-38, 129-130
Chow, Margot, 56
Cinepak, 40
Cipa-Tatum, Jillian, 56
CKS Interactive, 54-56
Claris Draw, 42
Client
 approvals by, 66-67,
 104-105
 change requests by,
 66-67
 creative brainstorming
 with, 62
CMF files, 31
Codec, 36, 39-40
Collage (Specular), 73
Color palettes, 101-102

Comdex, 29
Compression
 for CD-ROM data rate,
 130
 graphics, for Web, 125
 intraframe vs. interframe,
 40
 video file, 36, 39
Computer-based training
 (CBT), 8-9, 44-45, 95-96
Computer games, 16, 96
Computer shows, 29
Computer systems
 Mac vs. PC, 26-27
 upgrading, 26
"Computer Zoo, The,"
 114
Contracts, 60-62, 65
Control issues, 61
"Cookies," 111
Copyrights, 53, 65
Corel
 CD Creator, 46, 129
 CorelCHART, 47
 CorelDRAW 6, 42, 47
 CorelDREAM, 47
 CorelMOVE, 47
 CorelPHOTO PAINT,
 47
 CorelSHOW, 47
 VENTURA, 47
Corestates Bank website,
 71
Corporate style sheet, 104
Cosa After Image, 70
Cost bucket, 80
Costs
 controlling, 81
 discussing multimedia,
 58-59
 estimating, 79-81, 83
 summary for proposal, 60
Creative brainstorming,
 61-62
Credits, 66
Cross-platform develop-
 ment, 27, 45

Database
 formats, software for, 45
 programming, 16-17
 relational, 46
Data-rate, CD-ROM, 130
Data-streaming technolo-
 gy, 113
Davis, Matt, 55
Day planner, 82-83
DeBabelizer (Equilibri-
 um), 46, 55-56, 101, 125
Deck II, 25, 43
Delivery date, 61
Deneba Canvas, 42
Design document, 61, 105
Design metaphor, 99, 101
Design phase, 61, 67
Desktop publishing
 graphic production for,
 118
 software for, 47
 upgrading from, 29

Development platform, 30
Digital cameras, 30-31, 119
Digital Dexterity, 68, 70
DiRe, John, 12-13
Direct access, 90-91, 94
Director
 multimedia, 53
 video post-production,
 57
"Disc Wizard" interface,
 46, 129
Dolin, Guthrie, 20
"Donkey Kong Country,"
 125-126
"Doom," 96
Drawing programs, 42
Drives
 optical, 38
 tape backup, 38
Dubuque Business Hall of
 Fame, 49
DVA-4000, 36
DVD (Digital Versatile
 Disk), 40
Dynamic Graphics Educa-
 tional Foundation
 (DGEF), 19

Elastic Reality, 51, 123
Electric Image, 17, 43
Elemental, 34
Ellis, Jonathon, 24-25, 110
Employee orientation
 program, 104
EPS format, 41
Equilibrium DeBabelizer,
 46, 55-56, 101, 125
Ertl Company, The,
 47-49, 98-99
Executive Arts, Inc., 32-35
Exploration games, 96
Exploratorium, 132
Extreme 3D (Macrome-
 dia), 43, 47

Faramus, Eric, 47-49, 116
FastBack, 38
Feedback, importance of,
 97-98
Fetch (Adobe), 64
Files
 compression of video, 39
 conversion programs for,
 46
 formats for, 124-125
 labeling of, 130
Fjeldstrom, Gustaf, 55-56
Flash sketching exercise,
 85
Flatbed scanner, 87
Fontographer, 47
Fonts, 106
Form Graphics, 131
FOX Sports Website,
 135-136
Fractal Design Painter, 42,
 101, 121
Frames, 113
FreeHand (Macromedia),
 25, 42, 47, 103

Full-color RGB, 124
FWB Sledgehammers,
 55-56

Games, computer, 16, 96
Getting Started in Computer
 Graphics, 6
GIF (Graphic Interchange
 Format) files, 41,
 114-115, 125
Glock, Eleanor, 134
"Good Daughter, Bad
 Mother: Catharsis and
 Continuum," 86-87
Gordon, Sherry, 134
Graphic designer, 53, 57
Graphic Interchange
 Format (GIF) files, 125
Graphics
 designing, 106
 file formats for, 125
 optimizing Web page,
 114
 organic design of, 10
 preparing for multime-
 dia, 118-136
 repurposing Mac to PC,
 30
 resolution of color, 124
 video and, 107
Gunther, Suzanne, 73

Hardie, Steve, 7
Hardie Interactive, 7,
 24-25, 47-49
 cost estimating by, 80
 hardware used by, 30
 presentation package
 from, 93
 training at, 10
 website for, 3
Hardware
 basic considerations,
 26-40
 CD-recorder, 37-38
 digital cameras, 30-31
 leasing and renting, 38
 monitors, 29
 optical drives, 38
 scanners, 29-30
Harris, Jay and Lisa, 50
Henderson, Dr. Joe, 9,
 64
Higashi, Jun, 132
Higgins, Rebekah, 68
Hill, Bill, 84
Hoffman, Armin, 12
Home page, 106
HotDog, 109
Hot links, 56
Hot Metal, 109
Hot spots, 33
HotWired, 111
HSC Live Picture, 41
HTML (Hypertext
 Markup Language), 109
 customizing tags, 117
 programming, 16, 103
 text editing, 46
HTML Editor, 109